Marvin D. Cone and Grant Wood
AN AMERICAN TRADITION

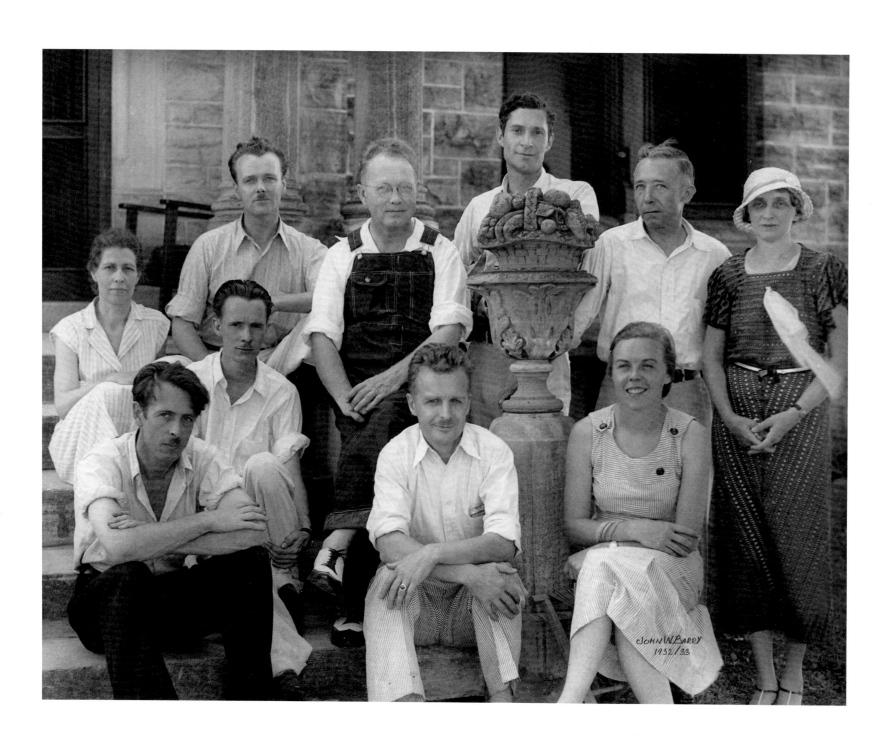

John W. Barry
1932/33

Marvin D. Cone and Grant Wood
AN AMERICAN TRADITION

CEDAR RAPIDS MUSEUM OF ART · IOWA

JOSEPH S. CZESTOCHOWSKI

This volume was published in conjunction with the opening of the new Cedar Rapids Museum of Art in December 1989.

This volume was published by generous grants from the National Endowment for the Arts, and the Robert O. Daniel and William B. Quarton Funds of the Cedar Rapids Museum of Art.

Library of Congress Cataloguing-in-Publication Data

Czestochowski, Joseph S.
 Marvin D. Cone and Grant Wood: an American Tradition/Joseph S. Czestochowki
 p. cm.
 Includes bibliographic references.
 1. Art, American--Catalogs. 2. Art, Modern--20th century--United States--Catalogs. 3. Cone, Marvin Dorwart, 1891-1965--Catalogs. 4. Wood, Grant, 1891-1942--Catalogs. 5. Regionalism in art--Catalogs. 6. Cedar Rapids Art Association--Catalogs. I. Cedar Rapids Art Association. II. Title.
N6512.C95 1989 759.13'074'77763--dc20 89-25430

ISBN 0-942982-09-6
ISBN 0-942982-08-8 (paperback)

Cover/Jacket and Frontispiece:
Marvin D. Cone and Grant Wood, the Stone City Art Colony faculty, summer 1932. Wood, who taught advanced painting, is in the center; Adrian Dornbush, another painter, is to Wood's immediate right; Arnold Pyle, teacher of frame making and painting, to his lower right; Marvin D. Cone, who taught figure drawing, sits in front of Wood; and Edward Rowan, who gave lectures on art, stands behind the stone ornament. Florence Sprague, the instructor of sculpture, stands at the right. Photograph by John W. Barry (1905-1988).

First Edition

CONTENTS

For
John B. Turner II
and
Bea Huston

FOREWORD AND ACKNOWLEDGMENTS

The Cedar Rapids Art Association is the oldest fine arts organization in the state of Iowa, with a history that dates to the 1890s. Since its beginning, the museum has been a community institution, and with the support of its generous donors has built one of America's finest collections of regional art. As the museum's centennial approaches, it seems appropriate to review the results of its long and productive relationship with its community. The museum is proud, therefore, to initiate a series of publications dealing exclusively with aspects of the permanent collections.

A group of individuals inspired by the 1893 Chicago World's Columbian Exposition provided the seeds of the Cedar Rapids Art Association. At first there was no organization, but there were frequent meetings and exhibitions, and many avenues of art appreciation were pursued. In the early 1900s the art association found a home in a newly constructed Carnegie Library. Designed by Henry S. Josselyn (1849-1934) and Eugene H. Taylor (1853-1924), Iowa's first formally trained architects, the library housed the art association until the late 1960s—and it will do so again. At about the same time as the new library opened, two young high school students with an interest in art were volunteering as security guards and helping to unpack, hang, and return exhibitions. Even then, their contribution to the art association was substantial.

Today, the legacy of Grant Wood and Marvin Cone constitutes one of the most important and most widely recognized collections of the Cedar Rapids Museum of Art. The museum made its earliest acquisition of works by Wood and Cone in 1920 for less than one hundred dollars. Two more works—Wood's *Woman With Plant(s)* (cat. no. 109) and Cone's *Old Iowa Barn* (cat. no. 80)—were acquired in 1931 and 1939, respectively, bringing the collection's total representation to four works. This number did not change until about 1972, but in the past fifteen years a series of gifts has increased our holdings to over 515 works. This comprehensive collection is at once our greatest asset and one of our least known.

The few works by Grant Wood and Marvin Cone regularly displayed in museum exhibitions only hint at their artistic diversity. With this publication we hope to introduce a wider public to the rich aesthetic tradition of these two important midwestern painters. With few exceptions, the Wood and Cone collections were acquired through donation. We are especially grateful to those who have contributed their valued works to the museum. This publication proudly celebrates not only the achievements of two distinguished artists, but the generosity of this institution's benefactors. In particular, Happy Young and John B. Turner II and Winnifred (Mrs. Marvin) Cone deserve special recognition for their vision and their singular dedication to the work of these artists. Their impact on the collection is clear from the frequency with which their names appear throughout this catalogue. The many others who have nurtured the art association through their time and varied contributions deserve appreciation as well. Thanks are also due members of the museum staff who have provided valuable assistance, including Marna Rehage, Reino Tuomala, Deanna Clemens, Pam Curran, Cindy Abel, and Karen McClain. Finally, I would like to acknowledge the Board of Directors-Trustees of the Cedar Rapids Art Association for their tremendous support.

Joseph S. Czestochowski

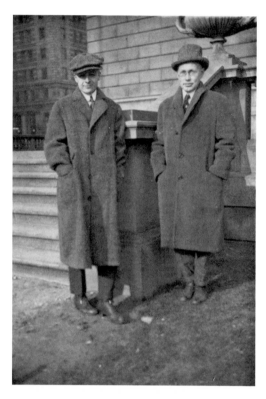

Marvin D. Cone and Grant Wood at The Art
Institute of Chicago, January, 1916.
Photograph by Arthur W. Hall [1889-1981].

MARVIN D. CONE AND GRANT WOOD: AN AMERICAN TRADITION

Joseph S. Czestochowski

AN INTRODUCTION TO THE COLLECTIONS

There is local, regional, and national significance in the lives and work of Grant Wood and Marvin D. Cone. They were Cedar Rapids' first professional artists, and they maintained close relationships with their community. As two of the more prominent artists of their time, they were important participants in the conscious rise of cultural expressiveness in the Midwest in the fifty years following the 1893 Chicago World's Columbian Exposition. Recently, art historians have begun to recognize the important contributions these two artists made to the larger fabric of American art.

Wood and Cone were part of an era in which regional artistic movements flourished. Yet it was a complex time that should not be characterized by art historical labels. In the Midwest, regionalism can be traced to 1892-93 and the efforts of three Chicagoans — writer Hamlin Garland, sculptor Lorado Taft, and painter Charles F. Browne — who vociferously advocated the Americanization of modern art in the form of an aesthetic nativism or regionalism. Those efforts led to the creation of the Hoosier School in Brown County, Indiana, at roughly the time Wood and Cone were born.

As aspiring and motivated young artists, Wood and Cone were first exposed to regionalism through their affiliation with the Cedar Rapids Art Association. Charles F. Browne, T. C. Steele, Charles W. Hawthorne, James Ottis Adams, George Gardner Symons, and Lorado Taft — all influential leaders of various regional schools throughout the country — organized exhibitions, recommended acquisitions, and gave periodic lectures at the association. Inevitably, their activities reflected their personal aesthetic inclinations, and, as a result, the early direction of the art association showed a preference for regionalism rather than for objective historicism.

Wood and Cone both reflect a fortunate confluence of personality and aesthetics in their work. Each artist received some of his training at the School of the Art Institute of Chicago at a time when impressionism was the dominant style. Wood returned to impressionism on and off throughout his career, while Cone aggressively sought and welcomed change. They shared an interest in design and decorative pattern, the product of both personal preferences and training. Grant Wood would become one of this country's best-known artists; Marvin Cone, because of the quality of his expression, deserves to be better known today.

There were many opportunities for the two lifelong friends to influence one another. They met in high school, traveled to Paris together in 1920, worked together throughout their careers, joined forces in the summers of 1932 and 1933 to create the Stone City Art Colony, and remained good friends during Wood's meteoric rise to fame in the 1930s. As people, they were direct opposites — Wood was outgoing and Cone was reserved — but they maintained a genuine mutual respect that precluded critical comments. They did not always agree, and often the difference was great, but their friendship transcended their disagreements.

Cone painted for himself. He never sought the public recognition his friend received, and he remained free of the uncertainty that periodically plagued Wood after he became well known. His subject matter had a depth and diversity rooted in self-confidence, and his images were individual rather than collective. From early in his career, Cone was more concerned with interpretive style and technique than was the design-oriented Wood. He began to layer the components of his paintings a number of years before Wood became famous. In the 1920s Cone produced accomplished works. In the 1930s, Wood won widespread recognition for his modernist simplification while capturing the American personality in a series of celebrated paintings. The works of both Cone and Wood are proof that Cone was equally important to this relationship.

The phenomenal success of *American Gothic* (1930, Collection of the Art Institute of Chicago) propelled Grant Wood into the national limelight. But even though the painting launched his career, it created a dilemma for him. The public response to his work was so enthusiastic, and the pressure to continue was so intense, that his need to satisfy public expectations began to influence his art. By the mid-1930s, he was unfortunately already consumed with self-doubt, and he soon reverted to a modified form of impressionism. It is difficult to speculate about what Wood might have accomplished had it not been for his untimely death in 1942.

Cone continued to paint for himself, remaining secure in his independence. His paintings represented his own inner being and, for Cone, that was enough. His method evolved with the times. Some of his earliest works from 1919 display a strong tendency toward abstraction that was carried to fruition in his stunning works of the 1950s and 1960s. Cone was satisfied to be an artist involved in the local and regional art communities, leaving the national attention focused on his more outgoing friend Wood.

This book is not intended to value the work of one artist over another, but to provide insight into the factors that inspired each of them. Although conclusions could be drawn and critical reputations could be corrected, that is not the purpose here. After all, such concerns would never have been issues between Grant Wood and Marvin Cone.

MARVIN D. CONE

Unlike his close friend Grant Wood, Marvin D. Cone did not fit the popular conception of an artist, nor did he share Wood's sense of mission about regionalism. His life was relatively unremarkable. He lived all his seventy-four years in Cedar Rapids, Iowa, where he married, raised a family, and, for more than four decades, taught art at Coe College. He was highly respected by his contemporaries, but he never achieved great fame in the art world. Yet as conventional as his life may seem, his work shows that he was a passionate artist who had a rare sensitivity to his environment. It is clear that Cone was an exquisite craftsman and an important figure in the long tradition of American painting.

Cone did not leave extensive autobiographical comments, but some of his writing does offer considerable insight into his singular artistic purpose. On one occasion in 1947 he wrote, "A work of art is a moving communication from an artist to a spectator. Therefore, when you look at a painting, don't worry too much about what it represents but look rather for the nature of the man who painted it—his spirit and fire."[1] It seems likely that Cone's lifelong objective was to sharpen his perception, to better understand and to reveal his surroundings and his own being through his art. Each of Cone's works reflects an individual moment in time and space, fixing the artist's identity within a universal context of inevitable change.

EMERGING INTERESTS

Marvin Cone was born and raised in Cedar Rapids, where in 1906 he began a lifelong friendship with Grant Wood. He graduated from Coe College in 1914 and then studied for several years at the School of the Art Institute of Chicago. His program there was diverse; class records indicate that he excelled in drawing, and extant works show a strong orientation to design. World War I interrupted his studies, and after being stationed in New Mexico, Cone left for France in 1917, where he served for several years as an interpreter. In 1919, Cone studied for about five months at the School of Fine Arts in Montpellier, France. When he returned to Cedar Rapids that year, he continued to pursue his interest in art. He considered commercial art, but chose instead to accept a position teaching French at Coe College for the 1919-20 academic year.

In Cedar Rapids, Cone quickly renewed his friendship with Grant Wood and resumed his active involvement with the local art association. Cone and Wood went abroad in the summer of 1920, hoping to improve their technical skills. The visit proved influential, resulting in a stunning series of impressionistic views of picturesque cityscapes and landscapes, Paris streets and gardens, and the French countryside. On the voyage home, Cone exhibited thirty of his paintings in the ship's salon. The exhibit was quite popular, with his cloud paintings earning the most praise from critics. These were Cone's first successful paintings, and his decision to show them indicated his confidence in the results of the summer experience. At the time of the exhibit, Wood introduced Cone to Winnifred Swift, whom Cone married the following fall.

Cone returned to Cedar Rapids with a fresh perspective on his work, and he immediately assumed expanded teaching duties at Coe College. In contrast to many of his contemporaries, who turned to teaching only as a last resort, Cone always pursued it with great enthusiasm. He kept a full teaching schedule, including studio and art history courses, and he thrived on the daily exchange with students. Cone's commitment to teaching was surpassed only by his devotion to his family. On one occasion in January 1927 he said, "Without putting painting aside, my chief hobby is my four-year-old daughter, Doris, and what time I get to paint is most graciously awarded to me by her."[2]

The experience of a final trip to Europe in 1929, together with the emerging spirit of cultural nationalism at home, resolved Cone's need for a sense of place and further reinforced his confidence as an experienced craftsman. Financed by twenty community patrons, the Cones spent the summer in Paris. Cone wrote that he was captivated by the luminosity of the city and noted, "There is much to write about in Paris—much material of the guide book variety . . . but it seems to me that personal observation on the life in and around Paris might be more readable than the date of the completion of the metal roof on Chartres Cathedral, for instance."[3] The experience always held a key place in the pattern of his artistic growth.

Cone soon applied his painterly interest in the commonplace realities of the Paris cityscape to his homeland. As Grant Wood later observed, "Still keeping his strong use of pattern and design, this past season of working so long and so directly from nature has given a certain depth and connection to his work. Happily, this added realism has in no way diminished the poetry that has always been so characteristic of Marvin Cone's paintings."[4] At the same time, Cone was influenced by an active regional literature; Ruth Suckow's *Country People* (1924) and *Iowa Interiors* (1926) were particular favorites. But in contrast to Grant Wood and the other well-known American regionalists Thomas Hart

Marvin D. Cone

THE MARVIN D. CONE COLLECTION

INTRODUCTION TO THE COLLECTION

A BRIEF HISTORY

Like his close friend Grant Wood, Marvin D. Cone was considered a working artist in Cedar Rapids. His acquaintances remember him fondly, and they readily point both to his accomplishments as an artist and an educator and his dedication as a friend and a family man. Cone is also something of a legend among the many students he taught from 1919 to 1965. Cedar Rapidians today are proud of his contribution to the community's history.

Over the years, many individuals have assiduously collected Cone's work. This is not surprising, considering the genuine sentiment people felt for Marvin Cone. It is surprising, however, that the Cedar Rapids Art Association only purchased two works directly from the artist: *Cloud Bank* (1930, cat. no. 53) and *Inner Light* (1950, cat. no. 97), acquired in 1932 and 1951 respectively.

Since these acquisitions, the museum's collection has had a relatively simple history. In 1969, Nell Cherry made a bequest of two early works, *Still Life* (1929, cat. no. 51) and *Figure Composition* (1931, cat. no. 59). In 1970, Ada Seeley made a bequest of *Sleeping Village* (1929, cat. no. 41), and the Cedar Rapids Community School District placed eight of Cone's works on a long-term loan to the museum. These were the beginnings of a comprehensive collection. With the exception of a drawing donated in 1973 by the Marvin Cone Club—*Anniversary* (1938, no. 227)—and three paintings from Winnifred Cone, Isobell Howell Brown, and Mr. and Mrs. Haven Y. Simmons in the early 1980s—the collection remained relatively unchanged.

In 1983 John B. Turner II (1909-1983) made a major donation of eleven works,

which had been purchased from Cone many years earlier by himself and by Turner's father, David (1882-1954) who was Grant Wood's patron. These paintings had been exhibited extensively and are generally considered to be among Cone's most important works. Ten years earlier, in 1972, Harriet Y. and John B. Turner II had given the museum eighty-six works by Grant Wood, which had become the nucleus of a major Wood collection. This was again the case with the 1983 Turner gift, which was the catalyst for the formation of a comprehensive collection of works by Marvin D. Cone.

The Turner gift was announced in 1983, along with three other gifts to the Cone collection from Judith and Sutherland Dows, John S. Vavra, and Mr. and Mrs. William P. Whipple. At the same time, the museum announced the donation of eighteen works from Winnifred Cone and her family. Mrs. Cone's initial gift was followed by a gift of thirteen works in 1983-84, 191 in 1986-87, and 9 in 1989. These gifts, along with many others from Cedar Rapids businesses, organizations and individuals during the same period, bring the total number of works in the Cone collection to 279. Mrs. Cone and her family have contributed 232 of these, ensuring that the Cedar Rapids Museum of Art will permanently house the most comprehensive selection of Marvin Cone's paintings and drawings.

THE NATURE OF THE COLLECTION

The Cedar Rapids Museum of Art's collection of Marvin D. Cone's works—the most comprehensive anywhere—can be said to

demonstrate the community's genuine pride in the creativity of one of its own citizens. Cone was born in Cedar Rapids, and he lived, worked, taught, and raised a family there, leaving a strong imprint on the city's cultural life. He was committed to the Cedar Rapids Art Association from its beginnings, so it is especially fitting that the museum now holds 279 paintings and drawings that represent the full richness of Cone's stylistic development.

Cone's earliest work, from his college years and his time at the School of the Art Institute of Chicago, consists of charcoals and oils, landscapes done either in class or on sketching trips around Chicago, and pen-and-ink magazine illustrations. His decorative illustrations—such as *Summer Afternoon* (1915-16, cat. no. 3), *Cloud Bank—Evening* (1916-17, cat. no. 9), *Sketch for a Mural Decoration* (1917, cat. no. 10) and *Big Hills* (1917, cat. no. 11)—show his aptitude for design and his sensitive use of color to articulate forms, both qualities that would characterize his later work. The more than seventy-five drawings Cone did for *The Continent* from 1915 to 1917 show that he enjoyed illustration; he would later incorporate details from these works into his paintings.

Cone's formative period, 1919 through 1929, followed his first exposure to the French landscape as a young soldier at the end of World War I. Early works such as *Sunny Afternoon—Montpellier* (1919, cat. no. 13), *Evening Light—French Village* (1919, cat. no. 14), *Edge of the Village—Lathes* (1919, cat. no. 15), show stylistic tendencies, ranging from impressionistic to abstract, that would evolve in later work. During and after his influential trip abroad with Grant Wood in 1920, Cone painted a magnificent group of impressionistic scenes of his favorite places in

Paris and the French countryside. *Poplars, France* (1920, cat. no. 17), *Rue Sufflot* (1920, cat. no. 20), *A Bit of Sun, Luxembourg Gardens* (1920, cat. no. 21), *Sun-Lighted Statue* (1920, cat. no. 25), all reflect his fascination with the Paris cityscape. *Ville d'Avray* (1920, cat. no. 18), *Reflections, Corot's Pond* (1920, cat. no. 23), and *Patterned Water—Corot's Pond* (1920, cat. no. 24), show that he was equally entranced with the countryside. When he returned to Iowa, Cone's technique became more sophisticated, as he began to use suggestive color rich with light. *In The Summer Air* (1921, cat. no. 29), *Golden Afternoon* (1922, cat. no. 30), *Autumn Landscape* (1924, cat. no. 32), and *Autumn Hillside* (1928, cat. no. 39) are typical of Cone's stylistic development during this period. Another trip abroad in 1929 resulted in still more cityscapes and landscapes. This time he seemed especially taken with a variety of subjects, including, *Notre Dame, Paris* (1929, cat. no. 45), *From a Paris Window* (1929, cat. no. 46), *Sunlight and Shadow* (1929, cat. no. 47), *French Countryside* (1929, cat. no. 48), and *In the Studio* (1929, cat. no. 49).

The 1930s was a decade of tremendous activity for Cone, and the paintings in the museum's collection from this period epitomize his work. He focused on the midwestern landscape, but he also indulged in his lifelong fascination with the circus and began to paint haunting interior scenes. In all of his work from this time, a personal, introspective aura prevails. Among the most splendid of his landscapes is *Prelude* (1931, cat. no. 57), which captures the flavor of

midwestern light and the complex shapes of the land and the sky. *July Clouds* (1931, cat. no. 56) is another expression of nature's sublimity. Between 1935 and 1940 he created a series of about fifteen works, each one distinctly different, that present an idealized but austere and unsentimental view of the Iowa landscape. Beginning with *River Bend* (1935, cat. no. 70), the series includes *Hills of Iowa* (1937, cat. no. 74), *River Bend No. 4* (1938, cat. no. 75) and *River Bend No. 5* (1938, cat. no. 76). The unfinished *Waiting for the Parade* (1934-35, cat. no. 69) is typical of the approximately thirteen circus paintings Cone completed during the 1930s. This and other works in the series—such as *Side Show* (1935, cat. no. 71) and *Carnival Scene* (1935, cat. no. 72)—reflect an uneasy balance between realism and abstraction.

In the late 1930s and into the 1940s, Cone continued to capture on canvas what he felt were disappearing aspects of the Iowa landscape. The museum's collection includes the popular *Old Iowa Barn* (1938-39, cat. no. 80), along with *Farm Life* (1938-39, cat. no. 81), *From Iowa* (1940, cat. no. 84), *Lafayette Farm* (1942, cat. no. 86), *Iowa Landscape* (1942, cat. no. 88), *Otis Tuttle's Barn* (1945, cat. no. 91); and *Red Barn—Sketch* (1953, cat. no. 99). At the same time, he began to explore a new theme. Beginning with *Anniversary* (1938-39, cat. no. 79)—among the best of the series—Cone created a group of haunting interiors that would ultimately serve as the bridge between his early naturalism and his emerging abstraction. The museum's

collection contains many fine examples, including *This Was Doubtless He* (1946, cat. no. 92), *Dear Departed* (1946, cat. no. 93), *The Custodian* (1948, cat. no. 95), and *Uncle Ben* (1951, cat. no. 98), and *Four Exits* (1954, cat. no. 101).

In the 1950s and 1960s, Cone's work reflected an abstract sensibility that had been present as early as his *Cloud Bank—Evening* (1916-17, cat. no. 9). During this time, he created a powerful series of expressionistic interpretations of earlier themes. Continuing his interest in interiors, he completed such works as *Blue Door* (1954, cat. no. 100) and *Rakish Steps* (1961, cat. no. 111). Other paintings that reflect Cone's attraction to the abstract aesthetic include *Inner Light* (1950, cat. no. 97), *Pattern of Rectangles* (1957, cat. no. 103), *Golden Object Suspended* (1959, cat. no. 107), and *Enigma* (1961, cat. no. 110). Then, in *Houses that Jack Built* (1960, cat. no. 109), completed close to the end of his life in 1965, Cone returned to an imaginative subject developed initially in 1929.

The full variety of Cone's work, from his early impressionism to his late abstraction, reveals the artist's consistent—and distinctly personal—purpose in painting: Cone was constantly striving to increase his capacity for perception, to better understand and to reveal his own being. By making this comprehensive collection of Cone's works accessible to scholars and to the public, the Cedar Rapids Museum of Art can continue to communicate Cone's artistic purpose and message.

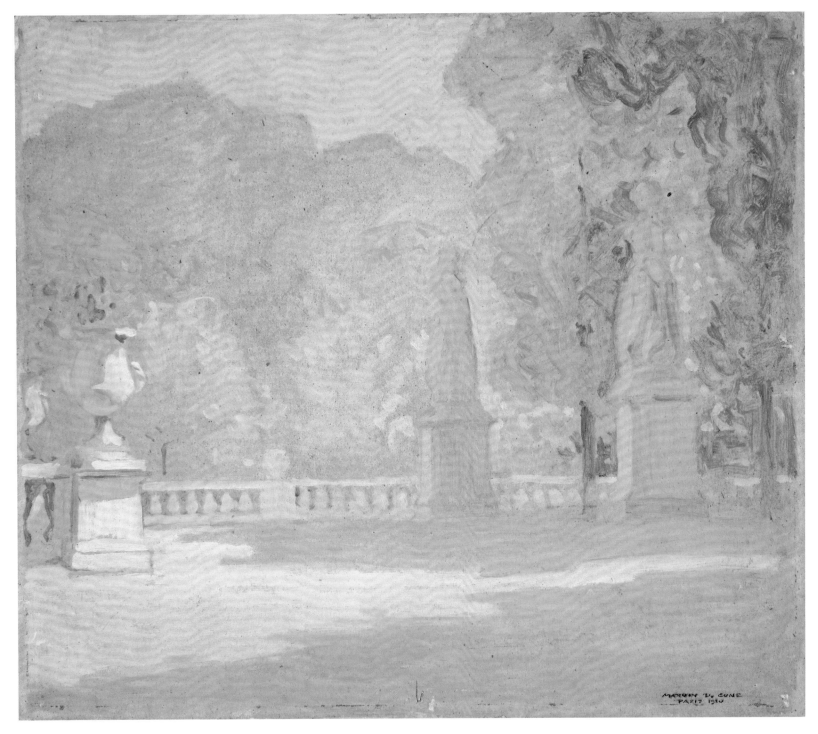

Sun-Lighted Statue, 1920
(cat. no. 25)

In the Summer Air, 1921
(cat. no. 29)

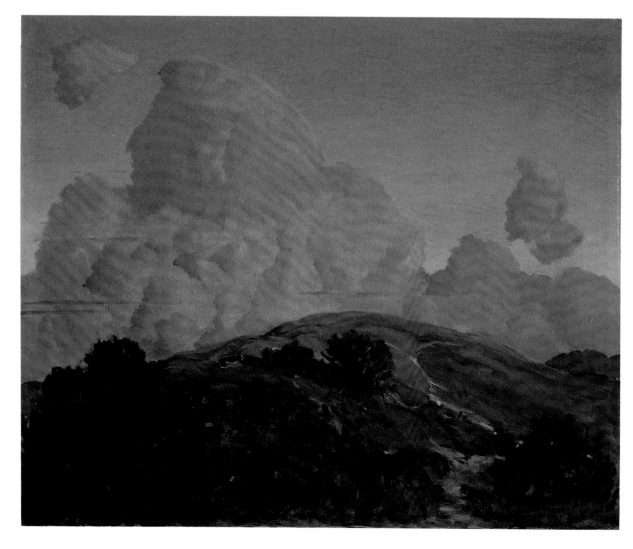

Golden Afternoon, 1922
(cat. no. 30)

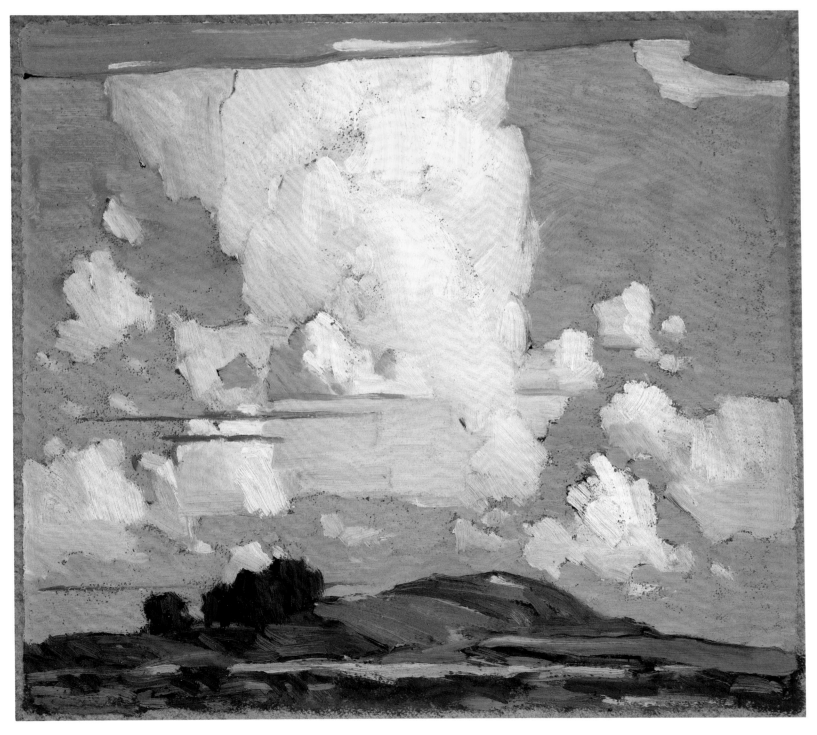

Cloud Bank, 1922
(cat. no. 31)

Autumn Landscape, 1924
(cat. no. 32)

Vieille Maison — Chatenay, 1926-27
(cat. no. 33)

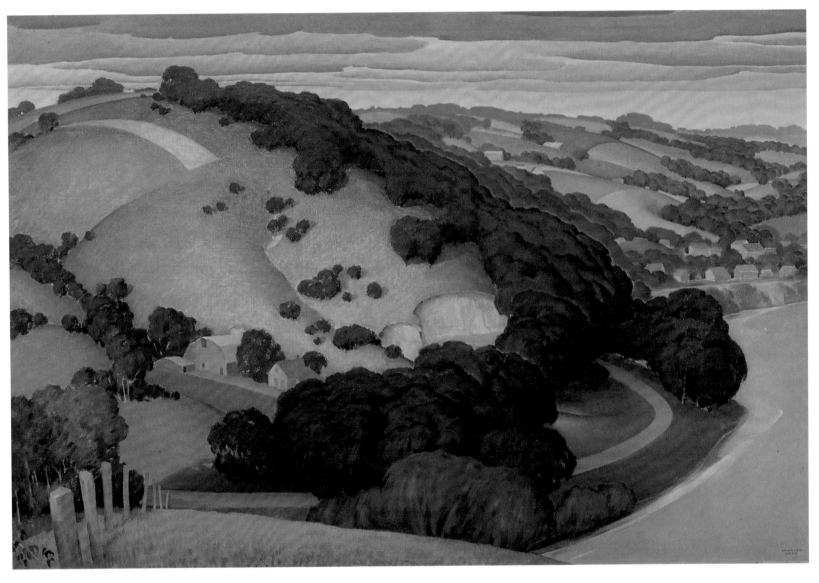

River Bend, 1935
(cat. no. 70)

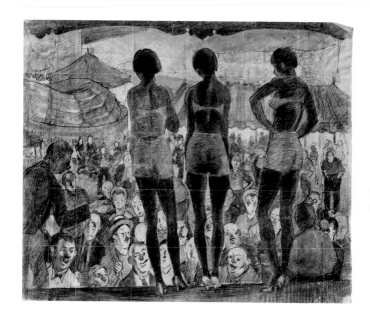

The Side Show, 1934-35
(cat no. 219)

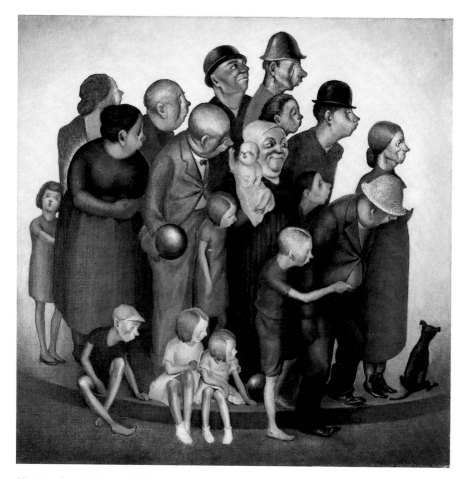

Waiting for the Parade, 1934-35
(cat. no. 69)

Fishing Fantasy, 1957
(cat. no. 102)

Pattern of Rectangles, 1957
(cat. no. 103)

"Marvin Cone Exhibits Paintings at Library." *Cedar Rapids Evening Gazette*, 15 April 1924, p. 14.

"Marvin Cone Shows Works." *Coe Cosmos*, 4 May 1961, p. 1.

"Marvin Cone Sketches Characters in Next Coe Production in Costume." *Cedar Rapids Gazette*, 15 March 1936, sec. 3, p. 6.

"Marvin Cone to Give Gallery Talk Sunday." *Cedar Rapids Evening Gazette*, 26 February 1927, p. 14.

"Marvin Cone Will Speak at Little Gallery Exhibit." *Coe College Cosmos*, 18 April 1929, p. 2.

"Marvin Cone Wins Coveted Prize in Exhibit." *Cedar Rapids Sunday Gazette and Republican*, 1 November 1931, p. 2.

"Marvin Cone Wins Mississippi Valley Award." *Art Digest*, 1 May 1940, p. 24.

"Marvin Cone's Paintings Are Put on Exhibition." *Coe College Cosmos*, 12 May 1927, p. 1.

"Marvin Cone's Pictures on Exhibition." *Cedar Rapids Republican*, 13 April 1924, p. 9.

McHugh, Roy. "Nation's Leading Exhibits Select Marvin Cone's Paintings." *Cedar Rapids Gazette*, 19 October 1941, sec. 1, p. 3.

"Midwest Exhibit Includes Painting by Marvin Cone." *Cedar Rapids Gazette*, 13 February 1977, sec. F, p. 21.

Montz, Wanda. "Ghosts and Marvin Cone Share Downtown Desert Island Studio." *Cedar Rapids Gazette*, 26 February 1939, sec. 2, p. 6.

"Mr. Cone Believes Art Is Inspired by Surroundings." *Coe College Cosmos*, 16 April 1931, p. 2.

"Murals, Landscapes, Decorative Art Are Part of Exhibition." *Cedar Rapids Evening Gazette*, 5 May 1923, p. 14.

Nelson, Allen. "Cone's Art Still Fills His Home." *Cedar Rapids Gazette*, 20 November 1966, sec. A, p. 12.

"New Features for Art Salon." *Des Moines Register*, 14 August 1936.

"New Paintings by Marvin Cone Are on Exhibit." *Coe College Cosmos*, 16 April 1931, p. 1.

"New Paintings by Marvin Cone Will Be Shown at Coe." *Cedar Rapids Evening Gazette and Republican*, 16 November 1928, p. 22.

"New Paintings of Marvin Cone to Be Exhibited." *Coe College Cosmos*, 15 November 1928, p. 1.

"New Studio for Coe Artists in Williston Hall." *Coe College Cosmos*, 18 November 1926, p. 3.

Northcott, Louise. "Cone Paintings Are Shown at Gallery." *Coe College Cosmos*, 27 November 1929, p. 1.

Nye, Frank. "Art Gallery in a Factory?" *Cedar Rapids Gazette*, 22 September 1946, sec. 1, p. 8.

O'Bryon, Kathryn. "Glassy Haunts of Science Museum Enclose Unusual Bird Specimens." *Coe College Cosmos*, 12 March 1936, pp. 1, 4.

"Officers, Directors of Art Association Elected." *Cedar Rapids Evening Gazette and Republican*, 31 January 1928, p. 10.

"Painting by Marvin Cone Selected for Philadelphia Show." *Cedar Rapids Gazette*, 19 January 1941, p. 5.

"Paintings by Two Local Artists Win Distinction." *Cedar Rapids Sunday Gazette and Republican*, 15 December 1929, sec. 2, p. 2.

"Paintings Late in Arriving." *Cedar Rapids Republican*, 21 September 1921, p. 6.

"Paintings of Coe Artist Selected for Annual Exhibits." *Coe College Courier*, December 1940, p. 2.

"Paintings of Grant Wood and Marvin Cone Are Praised." *Cedar Rapids Evening Gazette and Republican*, 15 November 1927, p. 13.

"Party of 175 Attends Opening Presentation of 'Night in Seville.'" *Cedar Rapids Evening Gazette*, 19 November 1926, p. 18.

"Pictures by Cone Exhibited in Art Room This Week." *Coe College Cosmos*, 13 March 1930, p. 1.

"Pictures Unveiled at Washington High." *Cedar Rapids Gazette and Republican*, 26 May 1932, p. 4.

"Postpone Art Tea." *Cedar Rapids Evening Gazette*, 8 April 1927, p. 18.

"Prof. and Mrs. Cone Entertain Fraternity." *Cedar Rapids Evening Gazette*, 4 January 1927, p. 12.

"Prof. Cone Exhibits Work in Little Gallery." *Coe College Cosmos*, 11 May 1933, p. 1.

"Prof. Cone Illustrates Talk on Paris." *Coe College Cosmos*, 28 April 1938, p. 3.

"Prof. Cone Is Speaker at Cornell." *Coe College Cosmos*, 17 March 1938, p. 1.

"Prof. Cone's Work on View." *Cedar Rapids Gazette*, 1 June 1939, p. 3.

"Prof. Marvin Cone Believes That Paintings Are Experience Records." *Coe College Cosmos*, 30 April 1936, p. 3.

"Prof. Marvin Cone Gives Art Viewpoint to A.A.U.W." *Cedar Rapids Gazette*, 26 May 1938, p. 8.

"Professor Cone's Paintings Shown by Corcoran Gallery." *Coe College Cosmos*, 1 April 1937, p. 3.

"Realism Is Feature of Cone Pictures." *Cedar Rapids Evening Gazette*, 12 May 1923, p. 14.

Reynolds, John. "Reporter Profiles an Artist." *Cedar Rapids Gazette*, 13 April 1947, sec. 4, pp. 1, 2.

"Rotary Club Views Local Art Display." *Cedar Rapids Republican*, 13 January 1926, p. 16.

Rowan, Edward B. "Art Exhibit of Marvin Cone." *Coe College Courier*, December 1929, p. 4.

————. "Art News of the Little Gallery." *Cedar Rapids Evening Gazette and Republican*, 28 November 1929, p. 9.

————. "Marvin Cone, Local Artist, Has Had an Interesting and Profitable Summer in France." *Cedar Rapids Sunday Gazette and Republican*, 1 September 1929, sec. 1, p. 8.

"Rowan Tells of His Trip to European Art Centers." *Cedar Rapids Sunday Gazette and Republican*, 25 August 1929, sec. 1, p. 2.

Seely, Garretson. "McKinley School." *Cedar Rapids Evening Gazette*, 12 May 1923, p. 13.

"Self Portraits of Iowa Artists Exhibited." *Des Moines Sunday Register*, 3 April 1932.

Shane, George. "Cone Exhibit Depicts Art in Transition." *Des Moines Register*, 30 October 1960.

————. "The Visual Arts." *Des Moines Register*, 23 May 1965, sec. L, p. 2.

Smith, Jeff. "Stone City Art Colony Will Open." *Coe College Cosmos*, 5 June 1933, p. 2.

"Splendid Exhibition of Paintings in Art Gallery at Public Library." *Cedar Rapids Republican*, 18 January 1925, p. 4.

Stern, Larry. "Marvin Cone: A Career of Guidance." *Cedar Rapids Gazette*, 29 May 1960, sec. 3, p. 6.

"Stone City Art Colony Will Be Opened Today." *Cedar Rapids Gazette*, 26 June 1932, sec. 1, p. 2.

Stroh, Charles. "Cone Show Depicts Expansion of Vision." *Cedar Rapids Gazette*, 11 September 1977, sec. F, p. 13.

"Students Show No Interest in Art Says Cone." *Coe College Cosmos*, 24 January 1929, p. 3.

Swain, Harriett. "Auction of Marvin Cone's Paintings." *Cedar Rapids Gazette*, 2 November 1939, p. 21.

Taylor, Adeline. "Artistic Caricatures Attract Attention." *Cedar Rapids Gazette and Republican*, 3 May 1936, sec. 2, p. 7.

"Marvin Cone Landscape 'River Bend.'" *Cedar Rapids Gazette*, 17 November 1935, sec. 2, p. 6.

"Tea Will Open Cone Exhibition." *Sunday Gazette and Republican*, 18 November 1928, sec. 4, p. 1.

David Turner. "Announcing a Private Sale of Paintings by Marvin Cone." *Cedar Rapids Republican*, 22 June 1926, p. 12.

"Variety of Art Being Displayed in Galleries." *Coe College Cosmos*, 13 June 1954, p. 2.

"Visitors Invited to Art Exhibition." *Cedar Rapids Republican*, 20 September 1921, p. 6.

"Week of Open House." *Cedar Rapids Republican*, 10 April 1921, p. 8.

"Weisenborn Pictures Big Attraction at Art Exhibit." *Cedar Rapids Republican*, 16 April 1921, p. 6.

White, Betty. "They Had Varied Childhood Aims But All Became Professors." *Coe College Cosmos*, 12 May 1938, p. 2.

"Wolf and Cone to Attend Iowa City Art Conference." *Coe College Cosmos*, 13 February 1930, p. 3.

Wood, Grant, et. al. "Art News of the Little Gallery." *Cedar Rapids Evening Gazette and Republican*, 6 December 1929, p. 27.

"Work of Henry S. Eddy and Local Artists on Exhibition at Library." *Cedar Rapids Evening Gazette*, 24 September 1921, p. 14.

"Work of Local Painters Attracts Many to Little Gallery Exhibition." *Coe College Cosmos*, 19 May 1933, p. 2.

"Works of Cone and Pyle to Be Shown in New York Exhibit." *Cedar Rapids Gazette*, 15 June 1937, p. 7.

Zug, John. "Marvin Cone." *Iowan Magazine*, Spring 1970, pp. 8-13.

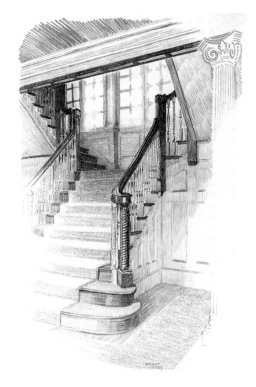

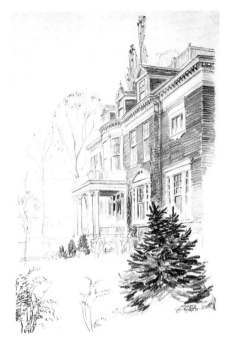

The Turner Mortuary,
Stairs and Balustrade, 1924
(cat. no. 67)

The Turner Mortuary,
Facade from the East, 1924
(cat. no. 65)

The Turner Mortuary, View from the Southwest, 1924
(cat. no. 64)

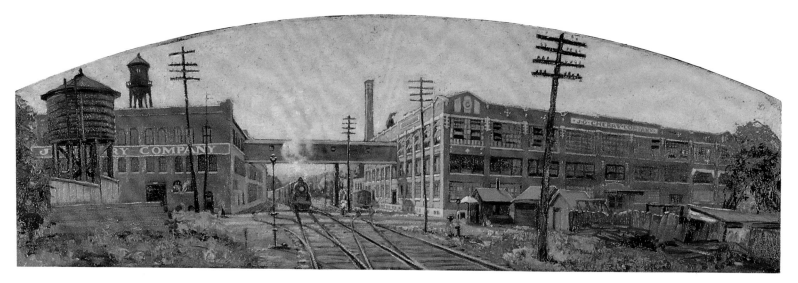

The Old J. G. Cherry Plant, 1925
(cat. no. 81)

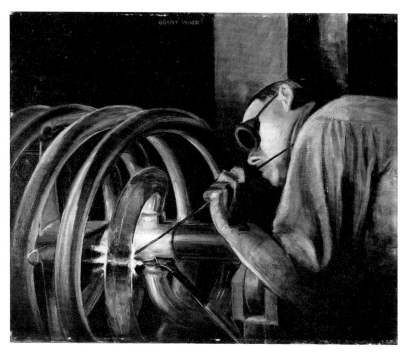

The Coil Welder, 1925
(cat. no. 79)

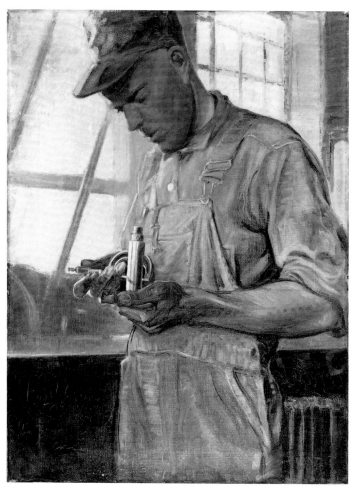

The Shop Inspector, 1925
(cat. no. 82)

Iowa Corn Room Murals, Montrose Hotel, 1925
(cat. no. 76)

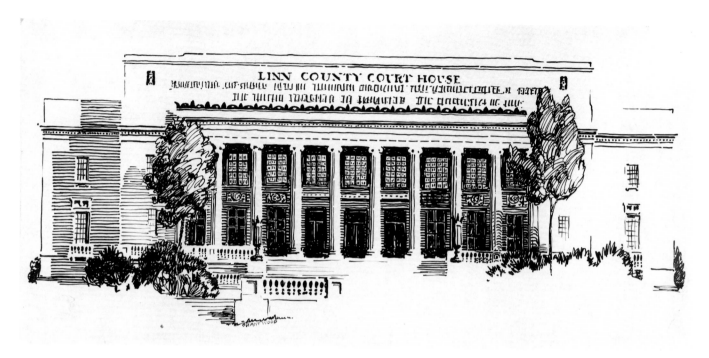

Linn County Courthouse, 1926
(cat. no. 84)

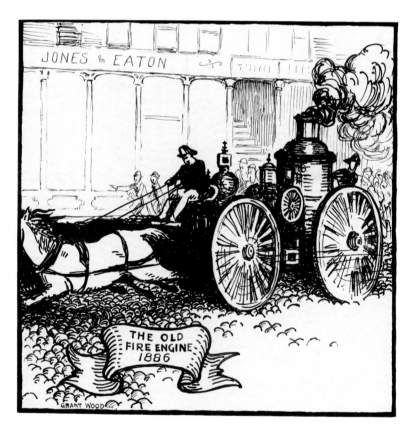

The Old Fire Engine — 1886, 1926
(cat. no. 87)

Overmantel Decoration, 1930
(cat. no. 110)

Stone City Landscape, 1932
(cat. no. 112)

Draft Horse, 1932

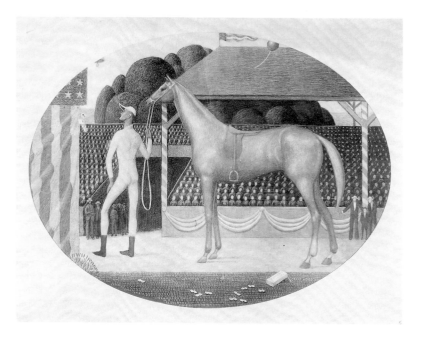

Race Horse, 1932

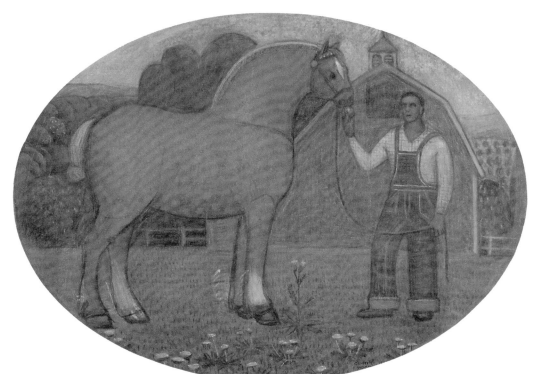

Sketch — Draft Horse, 1932
(cat. no. 113)

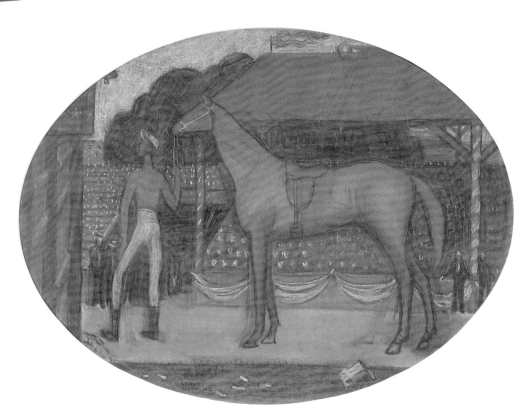

Sketch — Race Horse, 1932
(cat. no. 114)

Cedar Rapids Community Chest Poster, 1933
(cat. no. 117)

Portrait of John B. Northcott, 1933
(cat. no. 116)

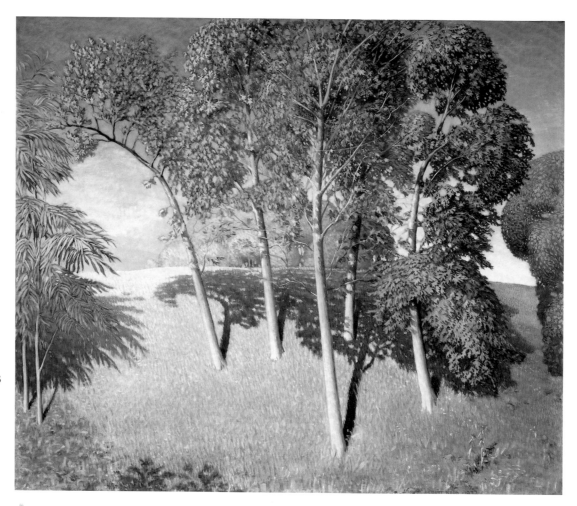

Autumn Oaks, 1933
(cat. no. 115)

The Early Bird, 1936
(cat. no. 118)

Young Calf, 1936
(cat. no. 119)

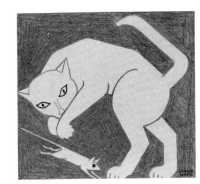

The Escape, 1936
(cat. no. 120)

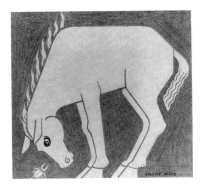

Bold Bug, 1936
(cat. no. 122)

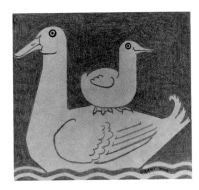

Joy Ride, 1936
(cat. no. 123)

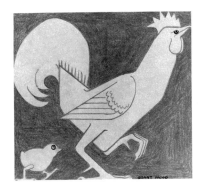

Hero Worship, 1936
(cat. no. 124)

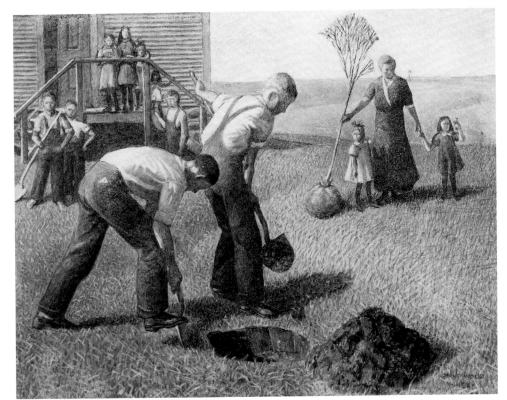

Tree Planting Group, 1937
(cat. no. 125)

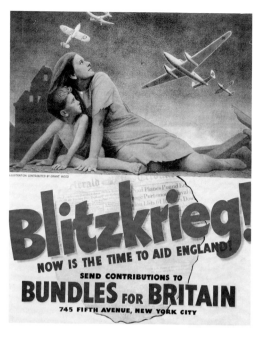

Blitzkrieg, 1940
(cat. no. 126)

Self-Portrait, 1917
(cat. no. 128)

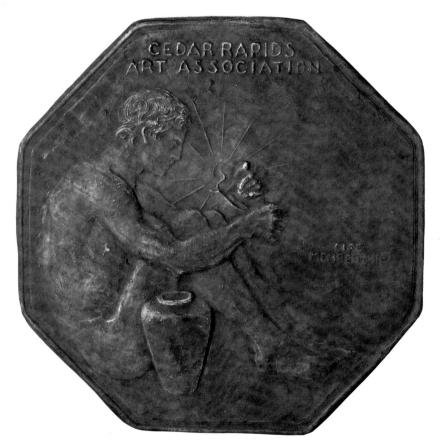

Cedar Rapids Art Association Life Membership Plaque, 1917
(cat. no. 129)

GRANT WOOD

CATALOGUE OF PAINTINGS & DRAWINGS

1. *Beets*, 1903-04
Watercolor on paper, 9 x 6 in.
(22.9 x 15.2 cm.)
Inscribed lower right: *G.D.W.*
Provenance: Artist; to David Turner; to Mr.
and Mrs. John B. Turner II; acquired in 1972
Exhibited: 1973 (59), 1985 (1)
Gift of Happy Young and John B. Turner II
(72.12.1)

2. *Blue Bird*, 1903-04
Ink on paper, 9 x 5⁷/₈ in. (22.9 x 14.9 cm.)
Unsigned
Provenance: Artist; to David Turner; to Mr.
and Mrs. John B. Turner II; acquired in 1972
Exhibited: 1973 (61)
Gift of Happy Young and John B. Turner II
(72.12.3)

3. *Leghorn*, 1903-04
Ink and watercolor on paper, 6 x 6¹/₂ in.
(15.2 x 16.5 cm.)
Unsigned
Provenance: Artist; to David Turner; to Mr.
and Mrs. John B. Turner II; acquired in 1972
Exhibited: 1973 (60)
Gift of Happy Young and John B. Turner II
(72.12.36)

4. *Boy in a Raincoat*, 1903-04
Charcoal on paper, 9 x 6 in.
(22.9 x 15.2 cm.)
Inscribed lower right: *G.D.W.*
Provenance: Artist; to David Turner; to Mr.
and Mrs. John B. Turner II; acquired in 1972
Exhibited: 1973 (63)
Gift of Happy Young and John B. Turner II
(72.12.5)

5. *Daffodils*, 1903-04
Watercolor and pencil on paper, 8³/₄ x 11¹/₂ in.
(22.2 x 29.2 cm.)
Inscribed lower right: *Grant Wood*
Provenance: Artist; to David Turner; to Mr.
and Mrs. John B. Turner II; acquired in 1972
Exhibited: 1973 (58)
Gift of Happy Young and John B. Turner II
(72.12.13)

6. *Return of Columbus from Amer(ica) Mch 15
1493*, 1903-04
Ink and watercolor on paper, 9 x 6 in.
(22.9 x 15.2 cm.)
Inscribed lower right: *G.D. Wood*
Provenance: Artist; to David Turner; to
Mr. and Mrs. John B. Turner II; acquired in
1972
Exhibited: 1973 (62), 1984 (1), 1989 (1)
Reference: Cedar Rapids Art Association, p.
21
Gift of Happy Young and John B. Turner II
(72.12.58)

7. *Iris*, 1903-04
Watercolor on paper, 9¹/₈ x 6 in.
(23.2 x 15.2 cm.)
Inscribed lower right: *G.D.W.*
Provenance: Artist; to David Turner; to Mr.
and Mrs. John B. Turner II; acquired in 1972
Exhibited: 1973 (57), 1984 (6)
References: Cedar Rapids Art Association, p.
21; Dennis, fig. 1
Gift of Happy Young and John B. Turner II
(72.12.31)

8. *Branch of Apples*, 1903-04
Watercolor and ink on paper, 7 x 3¹/₂ in.
(17.8 x 8.9 cm.)
Unsigned
Provenance: Artist; to Vida and Paul Hanson;
acquired in 1987
Art Museum Purchase (87.4.1)

9. *Still Life No. 1*, 1903-04
Pastel and pencil on paper, 7¹/₁₆ x 7¹/₂ in.
(17.9 x 19.1 cm.)
Unsigned
Provenance: Artist; to Vida and Paul Hanson;
acquired in 1987
Art Museum Purchase (87.4.2)

10. *Still Life No. 2*, 1903-04
Crayon and pencil on paper, 7³/₄ x 6 in.
(19.7 x 15.2 cm.)
Inscribed upper right: *GW*
Provenance: Artist; to Vida and Paul Hanson;
acquired in 1987
Art Museum Purchase (87.4.3)

11. *Cat with Fox Rug*, 1905
Alternate title: *A Fox Rug*; *A Scared Kitten*
Oil on muslin, 5⁷/₈ x 11¹/₂ in. (14.9 x 29.2 cm.)
Inscribed lower left: *G.D. Wood*
Provenance: Artist; to Jane Dingman
Hancock; to David Turner; to Mr. and Mrs.
John B. Turner II; acquired in 1972
Exhibited: 1973 (1)
Reference: Cedar Rapids Art Association, p. 9
Gift of Happy Young and John B. Turner II
(72.12.7)

12. *Pansies*, 1906
Oil on composition board, 5⁵/₈ x 11¹/₂ in.
(14.3 x 29.2 cm.)
Inscribed lower right: *Grant Wood 06*
Provenance: Artist; to Mrs. Charlotte Weaver
Faaborg; acquired in 1975
Gift of Mrs. Charlotte Weaver Faaborg (75.3)

13. *Sketch of a Bearded Man*, 1908
Ink on paper, 7¹/₁₆ x 5 in. (17.9 x 12.7 cm.)
Inscribed lower right: *G. Wood '10*
Provenance: Artist; to Vida and Paul Hanson;
acquired in 1987
Art Museum Purchase (87.4.6)
Note: The '10 in signature refers to Woods'
graduation class.

14. *Man of the Class*, 1908
Ink and pencil on paper, 4¹/₄ x 3¹/₁₆ in.
(10.8 x 7.8 cm.)
Inscribed lower center: *Grant Wood '10*; lower
left: *Man of the Class*
Provenance: Artist; to Vida and Paul Hanson;
acquired in 1987
Art Museum Purchase (87.4.4)
Note: The '10 in signature refers to Woods'
graduation class.

15. *Societies*, 1908
Ink and wash on paper, 6¹/₄ x 4¹/₁₆ in.
(15.9 x 10.3 cm.)
Inscribed lower right: *Grant Wood '10*
Provenance: Artist; to Vida and Paul Hanson;
acquired in 1987
Art Museum Purchase (87.4.5)
Note: The '10 in signature refers to Woods'
graduation class.

16. *Old House with Tree Shadows*, 1916
Alternate title: *The Dutchman's Old House with
Tree Shadows*
Oil on composition board, 13 x 15 in.
(33 x 38 cm.)
Inscribed lower left: *Grant Wood, 1916*
Provenance: Artist; to David Turner; to Mr.
and Mrs. John B. Turner II; acquired in 1972
Exhibited: 1935¹ (2), 1973 (2)
References: *Demcourier*, no. 2; Dennis, p. 23,
fig. 8
Gift of Happy Young and John B. Turner II
(72.12.47)

17. *Feeding the Chickens*, 1917
Alternate title: *Feeding Time*
Oil on composition board, 11 x 14 in.
(27.9 x 35.6 cm.)
Inscribed lower right: *Grant Wood 1917*
Provenance: Artist; to David Turner; to Mr.
and Mrs. John B. Turner II; acquired in 1972
Exhibited: 1920² (7), 1935¹ (2), 1935² (3),
1973 (3)
References: *Demcourier*, no. 3; Dennis, pp. 38,
42, fig. 26
Gift of Happy Young and John B. Turner II
(72.12.20)

18. *The Horsetraders*, 1917-18
Alternate title: *Two Horsetraders*
Oil on composition board, 11 x 14 in.
(27.9 x 35.6 cm.)
Inscribed lower left: *Grant Wood 1918*
Provenance: Artist; to David Turner; to Mr.
and Mrs. John B. Turner II; acquired in 1972
Exhibited: 1919 (9), 1920¹ (14), 1920² (6),
1935¹ (3), 1935² (4), 1973 (5), 1989 (2)
References: *Demcourier*, no. 4; Dennis, p. 38,
fig. 27
Gift of Happy Young and John B. Turner II
(72.12.28)

19. *Thirty-One Seventy-Eight*, 1918
Alternate title: *The House Grant Wood Built*
Oil on panel, 14⁷/₈ x 20 in. (37.8 x 50.8 cm.)
Inscribed lower left: *Grant Wood*
Provenance: Artist; to Mrs. Saltzman; to
Gordon Fennell; acquired in 1980
Exhibited: 1919 (10), 1920¹ (10), 1920² (2)
Gift of Gordon Fennell (80.2)

20. *Rustic Vista*, 1918-19
Oil on canvas, 16 x 18 in. (40.6 x 45.7 cm.)
Unsigned
Provenance: Artist; to the Cedar Rapids
Community School District; to the Cedar
Rapids Museum of Art in 1970
Exhibited: 1922 (47)
Community School District Collection
(70.3.165)

21. *Old Stone Barn*, 1919
Oil on composition board, 14³/₄ x 17⁷/₈ in.
(37.4 x 45.4 cm.)
Inscribed lower left: *Grant Wood*
Provenance: Artist; to David Turner; to Mr.
and Mrs. John B. Turner II; acquired in 1972
Exhibited: 1919 (12), 1920¹ (11), 1920² (3),
1973 (7)
References: Cedar Rapids Art Association, p.
11; Dennis, p. 43, fig. 31
Gift of Happy Young and John B. Turner II
(72.12.50)

22. *Old Sexton's Place*, 1919
Alternate title: *The Sexton's*
Oil on composition board, 15 x 18¹/₈ in.
(38 x 46 cm.)
Inscribed lower center: *Grant Wood 1919*
Provenance: Artist; to David Turner; to Mr.
and Mrs. John B. Turner II; acquired in 1972
Exhibited: 1919 (8), 1920¹ (12), 1920² (4),
1935² (5), 1959 (3), 1973 (4), 1981 (91), 1984
(4), 1989 (3)
References: Turner, n. p.; *Demcourier*, no. 5;
Cedar Rapids Art Association, p. 10;
Czestochowski, fig. 97; Corn, p. 64, pl. 1;
Dennis, pp. 38, 42, fig. 28
Gift of Happy Young and John B. Turner II
(72.12.48)

23. *Spring*, 1920
Oil on canvas, 24 x 30³/₈ in. (61 x 77.2 cm.)
Unsigned
Provenance: Artist; to the Cedar Rapids
Community School District; to the Cedar
Rapids Museum of Art in 1970
Exhibited: 1920¹ (21), 1973 (10), 1984 (6)
Reference: Cedar Rapids Art Association, p. 11
Community School District Collection
(70.3.173)

24. *Fanciful Depiction of the Roundhouse and Power Plant*, 1920
Oil on canvas, 35³/₄ x 72³/₄ in.
(90.8 x 184.8 cm.)
Inscribed lower right: *Grant Wood*
Provenance: Artist; to St. Luke's Hospital, Cedar Rapids; to the Cedar Rapids Museum of Art in 1975
Exhibited: 1981 (101)
References: Czestochowski, fig. 101; Dennis, fig. 161
St. Luke's Hospital Collection (75.10)

25. *Misty Day, Fountain of the Observatory, Paris*, 1920
Oil on composition board, 7¹/₈ x 10 in.
(18.1 x 25.4 cm.)
Inscribed lower right: *Grant Wood 1920*
Provenance: Artist; to David Turner; to Mr. and Mrs. John B. Turner II; acquired in 1972
Exhibited: 1920³ (1), 1935¹ (4), 1935² (4), 1942 (12), 1959 (6), 1973 (22)
References: Turner, n. p.; *Demcourier*, no. 6; Cedar Rapids Art Association, p. 26; Dennis, p. 44, fig. 38
Gift of Happy Young and John B. Turner II (72.12.43)

26. *Place de la Concorde*, 1920
Alternate title: *Tuileries Gate and Obelisk in Place de la Concorde*
Oil on composition board, 13 x 15 in.
(33 x 38 cm.)
Inscribed lower left: *Grant Wood, Paris, 1920*
Provenance: Artist; to David Turner; to Mr. and Mrs. John B. Turner II; acquired in 1972
Exhibited: 1920³ (2), 1973 (13)
References: Turner, n. p.; Cedar Rapids Art Association, p. 14; Dennis, p. 44, fig. 39
Gift of Happy Young and John B. Turner II (72.12.69)

27. *Avenue of Chestnuts*, 1920
Oil on composition board, 13 x 15 in.
(33 x 38 cm.)
Inscribed lower right: *Grant Wood, Paris, 1920*
Provenance: Artist; to David Turner; to Mr. and Mrs. John B. Turner II; acquired in 1972
Exhibited: 1920³ (4), 1973 (12)
Reference: Dennis, p. 43, fig. 34
Gift of Happy Young and John B. Turner II (72.12.52)

28. *Fountain of Voltaire, Chatenay*, 1920
Oil on composition board, 13 x 15 in.
(33 x 38 cm.)
Inscribed lower right: *Grant Wood*
Provenance: Artist; to David Turner; to Mr. and Mrs. John B. Turner II; acquired in 1972
Exhibited: 1920³ (5), 1973 (15), 1984 (8)
References: Turner, n. p.; Cedar Rapids Art Association, p. 14; Corn, fig. 17; Dennis, pp. 42-43, fig. 32
Gift of Happy Young and John B. Turner II (72.12.23)

29. *At Ville d'Avray, Paris*, 1920
Alternate title: *Corot's Pond, Ville d'Avray*
Oil on canvas, 23¹/₄ x 27¹/₄ in.
(59.1 x 69.2 cm.)
Unsigned
Provenance: Artist; to David Turner; to Mr. and Mrs. John B. Turner II; acquired in 1976
Exhibited: 1920³ (7), 1926¹, 1973 (25), 1984 (7)
Reference: Dennis, p. 28, fig. 17
Gift of Happy Young and John B. Turner II (76.2.4)

30. *The Lost Estate*, 1920
Alternate title: *Gate of the Old Chateau, Paris*
Oil on composition board, 13 x 15 in.
(33 x 38 cm.)
Inscribed lower right: *Grant Wood, Paris 1920*
Provenance: Artist; to David Turner; to Mr. and Mrs. John B. Turner II; acquired in 1972
Exhibited: 1920³ (10), 1973 (16)
Gift of Happy Young and John B. Turner II (72.12.25)

31. *St. Etienne du Mont*, 1920
Alternate title: *Church of Saint Genevieve*
Oil on composition board, 13 x 15 in.
(33 x 38 cm.)
Inscribed lower left: *Grant Wood Paris 1920*
Provenance: Artist; to David Turner; to Mr. and Mrs. John B. Turner II; acquired in 1972
Exhibited: 1920³ (15), 1973 (20)
Reference: Dennis, pp. 43-44, fig. 37
Gift of Happy Young and John B. Turner II (72.12.9)

32. *Old and New*, 1920
Alternate title: *Corner Cafe, Paris*
Oil on composition board, 13 x 15 in.
(33 x 38 cm.)
Inscribed lower left: *Grant Wood, Paris*
Provenance: Artist; to David Turner; to Mr. and Mrs. John B. Turner II; acquired in 1972
Exhibited: 1920³ (16), 1973 (21)
References: Cedar Rapids Art Association, p. 16; Dennis, pl. 2
Gift of Happy Young and John B. Turner II (72.12.10)

33. *From the Roman Amphitheatre*, 1920
Oil on composition board, 13 x 15 in.
(33 x 38 cm.)
Inscribed lower right: *Grant Wood*
Provenance: Artist; to David Turner; to Mr. and Mrs. John B. Turner II; acquired in 1972
Exhibited: 1920³ (17), 1973 (18)
References: Turner, n. p.; Dennis, fig. 33
Gift of Happy Young and John B. Turner II (72.12.56)
Note: Incorrectly titled *Rear of the Pantheon* in a 1973 publication.

34. *Square at Chatenay*, 1920
Alternate title: *The Square, Chatenay*
Oil on composition board, 13 x 15 in.
(33 x 38 cm.)
Inscribed lower left: *Grant Wood 1920*
Provenance: Artist; to David Turner; to Mr. and Mrs. John B. Turner II; acquired in 1972
Exhibited: 1920³ (18), 1924, 1935¹ (7), 1959 (5), 1973 (14)
References: Turner, n. p.; *Demcourier*, no. 7
Gift of Happy Young and John B. Turner II (72.12.63)

35. *Pantheon at Sunset*, 1920
Alternate title: *Back of the Pantheon*
Oil on composition board, 13 x 15 in.
(33 x 38 cm.)
Inscribed lower left: *Grant Wood*
Provenance: Artist; to the Cedar Rapids Community School District; to the Cedar Rapids Museum of Art in 1970
Exhibited: 1920³ (19), 1973 (19)
References: Cedar Rapids Art Association, p. 15; Dennis, p. 43, fig. 36
Community School District Collection (70.3.170)

36. *The Gate in the Wall*, 1920
Alternate title: *Street Scene through the Gate, Roman Arch*
Oil on composition board, 12⁷/₈ x 16¹/₈ in.
(32.7 x 41 cm.)
Inscribed lower left: *Grant Wood*
Provenance: Artist; to David Turner; to Mr. and Mrs. John B. Turner II; acquired in 1972
Exhibited: 1920³ (22), 1973 (24)
Reference: Dennis, fig. 35
Gift of Happy Young and John B. Turner II (72.12.66)

37. *Pool at Versailles*, 1920
Oil on composition board, 6¹/₂ x 9¹/₂ in.
(16.5 x 24.1 cm.)
Unsigned
Provenance: Artist; to David Turner; to Mr. and Mrs. John B. Turner II; acquired in 1972
Exhibited: 1920³ (25), 1973 (35)
Gift of Happy Young and John B. Turner II (72.12.21)

38. *Basket Willows*, 1920
Oil on composition board, 12³/₄ x 14¹/₂ in.
(32.4 x 36.8 cm.)
Inscribed lower left: *Grant Wood Paris 1920*
Provenance: Artist; to David Turner; to Mr. and Mrs. John B. Turner II; acquired in 1972
Exhibited: 1920³ (28)
Reference: Dennis, p. 26, fig. 13
Gift of Happy Young and John B. Turner II (72.12.35)

39. *Street in Chatenay*, 1920
Oil on composition board, 13 x 14⁷/₈ in.
(33 x 37.8 cm.)
Inscribed lower right: *Grant Wood, Paris 1920*
Provenance: Artist; to David Turner; to Mr. and Mrs. John B. Turner II; acquired in 1972
Exhibited: 1920³ (29), 1973 (17)
Reference: Cedar Rapids Art Association, p. 11
Gift of Happy Young and John B. Turner II (72.12.11)

40. *A Phantasy of Spring*, 1921
Alternate title: *Twilight—Triptych*
Oil on canvas, 34¹/₂ x 53¹/₄ in.
(87.6 x 135.3 cm.)
Inscribed lower right (right panel): *Grant Wood*
Provenance: Artist; to David Turner; to Mr. and Mrs. John B. Turner II; acquired in 1972
Exhibited: 1922 (44), 1973 (9)
Gift of Happy Young and John B. Turner II (72.12.77)
Note: Triptych with center crested panel. Side panels each 32 x 14⁷/₈ in. (81.3 x 37.8 cm.), center crested panel 34¹/₂ x 23¹/₂ in. (87.6 x 59.7 cm.)

41. *Cedar Rapids* or *Adoration of the Home*, 1921-22
Oil on canvas, 22³/₄ x 81³/₈ in.
(57.8 x 206.7 cm.)
Inscribed lower left: *Grant Wood 1922*
Provenance: Artist; to Henry S. Ely & Co.; to Roosevelt Hotel; to Mr. and Mrs. Peter F. Bezanson; to the Cedar Rapids Museum of Art in 1980
Exhibited: 1922 (49), 1981 (100), 1984 (9), 1989 (4)
References: Czestochowski, fig. 100; Corn, pp. 17-18, 80, fig. 27; Dennis, pp. 63, 238 (fn. 10), fig. 61
Mr. and Mrs. Peter F. Bezanson Collection (80.1)

Note: The following inscription originally appeared on either side of the painted canvas but incorporated into the completed frame: "CEDAR RAPIDS—OUT OF THE GOLDEN MISTS OF FUTURITY NEW CIVIC BUILDINGS RISE. IN MORE SOLID SILHOUETTE STAND STRUCTURES DEDICATED TO BUSINESS. THE CRAG-LIKE CONTOUR OF A FACTORY FORMS A BACKGROUND FOR A GROUP REPRESENTING VARIOUS INDUSTRIES AND TRADES. BACK OF THEM HOVERS THE SPIRIT OF COMMERCE SYMBOLIZING IN A SINGLE FIGURE THE MANY ACTIVITIES UPON WHICH THE COMMERCIAL LIFE OF A COMMUNITY DEPENDS. ON THE LEFT ARE THE FIGURES OF AGRICULTURE AND ANIMAL HUSBANDRY WITH THEIR ATTRIBUTES. THEIR BACKGROUND IS THE PRAIRIE FROM WHICH THEY AND THE CITY HAVE ARISEN. IN THE CENTER SITS CEDAR RAPIDS ENTHRONED. EDUCATION IS A CHILD AT HER KNEE. RELIGION UPHOLDS HER RIGHT HAND AND IN IT PROUDLY POISED—THE FOCUS OF ADORING EYES—BEHOLD THE HOME!"

42. *The Cow Path*, 1921-22
Alternate title: *Midsummer, Cowpath*
Oil on canvas, 18 x 24¹/₈ in. (45.7 x 61.3 cm.)
Inscribed lower left: *Grant Wood, 1922*
Provenance: Artist; to David Turner; to Mr. and Mrs. John B. Turner II; acquired in 1972
Exhibited: 1922¹ (46), 1935 (10), 1973 (29)
References: Turner, n. p.; *Demcourier* no. 10
Gift of Happy Young and John B. Turner II (72.12.12)

43. *Lunette of Autumn*, 1922-23
Oil on canvas mounted on panel, 16 x 45¹/₄ in. (40.6 x 114.9 cm.)
Unsigned
Provenance: Commissioned by the Cedar Rapids Community School District; to the Cedar Rapids Museum of Art in 1970
Exhibited: 1923, 1973 (33), 1981 (102), 1983 (6), 1984 (11)
References: Czestochowski, fig. 102; Corn, fig. 26; Dennis, p. 63
Community School District Collection (70.3.160a)

44. *Lunette of Spring*, 1922-23
Oil on canvas mounted on panel, 19¹/₂ x 39¹/₄ in. (49.5 x 99.7 cm.)
Unsigned
Provenance: Commissioned by the Cedar Rapids Community School District; to the Cedar Rapids Museum of Art in 1970
Exhibited: 1923, 1973 (31), 1981 (104)
References: Czestochowski, fig. 104; Dennis, p. 63, fig. 59
Community School District Collection (70.3.160b)

45. *Lunette of Summer*, 1922-23
Oil on canvas mounted on panel, 16 x 39 in. (40.6 x 99.1 cm.)
Unsigned
Provenance: Commissioned by the Cedar Rapids Community School District; to the Cedar Rapids Museum of Art in 1970
Exhibited: 1923, 1973 (32), 1981 (105), 1984 (10)
References: Dennis, p. 63, fig. 59; Czestochowski, fig. 105; Corn, fig. 25
Community School District Collection (70.3.160c)

46. *Lunette of Winter*, 1922-23
Oil on canvas mounted on panel,
19½ x 39¼ in. (49.5 x 99.7 cm.)
Unsigned
Provenance: Commissioned by the Cedar
Rapids Community School District; to the
Cedar Rapids Museum of Art in 1970
Exhibited: 1923, 1973 (30), 1981 (103)
References: Czestochowski, fig. 103; Dennis,
p. 63
Community School District Collection
(70.3.160d)

47. *Van Antwerp Place*, 1922-23
Alternate title: *Yellow House and Leaning Tree*
Oil on composition board, 12⁷⁄₈ x 14⁷⁄₈ in.
(32.7 x 37.8 cm.)
Unsigned
Provenance: Artist; to David Turner; to Mr.
and Mrs. John B. Turner II; acquired in 1972
Exhibited: 1923, 1973 (6), 1984 (5)
Reference: Dennis, pl. 1
Gift of Happy Young and John B. Turner II
(72.12.78)

48. *Landscape with Tree*, 1923
Oil on composition board, 7½ x 10⁵⁄₈ in.
(19.1 x 27 cm.)
Unsigned
Provenance: Artist; to Mr. and Mrs. Nate
Cohn; acquired in 1970
Exhibited: 1923, 1973 (27)
Gift of Mr. and Mrs. Nate Cohn (70.2.2)

49. *Landscape near Indian Creek*, 1923
Oil on composition board, 7⅛ x 10³⁄₄ in.
(18.1 x 27.3 cm.)
Unsigned
Provenance: Artist; to Mr. and Mrs. Nate
Cohn; acquired in 1970
Exhibited: 1923, 1973 (28)
Gift of Mr. and Mrs. Nate Cohn (70.2.1)

50. *Decorative Landscape*, 1923
Oil on canvas, 21⅛ x 25½ in.
(53.7 x 64.8 cm.)
Unsigned
Provenance: Artist; to David Turner; to Mr.
and Mrs. John B. Turner II; acquired in 1972
Gift of Happy Young and John B. Turner II
(81.17.7)
Note: Executed as a demonstration piece
during Grant Wood's 1923 exhibition at the
Cedar Rapids Art Association Public Library
Art Gallery.

51. *New Plaster, Paris*, 1924
Oil on composition board, 13 x 15 in.
(33 x 38 cm.)
Inscribed lower left: *Grant Wood*
Provenance: Artist; to John C. and Sophie S.
Reid; to James L. and Catherine Reid Cooper;
acquired in 1989
Exhibited: 1926¹, 1989 (5)
Gift of John Reid Cooper and Lee Cooper
van de Velde in honor of their grandparents
John C. and Sophie S. Reid, and their parents
James L. and Catherine Reid Cooper (89.5.1)

52. *The Blue Door*, 1924
Alternate title: *Portal with Blue Door*
Oil on composition board, 10 x 8 in.
(25.4 x 20.3 cm.)
Unsigned
Provenance: Artist; to David Turner; to Mr.
and Mrs. John B. Turner II; acquired in 1972
Exhibited: 1926¹, 1935¹ (13), 1935² (7), 1973
(37)
References: Turner, n. p.; *Demcourier*, no. 13;
Dennis, p. 51, fig. 49
Gift of Happy Young and John B. Turner II
(72.12.4)
Note: Companion piece to *Italian Farmyard*.

53. *Italian Farmyard*, 1924
Oil on composition board, 10 x 8 in.
(25.4 x 20.3 cm.)
Unsigned
Provenance: Artist; to David Turner; to Mr.
and Mrs. John B. Turner II; acquired in 1972
Exhibited: 1926¹, 1935¹ (12), 1935² (6), 1959
(8), 1973 (36)
References: Turner, n. p.; *Demcourier*, no. 12;
Dennis, p. 51, fig. 48
Gift of Happy Young and John B. Turner II
(72.12.32)
Note: Companion piece to *The Blue Door*.

54. *Old House and Staircase*, 1924
Oil on paper, 9¼ x 7¼ in. (23.5 x 18.4 cm.)
Unsigned
Provenance: Artist; to David Turner; to Mr.
and Mrs. John B. Turner II; acquired in 1972
Exhibited: 1926¹
Gift of Happy Young and John B. Turner II
(72.12.46)

55. *Breton Market Place*, 1924
Pastel on paper, 8½ x 8³⁄₄ in.
(21.6 x 22.2 cm.)
Unsigned
Provenance: Artist; to David Turner; to Mr.
and Mrs. John B. Turner II; acquired in 1972
Exhibited: 1926¹, 1935¹ (11), 1935² (5), 1973
(65)
Reference: *Demcourier*, no. 11
Gift of Happy Young and John B. Turner II
(72.12.6)

56. *Fountain of the Medici, Paris*, 1924
Alternate title: *Fountain, Luxembourg Gardens*
Oil on composition board, 12³⁄₄ x 14³⁄₈ in.
(32.4 x 36.5 cm.)
Inscribed lower center: *Grant Wood 1924*
Provenance: Artist; to David Turner; to Mr.
and Mrs. John B. Turner II; acquired in 1972
Exhibited: 1926¹, 1935¹ (14), 1935² (8), 1959
(7), 1973 (39), 1989 (6)
References: Turner, n. p.; *Demcourier*, no. 14;
Cedar Rapids Art Association, p. 18; Dennis,
p. 48, fig. 41
Gift of Happy Young and John B. Turner II
(72.12.22)

57. *House with Blue Pole*, 1924
Watercolor on paper, 9 x 11 in.
(22.9 x 27.9 cm.)
Inscribed lower right: *Grant Wood 1924*
Provenance: Artist; to David Turner; to Mr.
and Mrs. John B. Turner II; acquired in 1972
Exhibited: 1926¹, 1973 (40)
References: Cedar Rapids Art Association, p.
18; Dennis, p. 50, fig. 42
Gift of Happy Young and John B. Turner II
(72.12.29)

58. *Street of the Dragon, Paris*, 1924
Oil on composition board, 16 x 13 in.
(40.6 x 33 cm.)
Inscribed lower left: *Grant Wood*: lower right:
Grant Wood--Paris 1925
Provenance: Artist; to David Turner; to Mr.
and Mrs. John B. Turner II; acquired in 1972
Exhibited: 1926¹, 1973 (41)
Gift of Happy Young and John B. Turner II
(72.12.65)
Note: This painting was later incorrectly
signed and dated 1925.

59. *The Runners, Luxembourg Gardens, Paris*, 1924
Alternate title: *The Pool, Luxembourg Gardens*
Oil on composition board, 15⁵⁄₈ x 12½ in.
(39.7 x 31.8 cm.)
Inscribed lower left: *Grant Wood Paris 1925*
Provenance: Artist; to Miss Nell Cherry;
acquired in 1969
Exhibited: 1926¹, 1973 (26), 1981 (99)

References: Cedar Rapids Art Association, p.
16; Czestochowski, fig. 99; Corn, fig. 18;
Dennis, p. 44, pl. 3
Bequest of Miss Nell Cherry (69.4.1)
Note: This painting was later incorrectly dated
Paris, 1925.

60. *Bridge at Moret*, 1924
Oil on composition board, 12³⁄₄ x 16 in.
(32.4 x 40.6 cm.)
Inscribed lower left: *Grant Wood Paris, 1924*
Provenance: Artist; to the Cedar Rapids
Community School District; to the Cedar
Rapids Museum of Art in 1970
Exhibited: 1973 (34)
Community School District Collection
(70.3.171)

61. *Fall Landscape*, 1924
Oil on composition board, 13⅛ x 15 in.
(33.3 x 38 cm.)
Inscribed lower center: *Grant Wood*
Provenance: Artist; to David Turner; to Mr.
and Mrs. John B. Turner II; acquired in 1972
Exhibited: 1926¹, 1973 (8)
Reference: Dennis, fig. 9
Gift of Happy Young and John B. Turner II
(72.12.17)
Note: Verso: Unidentified oil sketch.

62. *Iowa Afternoon*, 1924
Oil on composition board, 13 x 14⁷⁄₈ in.
(33 x 37.8 cm.)
Inscribed lower left: *Grant Wood 1924: Grant
Wood*
Provenance: Artist; to Frank and Margaret
Race; acquired in 1986
Exhibited: 1926¹, 1989 (7)
Gift of Margaret and Frank Race (86.2)

63-75. Turner Mortuary Drawings, John B.
Turner and Son, Cedar Rapids, Iowa
Note: Commissioned by John B. and David
Turner for a December 1924 publication to
announce the completion of their new
mortuary, John B. Turner and Son
(established 1889), on Second Avenue and
Eighth Street, Cedar Rapids. Six of Wood's
sketches were used in this publication. The
building had been the residence of Edward
Mansfield, George Bruce Douglas, and T. M.
Sinclair.

63. *The Turner Mortuary, Front View, Wall and
Gate*, 1924
Ink on paper, 9¼ x 13⁷⁄₈ in. (23.5 x 35.4 cm.)
Unsigned
Provenance: Artist; to David Turner; to Mr.
and Mrs. John B. Turner II; acquired in 1972
Exhibited: 1973 (66), 1984 (13)
Gift of Happy Young and John B. Turner II
(72.12.74)

64. *The Turner Mortuary, View from the Southwest*,
1924
Pencil on paper, 18 x 29½ in.
(45.7 x 74.9 cm.)
Inscribed lower right: *Grant Wood*
Provenance: Artist; to David Turner; to Mr.
and Mrs. John B. Turner II; acquired in 1972
Exhibited: 1972 (10), 1973 (76), 1981 (106)
References: Cedar Rapids Art Association, p.
22; Czestochowski, fig. 106
Gift of Happy Young and John B. Turner II
(72.12.72)

65. *The Turner Mortuary, Facade from the East*,
1924
Pencil on paper, 20 x 14½ in.
(50.8 x 36.8 cm.)
Inscribed lower right: *Grant Wood*
Provenance: Artist; to David Turner; to Mr.
and Mrs. John B. Turner II; acquired in 1972
Exhibited: 1973 (75)
Gift of Happy Young and John B. Turner II
(72.12.70)

66. *The Turner Mortuary, Open Gate and Tree*,
1924
Pencil on paper, 20 x 14³⁄₄ in.
(50.8 x 37.5 cm.)
Inscribed lower right: *Grant Wood*
Provenance: Artist; to David Turner; to John
B. Turner II; acquired in 1972
Exhibited: 1973 (77)
Gift of Happy Young and John B. Turner II
(72.12.75)

67. *The Turner Mortuary, Stairs and Balustrade*,
1924
Pencil on paper, 20 x 14³⁄₄ in.
(50.8 x 37.5 cm.)
Inscribed lower center: *Grant Wood*
Provenance: Artist; to David Turner; to Mr.
and Mrs. John B. Turner II; acquired in 1972
Exhibited: 1972 (11), 1973 (78)
Reference: Cedar Rapids Art Association, p.
22
Gift of Happy Young and John B. Turner II
(72.12.76)

68. *The Turner Mortuary, Fireplace, Round Room*,
1924
Pen and ink on board, 12½ x 11½ in.
(31.8 x 29.2 cm.)
Inscribed lower right: *Grant Wood*
Provenance: Artist; to David Turner; to Mr.
and Mrs. John B. Turner II; acquired in 1972
Exhibited: 1973 (71)
Gift of Happy Young and John B. Turner II
(72.12.71)

69. *The Turner Mortuary, Front Portico Columns*,
1924
Pen, brush, and ink on paper, 12 x 7¼ in.
(30.5 x 18.4 cm.)
Inscribed lower left: *Wood*
Provenance: Artist; to David Turner; to Mr.
and Mrs. John B. Turner II; acquired in 1972
Exhibited: 1973 (69)
Gift of Happy Young and John B. Turner II
(72.12.73)

70. *The Turner Mortuary, Gate and Columns*, 1924
Pen and ink on cardboard, 13½ x 18 in.
(34.3 x 45.7 cm.)
Unsigned
Provenance: Artist; to David Turner; to Mr.
and Mrs. John B. Turner II; acquired in 1972
Exhibited: 1973 (67)
Gift of Happy Young and John B. Turner II
(72.12.80)

71. *The Turner Mortuary, Table, Lamp and Two
Chairs*, 1924
Ink on paper, 9 x 11½ in. (22.9 x 29.2 cm.)
Inscribed lower left: *Grant Wood*
Provenance: Artist; to David Turner; to Mr.
and Mrs. John B. Turner II; acquired in 1972
Exhibited: 1973 (70)
Gift of Happy Young and John B. Turner II
(72.12.68)

72. *The Turner Mortuary, Gatehouse*, 1924
Pen and ink on cardboard, 7½ x 13½ in.
(19.1 x 34.3 cm.)
Inscribed lower right: *Grant Wood*
Provenance: Artist; to David Turner; to Mr.
and Mrs. John B. Turner II; acquired in 1972
Exhibited: 1973 (73)
Gift of Happy Young and John B. Turner II
(72.12.83)

73. *The Turner Mortuary, Gate and Columns*, 1924
Pencil and ink on cardboard, 13⅛ x 10 in.
(33.3 x 25.4 cm.)
Inscribed lower right: *Grant Wood*
Provenance: Artist; to David Turner; to Mr.
and Mrs. John B. Turner II; acquired in 1972
Exhibited: 1973 (68)
Gift of Happy Young and John B. Turner II
(72.12.81)

74. *The Turner Mortuary, Birdhouse*, 1924
Pen and ink on paper, 12 x 8½ in.
(30.5 x 21.6 cm.)
Inscribed lower center: *Wood*
Provenance: Artist; to David Turner; to Mr.
and Mrs. John B. Turner II; acquired in 1972
Exhibited: 1955 (6), 1973 (74)
Gift of Happy Young and John B. Turner II
(72.12.2)

75. *The Turner Mortuary, Fireplace, Reception
Room*, 1924
Pen and ink on paper, 8¾ x 12½ in.
(22.2 x 31.8 cm.)
Inscribed lower center: *Grant Wood*
Provenance: Artist; to David Turner; to Mr.
and Mrs. John B. Turner II; acquired in 1972
Exhibited: 1973 (72)
Gift of Happy Young and John B. Turner II
(72.12.82)

76. *Iowa Corn Room Murals, Montrose Hotel*, 1925.
Although Wood's work was finished in 1925,
the Iowa Corn Room was not opened to the
public until June 1926, when Wood was in
Europe. These murals were companions to the
Fruits of Iowa murals, also made for the
Montrose Hotel and currently owned by Coe
College, Cedar Rapids. Wood created a similar
mural in about 1927 for the Corn Room in
Eugene Eppley's Martin Hotel, Sioux City,
Iowa; these murals are currently owned by the
Sioux City Art Center.
Note: Grant Wood was assisted by Edgar
Britton (1901-81)

Unit 1: *Corn Stalk with Two Ears*
Oil on canvas, 80 x 49 in. (203.2 x 124.5 cm.)
Unsigned
Provenance: Commissioned by Eugene Eppley
for the Montrose Hotel, Cedar Rapids; to Mr.
and Mrs. John B. Turner II; acquired in 1981
Exhibited: 1984 (20)
Gift of Happy Young and John B. Turner II
(81.17.1)

Unit 2: *Fence and Sign*
Oil on canvas, 80 x 183 ½ in.
(203.2 x 466.1 cm.)
Inscribed lower center: *Grant Wood and Edgar
Britton*
Provenance: Commissioned by Eugene Eppley
for the Montrose Hotel, Cedar Rapids; to Mr.
and Mrs. John B. Turner II; acquired in 1981
Exhibited: 1984 (20)
Reference: Corn, p. 26, fig. 37
Gift of Happy Young and John B. Turner II
(81.17.2)

Unit 3: *Corn Stalk*
Oil on canvas, 80 x 38 in. (203.2 x 96.5 cm.)
Unsigned
Provenance: Commissioned by Eugene Eppley
for the Montrose Hotel, Cedar Rapids; to
Margaret Worth Averill; acquired in 1973
Exhibited: 1984 (20)
Gift of Margaret Worth Averill (73.7.1)

Unit 4: *Corn Rows With Pumpkins*
Oil on canvas, 80 x 178 ½ in.
(203.2 x 453.4 cm.)
Unsigned
Provenance: Commissioned by Eugene Eppley
for the Montrose Hotel, Cedar Rapids; to
Margaret Worth Averill; acquired in 1973
Exhibited: 1984 (20)
Gift of Margaret Worth Averill (73.7.2)

77. *The Painter*, 1925
Oil on canvas, 18 x 24 in. (45.7 x 61 cm.)
Inscribed lower right: *Grant Wood*
Provenance: Commissioned by J. G. Cherry
Company; to Cherry Burrell Charitable
Foundation; acquired in 1974
Exhibited: 1926[1], 1973 (48)
References: *Gazette*, 17 November 1925, p. 24;
Dennis, fig. 152
Cherry Burrell Charitable Foundation
Collection (74.5.5)
Note: Depicts J. G. Cherry employee Joe
Horsky.

78. *The Coppersmith*, 1925
Oil on canvas, 18 x 24 in. (45.7 x 61 cm.)
Unsigned
Provenance: Commissioned by J. G. Cherry
Company; to Cherry Burrell Charitable
Foundation; acquired in 1974
Exhibited: 1926[1], 1959 (12), 1973 (46)
References: *Gazette*, 17 November 1925, p. 24;
Dennis, fig. 153
Cherry Burrell Charitable Foundation
Collection (74.5.3)
Note: Depicts J. G. Cherry employee Louis
Jandl.

79. *The Coil Welder*, 1925
Oil on canvas, 18¼ x 22 in. (46.4 x 55.9 cm.)
Inscribed upper center: *Grant Wood*
Provenance: Commissioned by J. G. Cherry
Company; to Cherry Burrell Charitable
Foundation; acquired in 1974
Exhibited: 1926[1], 1973 (47)
References: *Gazette*, 17 November 1925, p. 24;
Dennis, fig. 154
Cherry Burrell Charitable Foundation
Collection (74.5.2)
Note: Depicts J. G. Cherry employee Charles
H. Sheldon.

80. *Ten Tons of Accuracy*, 1925
Oil on composition board, 21¼ x 36¼ in.
(54 x 92.1 cm.)
Inscribed lower right: *Grant Wood*
Provenance: Commissioned by J. G. Cherry
Company; to Cherry Burrell Charitable
Foundation; acquired in 1974
Exhibited: 1926[1], 1959 (10), 1973 (43), 1981 (108)
References: *Gazette*, 17 November 1925, p. 24;
Czestochowski, fig. 108; Dennis, fig. 149
Cherry Burrell Charitable Foundation
Collection (74.5.7)
Note: Depicts J. G. Cherry employee Clare W.
Weber.

81. *The Old J. G. Cherry Plant*, 1925
Oil on composition board, 13¼ x 40¾ in.
(33.7 x 103.5 cm.)
Unsigned
Provenance: Commissioned by J. G. Cherry
Company; to Cherry Burrell Charitable
Foundation; acquired in 1974
Exhibited: 1926[1], 1959 (13), 1973 (42), 1981
(107), 1984 (17), 1989 (8)
References: *Gazette*, 17 November 1925, p. 24;
Cedar Rapids Art Association, p. 20;
Czestochowski, fig. 107; Corn, fig. 23; Dennis,
fig. 162
Cherry Burrell Charitable Foundation
Collection (74.5.4)

82. *The Shop Inspector*, 1925
Oil on canvas, 24 x 18 in. (61 x 45.7 cm.)
Inscribed lower right: *Grant Wood*
Provenance: Commissioned by the J. G.
Cherry Company; to Cherry Burrell
Charitable Foundation; acquired in 1974
Exhibited: 1926[1], 1973 (44), 1984 (16)
References: *Gazette*, 17 November 1925, p. 24;
Dennis, fig. 151; Corn, fig. 24
Cherry Burrell Charitable Foundation
Collection (74.5.6)
Note: Depicts J. G. Cherry employee Jerry
Nejdl.

83. *Turret Lathe Operator*, 1925
Oil on composition board, 18¾ x 24 in.
(47.6 x 61 cm.)
Inscribed lower right: *Grant Wood*
Provenance: Commissioned by the J. G.
Cherry Company; to Cherry Burrell
Charitable Foundation; acquired in 1974
Exhibited: 1926[1], 1959 (11), 1973 (45)
References: *Gazette*, 17 November 1925;
Dennis, fig. 148
Cherry Burrell Charitable Foundation
Collection (74.5.8)
Note: Depicts J. G. Cherry employee Joe
Polehna.

84. *Linn County Courthouse*, 1926
Pen, brush, and ink on cardboard, 11 x 22 in.
(27.9 x 55.9 cm.)
Inscribed lower center: *Grant Wood*
Provenance: Artist; to David Turner; to Mr.
and Mrs. John B. Turner II; acquired in 1972
Gift of Happy Young and John B. Turner II
(81.17.5)

85-87. The following three drawings were
inspired by Luther Brewer's book, *The History
of Linn County* (Chicago: Pioneer Publishing
Company, 1911) and dealt with the pioneer
background of Iowa as exemplified by Cedar
Rapids. David Turner intended to issue this in
a portfolio of five drawings entitled *Early Iowa*,
but the project was never completed. Two
additional ink on paper drawings (11¼ x
11¼ in.) were prepared as part of this
portfolio: *Little Muddy Church* and *Going
Shopping*, 1840. Both works were accidentally
destroyed in April 1942.

85. *Old Steam Motor 1880-1892*, 1926
Ink on paper, 11 x 11 in. (27.9 x 27.9 cm.)
Inscribed lower right: *Grant Wood*
Provenance: Artist; to David Turner; to Mr.
and Mrs. John B. Turner II; acquired in 1972
Exhibited: 1972 (9), 1973 (80)
Gift of Happy Young and John B. Turner II
(72.12.49)

86. *Higley's Block 1863-1914*, 1926
Ink on paper, 11 x 11 in. (27.9 x 27.9 cm.)
Inscribed lower left: *Grant Wood*
Provenance: Artist; to David Turner; to Mr.
and Mrs. John B. Turner II; acquired in 1972
Exhibited: 1972 (7), 1973 (79), 1984 (19)
Reference: Cedar Rapids Art Association, p. 23
Gift of Happy Young and John B. Turner II
(72.12.26)

87. *The Old Fire Engine—1886*, 1926
Ink and collage on paper, 14¼ x 13¾ in.
(36.2 x 34.9 cm.)
Inscribed lower left: *Grant Wood*
Provenance: Artist; to David Turner; to Mr.
and Mrs. John B. Turner II; acquired in 1972
Exhibited: 1972 (8), 1973 (81), 1984 (19)
Reference: Cedar Rapids Art Association, p. 23
Gift of Happy Young and John B. Turner II
(72.12.45)

88. *Terraced Mountain*, 1926
Oil on canvas, 28¾ x 36¾ in. (73 x 93.3 cm.)
Unsigned
Provenance: Artist; to the Cedar Rapids
Chamber of Commerce; to the Cedar Rapids
Museum of Art in 1982
Exhibited: 1926[1]
Cedar Rapids Chamber of Commerce
(82.22.2a)
Note: Verso: *Midsummer*, 1929 (cat. no. 103)

89. *The Barred Door, Chancelade*, 1926
Alternate title: *La Porte Barree, Chancelade*
Oil on composition board, 16⅛ x 13 in.
(41 x 33 cm.)
Inscribed lower right: *Grant Wood*
Provenance: Artist; estate of Dr. Joseph and
Dr. Edna Hoegen, to Mr. and Mrs. J. Thomas
Hoegen; acquired in 1979
Exhibited: 1926[2] (1), 1926[3] (58)
Gift of Mr. and Mrs. J. Thomas Hoegen in
Memory of Dr. and Mrs. Arlo R. Zuercher and
Dr. Joseph and Dr. Edna Hoegen (79.1)

90. *Porte du Clocher, St. Emilion*, 1926
Oil on composition board, 16 x 12⅞ in.
(40.6 x 32.7 cm.)
Inscribed lower left: *Grant Wood*
Provenance: Artist; to Janet Coquillette Wray;
acquired in 1987
Exhibited: 1926[2] (21), 1926[3] (9)
Gift of Janet Coquillette Wray (87.3.2)

91. *Yellow Doorway, St. Emilion*, 1926
Alternate title: *Porte des Cloitres de l'Eglise
Collegiale*
Oil on composition board, 16½ x 13 in.
(41.9 x 33 cm.)
Unsigned
Provenance: Artist; to David Turner; to Mr.
and Mrs. John B. Turner II; acquired in 1972
Exhibited: 1926[2] (23), 1926[3] (2), 1929[1] (14),
1935[1] (21), 1935[2] (12), 1973 (50), 1984 (12)
References: *Demcourier* no. 21; Cedar Rapids
Art Association, p. 19; Corn, p. 64, pl. 2
Gift of Happy Young and John B. Turner II
(72.12.8)
Note: Study for *Porte de l'Eglise Collegiale—St.
Emilion*.

92. *Door by the Old Well, St. Emilion*, 1926
Alternate title: *Porte pres Vieux Puits—St. Emilion*
Oil on composition board, 13 x 16⅛ in.
(33 x 41 cm.)
Inscribed lower right: *Grant Wood*
Provenance: Artist; to Gordon Fennell; to Mr.
and Mrs. Robert South; acquired in 1986
Exhibited: 1926[2] (26), 1926[3] (5)
Gift of Mr. and Mrs. Robert South (86.7)

93. *The Doorway, Perigueux*, 1926
Alternate title: *Door at the Foot of the Stair,
Perigueux; Porte au pied de l'escalier, Perigueux*
Oil on canvas, 24½ x 18¼ in.
(61.6 x 46.4 cm.)
Inscribed lower left: *Grant Wood 1927*
Provenance: Artist; acquired in 1932
Exhibited: 1926[2] (5), 1926[3] (46), 1927[1], 1927[2],
1935[1] (23), 1955 (7), 1957 (4), 1973 (51), 1981
(109), 1989 (10)
References: *Demcourier*, no. 23; Cedar Rapids
Art Association, p. 12; Czestochowski, fig. 109;
Dennis, fig. 54
Art Association Purchase (32.2)
Note: This painting was later incorrectly dated
1927.

94. *Bowl of Flowers*, 1926
Oil on canvas, 22 x 22 in. (55.9 x 55.9 cm.)
Inscribed lower left: *Grant Wood*
Provenance: Artist; unknown; to Gordon
Fennell; acquired in 1985
Exhibited: 1926[3] (36), 1981 (111)
References: Czestochowski, fig. 111; Dennis,
1985, no. 9
Gift of Mr. Gordon Fennell (84.12)

95. *Old Shoes*, 1926
Oil on composition board, 9¾ x 10 in.
(24.8 x 25.4 cm.)
Inscribed lower left: *Grant Wood 1926*
Provenance: Artist; to David Turner; to Mr.
and Mrs. John B. Turner II; acquired in 1972
Exhibited: 1926[3] (38), 1935[1] (19), 1935[2] (11),
1939 (21), 1942 (19), 1959 (14), 1973 (49), 1984
(18), 1989 (9)
References: *Demcourier*, no. 19; Cedar Rapids

Art Association, p. 12; Corn, fig. 21
Gift of Happy Young and John B. Turner II
(76.2.3)

96. *Amber*, 1927
Alternate title: *Indian Creek-Fall*
Oil on composition board, 13 x 15 in.
(33 x 38 cm.)
Inscribed lower right: *Grant Wood 1927*
Provenance: Artist; to John C. and Sophie S.
Reid; to James L. and Catherine Reid Cooper;
acquired in 1989
Exhibited: 1989 (11)
Gift of John Reid Cooper and Lee Cooper
van de Velde in honor of their grandparents
John C. and Sophie S. Reid, and their parents
James L. and Catherine Reid Cooper (89.5.3)

97. *Veterans Memorial Coliseum Window—
Drawings*, 1927-28
The window drawings consist of fifty-eight
sections that measure a collective 24 x 20 feet.
All sections are in the collection of the Cedar
Rapids Museum of Art. Wood was awarded
the commission to design the Veterans
Memorial Coliseum stained glass window in
January 1927; he received the formal contract
in March 1927 and was authorized to assemble
it in January 1928. Working with Arnold Pyle
(1908-73), Wood assembled the window
drawings at the Quaker Oats Company
recreation room. The window was installed in
1929 at the Second Avenue City Hall location,
where it stands today.

American Revolution Soldier (Sections 44 and 53)
Ink, pencil, pastel and watercolor on paper,
40³/₄ x 31¹/₈ in. (103.5 x 79.1 cm.) and
36¹/₂ x 31¹/₈ in. (92.7 x 79.1 cm.)

World War I Soldier (Sections 52 and 58)
Ink, pencil, pastel and watercolor on paper,
40³/₄ x 31¹/₈ in. (103.4 x 79.1 cm.) and
36¹/₂ x 31¹/₈ in. (92.7 x 79.1 cm.)
Unsigned
Provenance: Commissioned by the Veterans
Memorial Coliseum Commission; acquired in
1973
Exhibited: 1972 (12-14), 1984 (21)
References: Corn, p. 66, 98-100, pl. 3; Dennis,
pp. 67-68
Veterans Memorial Coliseum Collection (73.6)

98. *Chaff*, 1927
Oil on panel, 10¹/₈ x 13 in. (25.7 x 33 cm.)
Unsigned
Provenance: Artist; to David Turner; to Mr.
and Mrs. John B. Turner II; acquired in 1981
Gift of John B. Turner II in Memory of
Happy Turner (81.17.6)

99. *The Three Minute Mill*, 1927
Oil on composition board, 6³/₄ x 14 ¹³/₁₆ in.
(17.1 x 37.7 cm.)
Unsigned
Provenance: Artist; to Gordon Fennell; to Mrs.
Geraldine F. Eliot; acquired in 1986
Gift of Mrs. Geraldine F. Eliot (86.6)
Note: This painting is a preliminary sketch for
The Three Minute Mill, c. 1927, oil on canvas,
22¹/₄ x 60 in., signed lower left: *Grant Wood*, in
the collection of National Oats, Cedar Rapids.

100. *Night Scene-National Oats*
Oil on canvas, 22 x 18 in. (55.9 x 45.7 cm.)
Unsigned
Provenance: Artist; to John C. and Sophie S.
Reid; to James L. and Catherine Reid Cooper;
acquired in 1989
Gift of John Reid Cooper and Lee Cooper
van de Velde in honor of their grandparents
John C. and Sophie S. Reid, and their parents,
James L. and Catherine Reid Cooper (89.5.5)
Note: This painting is a preliminary sketch for
The Three Minute Mill, c. 1927, oil on canvas,
22¹/₄ x 60 in., signed lower left: *Grant Wood*, in
the collection of National Oats, Cedar Rapids.

101. *Market Place, Nuremberg*, 1928
Oil on canvas, 22 x 17³/₄ in. (55.9 x 45.1 cm.)
Unsigned
Provenance: Artist; to the Cedar Rapids
Chamber of Commerce; to the Cedar Rapids
Museum of Art in 1982
Exhibited: 1929¹ (12)
Chamber of Commerce Collection (82.22.1a)
Note: Verso: *Indian Creek*, 1929 (cat. no. 105).
This work has been cut down from a larger
canvas.

102. *Calendulas*, 1928-29
Oil on composition board, 17¹/₂ x 20 in.
(44.5 x 50.8 cm.)
Inscribed lower right: *Grant Wood*
Provenance: Artist; to John C. and Sophie S.
Reid; to James L. and Catherine Reid Cooper;
acquired in 1989
Exhibited: 1929¹ (19), 1942 (6), 1983 (17), 1989
(12)
Reference: Dennis p. 104, pl. 13; Corn p. 33,
fig. 44
Gift of John Reid Cooper and Lee Cooper
van de Velde in honor of their grandparents,
John C. and Sophie S. Reid, and their parents,
James L. and Catherine Reid Cooper (89.5.4)

103. *Midsummer*, 1929
Oil on canvas, 28³/₄ x 36³/₄ in. (73 x 93.3 cm.)
Inscribed lower left: *Grant Wood 1929*
Provenance: Artist; to the Cedar Rapids
Chamber of Commerce; to the Cedar Rapids
Museum of Art in 1982
Exhibited: 1935¹ (25)
References: *Demcourier*, no. 25; Dennis, fig. 24
Chamber of Commerce Collection (82.22.2b)
Note: Verso: *Terraced Mountain*, 1926 (cat. no.
88).

104. *Portrait of John B. Turner, Pioneer*, 1928-30
Oil on canvas, 30¹/₄ x 25¹/₂ in.
(76.8 x 64.8 cm.)
Inscribed lower left: *Grant Wood 1928*; lower
right: *Grant Wood 1930*
Provenance: Commissioned by David Turner;
to Mr. and Mrs. John B. Turner II; acquired
in 1972
Exhibited: 1929¹ (22), 1933¹ (15), 1935 (31),
1939 (20), 1942 (15), 1959 (23), 1973 (53), 1981
(114), 1984 (22), 1989 (13)
References: *Gazette and Republican*, 21 August
1929, p. 13; *Gazette and Republican*, 25 January
1931, p. 4; *Demcourier*, no. 31; Cedar Rapids
Art Association, p. 13; Czestochowski, fig. 114;
Corn, p. 68, pl. 4, fig. 107; Dennis, p. 116, fig.
72
Gift of Happy Young and John B. Turner II
(76.2.2)
Note: John B. Turner (1845-1936) was the
father of David Turner (1882-1954) and the
grandfather of John B. Turner II (1909-1983).

105. *Indian Creek*, 1929
Oil on canvas, 22 x 17³/₄ in. (55.9 x 45.1 cm.)
Inscribed lower left: *Grant Wood*
Provenance: Artist; to the Cedar Rapids
Chamber of Commerce; to the Cedar Rapids
Museum of Art in 1982
Reference: Dennis, pl. 8
Chamber of Commerce Collection (82.22.1b)
Note: Verso: *Market Place, Nuremberg*, 1928 (cat.
no. 101). This work is conceptually similar to
Midwestern Summer, Indian Creek, 1927, oil on
canvas, 31¹/₂ x 22 in., Private Collection. It is
likely that it was executed after the February
1929 exhibition of *Market Place, Nuremberg*, but
before its May 1929 purchase by the Chamber
of Commerce.

106. *Indian Creek-Summer*, 1929
Oil on composition board, 13 x 15 in.
(33 x 38 cm.)
Inscribed lower center: *Grant Wood*
Provenance: Artist; to John C. and Sophie S.
Reid; to James L. and Catherine Reid Cooper;
acquired in 1989
Gift of John Reid Cooper and Lee Cooper
van de Velde in honor of their grandparents,
John C. and Sophie S. Reid, and their parents,
James L. and Catherine Reid Cooper (89.5.2)

107. *Portrait of Master Gordon Fennell*, 1929
Alternate title: *Young Gordon, Age Three*
Oil on canvas, 24¹/₄ x 20¹/₄ in.
(61.6 x 51.4 cm.)
Inscribed lower right: *Grant Wood 1929*
Provenance: Commissioned by John C. Reid;
to Mr. and Mrs. Gordon Fennell; acquired in
1978
Exhibited: 1929 (23)
Reference: Dennis, p. 73, fig. 74
Gift of Mr. Gordon Fennell (78.1)

108. *Portrait of Frances Fiske Marshall*, 1929
Oil on canvas, 40³/₈ x 30 in. (102.6 x 76.2 cm.)
Inscribed lower right: *Grant Wood 1929*
Provenance: Commissioned by Verne
Marshall; to Frances Marshall Lash, Patricia
Marshall Sheehy, and Jeanne Marshall Byers; acquired in 1981
Reference: Corn, fig. 43
Gift of Frances Marshall Lash, Patricia
Marshall Sheehy, Barbara Marshall Hoffman,
and Jeanne Marshall Byers (81.11)

109. *Woman with Plant(s)*, 1929
Oil on upsom board, 20¹/₂ x 17⁷/₈ in.
(52.1 x 45.4 cm.)
Inscribed lower left: *Grant Wood—1929*
Provenance: Artist; acquired in 1931
Exhibited: 1929³ (1), 1930, 1931¹ (261), 1933
(3), 1935¹ (30), 1935² (13), 1939 (19), 1942
(28), 1973 (54), 1981 (113)
References: *Gazette and Republican*, 5 January
1930, p. 4; *New York Times*, 8 February 1931, p.
3; *Demcourier*, no. 29; Czestochowski, fig. 113;
Corn, frontispiece, pp. 70- 71, 129, fig. 45, pl.
5; Dennis, p. 15
Art Association Purchase (31.1)

110. *Overmantel Decoration*, 1930
Oil on upsom board, 41 x 63¹/₂ in.
(104.1 x 161.3 cm.)
Inscribed lower right: *Grant Wood 1930*
Provenance: Commissioned by Herbert S.
Stamats for Isabel R. Stamats; acquired in
1973
Exhibited: 1933¹ (9), 1935 (34), 1973 (54),
1981 (13), 1989 (14)
References: *Gazette and Republican*, 25 January
1931, p. 4; *Demcourier*, no. 34; Czestochowski,
pl. 13; Corn, pp. 75-77; Dennis, pl. 24
Gift of Isabel R. Stamats in Memory of
Herbert S. Stamats (73.3)

111. *Young Corn*, 1931
Oil on masonite panel, 24 x 29⁷/₈ in.
(61 x 75.9 cm.)
Inscribed lower right: *Grant Wood 1931*
Provenance: Artist; to the Cedar Rapids
Community School District; to the Cedar
Rapids Museum of Art in 1970
Exhibited: 1933 (4), 1935¹ (44), 1935² (22),
1939 (28), 1942 (29), 1954 (175), 1955 (12),
1957 (8), 1959 (28), 1973 (55), 1980 (339),
1983 (34), 1984 (23), 1989 (15)
References: *Demcourier*, no. 44; Cedar Rapids
Art Association, p. 17; Czestochowski, pl. 17;
Corn, pp. 90, pl. 15; Dennis, pp. 92, 159, 168,
pl. 22
Community School District Collection
(70.3.117)

112. *Stone City Landscape*, 1932
Alternate title: *Cornstalks*
Oil on composition board, 13 x 15 in.
(33 x 38 cm.)
Inscribed lower right: *Grant Wood*; verso: *1932
Colony*
Provenance: Artist; to Don and Criss Glasell;
to Donald Glasell; acquired in 1985
Exhibited: 1931² (51)
Gift of Donald Glasell (85.5)

113. *Sketch—Draft Horse*, 1932
Charcoal and pencil on paper, 16 x 22 in.
(40.6 x 55.9 cm.)
Inscribed lower right: *Grant Wood 1932*
Provenance: Artist; to David Turner; to Mr.
and Mrs. John B. Turner II; acquired in 1972
Exhibited: 1935¹ (55), 1942 (38), 1959 (34),
1972 (26), 1973 (83), 1981 (123), 1984 (24),
1989 (16)
References: *Demcourier*, no. 51; Cedar Rapids
Art Association, p. 25; Czestochowski, fig. 123;
Corn, p. 82; Dennis, fig. 109
Gift of Happy Young and John B. Turner II
(72.12.16)
Note: This work is related to the definitive
drawing [pencil, white chalk, black ink and
gouache on brown paper - 17³/₈ x 23¹/₈ inches]
sold at Christie's (New York) on 18 March
1983.

114. *Sketch—Race Horse*, 1932
Charcoal and pencil on paper, 16¹/₄ x 21¹/₄ in.
(41.3 x 54 cm.)
Inscribed lower left: *Grant Wood, 1932*
Provenance: Artist; to David Turner; to Mr.
and Mrs. John B. Turner II; acquired in 1972
Exhibited: 1935¹ (54), 1942 (45), 1959 (33),
1972 (25), 1973 (82)
References: *Demcourier*, no. 50; Corn, p. 82;
Dennis, fig. 110
Gift of Happy Young and John B. Turner II
(72.12.55)
Note: This work is related to the definitive
drawing [pencil, white chalk and gouache on
brown paper - 17¹/₂ x 23 inches] in a private
collection.

115. *Autumn Oaks*, 1933
Oil on masonite, 31¹/₂ x 37¹/₂ in.
(80 x 95.3 cm.)
Inscribed lower right: *Grant Wood 1932*
Provenance: Artist; to the Cedar Rapids
Community School District; to the Cedar
Rapids Museum of Art in 1970
Exhibited: 1973 (56), 1981 (130), 1989 (17)
References: Cedar Rapids Art Association, p.
20; Czestochowski, fig. 130; Dennis, p. 34, fig.
25
Community School District Collection
(70.3.176)

116. *Portrait of John B. Northcott*, 1933
Pencil and ink on paper, 11¹/₂ x 10¹/₄ in.
(29.2 x 26 cm.)
Inscribed lower left: *Grant Wood*
Provenance: Commissioned by Cedar Rapids
Community Chest; to Mrs. John B. Northcott;
to Louise and Russell Knapp; acquired in
1980
Exhibited: 1972 (32)
Reference: Dennis, p. 237 (fn. 2)
Gift of Louise and Russell Knapp (80.5.1)
Note: Portrait executed from a photograph
after Northcott's death.

117. *Cedar Rapids Community Chest Poster*, 1933
Offset lithograph, 22³/₈ x 17⁵/₈ in.
(56.8 x 44.8 cm.)
Unsigned
Provenance: Artist; to Mrs. John Northcott; to
Russell and Louise Knapp; acquired in 1980
Reference: *Gazette*, 31 December 1933, p. 12
Gift of Louise and Russell Knapp (80.5.2)

118. *The Early Bird*, 1936
Crayon on paper, 5⅞ x 6½ in.
(14.9 x 16.5 cm.)
Inscribed lower right: *Grant Wood*
Provenance: Artist; to Nan Wood Graham; to
Frances Prescott; to the Cedar Rapids
Community School District; to the Cedar
Rapids Museum of Art in 1970
Exhibited: 1936, 1972 (42), 1973 (84), 1981
(139)
References: Czestochowski, fig. 139; Dennis,
fig. 140
Community School District Collection
(70.3.162b)
Note: Endpaper illustration for Madeline
Darrough Horn's *Farm on the Hill* (New York:
Charles Scribner's Sons, 1936).

119. *Young Calf*, 1936
Crayon on paper, 5¾ x 6½ in.
(14.6 x 16.5 cm.)
Inscribed lower center: *Grant Wood*
Provenance: Artist; to Nan Wood Graham; to
the Cedar Rapids Community School District;
to the Cedar Rapids Museum of Art in 1970
Exhibited: 1936, 1972 (45), 1973 (85), 1981
(140)
References: Czestochowski, fig. 140; Dennis,
fig. 137
Community School District Collection
(70.3.162g)
Note: Endpaper illustration for Madeline
Darrough Horn's *Farm on the Hill* (New York:
Charles Scribner's Sons, 1936).

120. *The Escape*, 1936
Crayon on paper, 5¾ x 6½ in.
(14.6 x 16.5 cm.)
Inscribed lower right: *Grant Wood*
Provenance: Artist; to Nan Wood Graham; to
the Cedar Rapids Community School District;
to the Cedar Rapids Museum of Art in 1970
Exhibited: 1936, 1972 (41), 1973 (86), 1981
(141)
References: Czestochowski, fig. 141; Dennis,
fig. 136
Community School District Collection
(70.3.162c)
Note: Endpaper illustration for Madeline
Darrough Horn's *Farm on the Hill* (New York:
Charles Scribner's Sons, 1936).

121. *Insect Suicide*, 1936
Crayon on paper, 5¾ x 6½ in.
(14.6 x 16.5 cm.)
Inscribed lower right: *Grant Wood*
Provenance: Artist; to Nan Wood Graham; to
the Cedar Rapids Community School District;
to the Cedar Rapids Museum of Art in 1970
Exhibited: 1936, 1972 (47), 1973 (87), 1981
(142)
Reference: Czestochowski, fig. 142
Community School District Collection
(70.3.162e)
Note: Endpaper illustration for Madeline
Darrough Horn's *Farm on the Hill* (New York:
Charles Scribner's Sons, 1936).

122. *Bold Bug*, 1936
Crayon on paper, 5⅞ x 6½ in.
(14.9 x 16.5 cm.)
Inscribed lower right: *Grant Wood*
Provenance: Artist; to Nan Wood Graham; to
the Cedar Rapids Community School District;
to the Cedar Rapids Museum of Art in 1970
Exhibited: 1936, 1972 (46), 1973 (88), 1981
(143)
References: Czestochowski, fig. 143; Dennis,
fig. 138
Community School District Collection
(70.3.162a)
Note: Endpaper illustration for Madeline
Darrough Horn's *Farm on the Hill* (New York:
Charles Scribner's Sons, 1936).

123. *Joy Ride*, 1936
Crayon on paper, 5⅞ x 6½ in.
(14.9 x 16.5 cm.)
Inscribed lower right: *Grant Wood*
Provenance: Artist; to Nan Wood Graham; to
the Cedar Rapids Community School District;
to the Cedar Rapids Museum of Art in 1970
Exhibited: 1936, 1972 (43), 1973 (89)
Community School District Collection
(70.3.162f)
Note: Endpaper illustration for Madeline
Darrough Horn's *Farm on the Hill* (New York:
Charles Scribner's Sons, 1936).

124. *Hero Worship*, 1936
Crayon on paper, 5¾ x 6½ in.
(14.6 x 16.5 cm.)
Inscribed lower right: *Grant Wood*
Provenance: Artist; to Nan Wood Graham; to
the Cedar Rapids Community School District;
to the Cedar Rapids Museum of Art in 1970
Exhibited: 1936, 1972 (44), 1973 (90), 1984
(25), 1989 (18)
References: Cedar Rapids Art Association, p.
24; Dennis, fig. 139
Community School District Collection
(70.3.162d)
Note: Endpaper illustration for Madeline
Darrough Horn's *Farm on the Hill* (New York:
Charles Scribner's Sons, 1936).

125. *Tree Planting Group*, 1937
Charcoal on paper, 21¾ x 28 in.
(55.2 x 71.1 cm.)
Inscribed lower right: *Grant Wood, 1937*
Provenance: Artist; to the Cedar Rapids
Community School District; to the Cedar
Rapids Museum of Art in 1970
Exhibited: 1955 (14), 1957 (15), 1959 (32),
1972 (33), 1973 (91), 1984 (26), 1989 (19)
Reference: Cedar Rapids Art Association, p. 26
Community School District Collection
(70.3.175)

126. *Blitzkrieg*, 1940
Alternate title: *Bundles for Britain*; *Horrors of
War*
Offset lithograph, 25¼ x 20½ in.
(64.1 x 52.1 cm.)
Inscribed lower left: *Grant Wood 1940*
Provenance: Artist; to Edwin B. Green;
acquired 1972
Exhibited: 1973 (110), 1980 (351)
References: Cedar Rapids Art Association, p.
29; Dennis, fig. 130
Gift of Edwin B. Green (72.13)
Note: The drawing of charcoal, pencil, chalk,
and gesso on paper (20½ x 33 in.) is in the
collection of the Everson Museum of Art,
Syracuse University.

WORKS IN OTHER MEDIA

127. *Necklace*, 1914-15
Copper and mother-of-pearl, 12 x 1⅜ x ⅜ in.
(30.5 x 3.5 x 1 cm.)
Unsigned
Provenance: Artist; to David Turner; to Mr.
and Mrs. John B. Turner II; acquired in 1982
Exhibited: 1984 (3)
Gift of Happy Young and John B. Turner II
(82.1.5)
Note: During 1914-15, Wood, along with
fellow Iowa craftsman Kristoffer Hagan,
opened the Volund Crafts Shop in Park Ridge,
Illinois, specializing in handmade jewelry of
distinctive design.

128. *Self-Portrait*, 1917
Brass, 3 x 2 x 1 in. (7.6 x 5.1 x 2.5 cm.)
Unsigned
Provenance: Artist; to David Turner; to Mr.
and Mrs. John B. Turner II; acquired in 1972
Exhibited: 1973 (122)
Gift of Happy Young and John B. Turner II
(72.12.59)
Note: This work was originally done in plaster-
of-paris painted in antique gold with a ribbon
attached to the pince-nez glasses. Wood was
making plaster portraits as early as 1915-16,
exhibiting one in the Art Institute of Chicago
in April 1916. A group of six plaster works
exists in the Davenport Art Gallery, Iowa. This
collection, purchased from Nan Wood
Graham, includes two plaster cast portraits of
Lawrence Bartlett and Harland Zimmerman;
three bas-reliefs of Sylvester Neville, Charles
Keeler, and Robert Hanson; and a similar self-
portrait.

129. *Cedar Rapids Art Association Life Membership
Plaque*, 1917
Painted plaster (irregular octagon),
8¼ x 8¼ x ¼ in (21 x 21 x .6 cm.)
Unsigned
Provenance: Artist; to David Turner; to Mr.
and Mrs. John B. Turner II; acquired in 1972
Exhibited: 1973 (124), 1984 (30)
Gift of Happy Young and John B. Turner II
(72.12.37)
Gift of Mr. and Mrs. Peter O. Stamats (74.4)
Note: Edition of forty in plaster and three in
bronze was produced by Grant Wood in 1917
for life members of the Cedar Rapids Art
Association. In 1980, an edition of twenty was
cast to recognize distinguished service by art
association patrons. Each cast is clearly
marked. The design of this plaque was
strongly influenced by Luther A. Brewer, who
was president of the art association and owner
of the Torch Press of Cedar Rapids. The
Torch Press published limited edition books
and printed the presentation works of Alfred
Fowler's Woodcut Society (Kansas City).

130. *Classical Figure Relief Plaque*, 1917-18
Plaster and paint, 15¼ x 8¾ x 2½ in.
(38.7 x 22.2 x 6.4 cm.)
Unsigned
Provenance: Artist; to David Turner; to Mr.
and Mrs. John B. Turner II; acquired in 1972
Exhibited: 1973 (125)
Gift of Happy Young and John B. Turner II
(72.12.54)

131. *Plaque of Charles B. Keeler*, 1920
Plaster, 5 x 4½ x ¼ in. (12.7 x 11.4 x .6 cm.)
Unsigned
Provenance: Artist; to David Turner; to Mr.
and Mrs. John B. Turner II; acquired in 1972
Exhibited: 1973 (123), 1984 (31)
Gift of Happy Young and John B. Turner II
(72.12.53)
Note: Cast in an edition of fewer than five in
plaster and three in bronze

132. *Relief Plaque of Marvin Cone*, 1920
Bronze, 3¼ x 3¼ in. (8.3 x 8.3 cm.)
Inscribed upper left: *Paris 1920*
Provenance: Artist; to David Turner; to Mr.
and Mrs. John B. Turner II; acquired in 1972
Exhibited: 1920³, 1973 (111), 1984 (32)
Gift of Happy Young and John B. Turner II
(72.12.57)
Note: The Museum also owns the drawing for
this plaque in pencil, chalk and gouache on
paper (4½ x 4¼ in.) The drawing is
unsigned, but carries the inscription *Paris
1920*. Gift of Winnifred D. Cone
(80.10)

133. *Percy Heavy Thinker*, 1924
Painted papier-mache, 8½ x 6½ x 7½ in.
(21.6 x 16.5 x 19.1 cm.)
Unsigned
Provenance: Artist; to Cedar Rapids
Community School District; to the Cedar
Rapids Museum of Art in 1970
Exhibited: 1973 (114)
Reference: Art Association, fig. 114
Community School District Collection
(70.3.172)

134. *Star Screen*, 1924
Mixed media, 71¾ x 100⅜ in.
(182.2 x 255 cm.)
Unsigned
Provenance: Artist; to David Turner; to Mr.
and Mrs. John B. Turner II; acquired in 1972
Exhibited: 1973 (116)
Gift of Happy Young and John B. Turner II
(72.12.64)

135. *Door to 5 Turner Alley*, 1924
Painted wood, glass, and wrought-iron
hardware, 78 x 29⅞ x 1¼ in
(198.1 x 75.9 x 3.2 cm.)
Unsigned
Provenance: Artist; to David Turner; to Mr.
and Mrs. John B. Turner II; acquired in 1972
Exhibited: 1973 (120)
References: Art Association, fig. 120; Corn, p.
22, fig. 2
Gift of Happy Young and John B. Turner II
(72.12.15)

136. *Dingbat to Grant Wood's Studio*, 1924
Painted wood, 3¾ x 19½ x ¾ in.
(9.5 x 49.5 x 1.9 cm.)
Unsigned
Provenance: Artist; to David Turner; to Mr.
and Mrs. John B. Turner II; acquired in 1982
Gift of Happy Young and John B. Turner II
(82.1.2)

137. *Mailbox to Grant Wood's Studio*, 1924
Paint, wood, and metal, 21⅜ x 12 x 6¾ in.
(54.3 x 30.5 x 17.1 cm.)
Unsigned
Provenance: Artist; to David Turner; to Mr.
and Mrs. John B. Turner II; acquired in 1982
Gift of Happy Young and John B. Turner II
(82.1.3)

138. *Overall-Covered Screen from Grant Wood's
Studio*, 1924
Wood and cloth, 56 x 52¼ in.
(142.2 x 132.7 cm.)
Unsigned
Provenance: Artist; to David Turner; to Mr.
and Mrs. John B. Turner II; acquired in 1972
Exhibited: 1973 (117)
Gift of Happy Young and John B. Turner II
(72.12.51)

139. *Lilies of the Alley*, 1924-25
Earthenware flower pot and found objects
(clothespin), 12 x 12 x 6½ in.
(30.5 x 30.5 x 16.5 cm.)
Unsigned
Provenance: Artist; to David Turner; to Mr.
and Mrs. John B. Turner II; acquired in 1972
Exhibited: 1973 (112), 1985 (5)
Reference: Art Association, fig. 112
Gift of Happy Young and John B. Turner II
(72.12.38)
Note: With clothespin

140. *Lilies of the Alley*, 1924-25
Earthenware flower pot and found objects
(shoehorn), 8³/₄ x 9 x 8⁵/₈ in
(22.2 x 22.9 x 21.9 cm.)
Unsigned
Provenance: Artist; to David Turner; to Mr.
and Mrs. John B. Turner II; acquired in 1972
Exhibited: 1973 (113), 1984 (15)
References: Corn, fig. 10; Dennis, p. 87, fig.
84
Gift of Happy Young and John B. Turner II
(72.12.39)
Note: With shoehorn

RELATED WORKS

141. *Album Quilt*, 1850
Cotton and calico, 78¹/₂ x 68 in.
(199.4 x 172.7 cm.)
Inscriptions: Center block: *Charles L. Wood and
Rebecca Wood, 1850*
Provenance: Artist; to Nan Wood Graham;
acquired in 1983
Reference: Cross, p. 105
Gift of Nan Wood Graham (83.12)

142. *Four Patch*, 1891
Cotton and calico, 31 x 34 in.
(78.7 x 86.4 cm.)
Unsigned
Provenance: Artist; to David Turner; to Mr.
and Mrs. John B. Turner II; acquired in 1972
Reference: Cross, p. 106, fig. 4
Gift of Happy Young and John B. Turner II
(72.12.79)
Note: Grant Wood's baby blanket, made by
Nancy Weaver.

143. *Mourner's Bench*, 1921-22
Oak, 37 x 49 x 16 in. (94 x 124.5 x 40.6 cm.)
Inscribed back rest: *The Way of the Transgressor
is Hard*
Provenance: Artist; to the Cedar Rapids
Community School District; to the Cedar
Rapids Museum of Art in 1970
Exhibited: 1973 (115)
References: Art Association, fig. 115; Corn, fig.
11; Dennis, fig. 146
Community School District Collection
(70.3.169)
Note: The bench design and individual
carvings were done by Grant Wood. It was
installed in the waiting room of the principal's
office in McKinley Junior High School.

144. *Fire Screen Ornament*, 1923
Wrought iron, 50¹/₄ x 21¹/₄ x 4¹/₂ in.
(127.6 x 54 x 10.8 cm.)
Unsigned
Provenance: Artist; to John T. Hamilton III;
acquired in 1969
Exhibited: 1973 (121)
Gift of John T. Hamilton III (69.12)
Note: Designed by Grant Wood. Forged by
George Keeler (1908-44).

145. *Single Candle Holder*, 1923
Wrought iron, 42 in. high (106.7 cm.)
Unsigned
Provenance: Artist; to David Turner; to Mr.
and Mrs. John B. Turner II; acquired in 1972
Exhibited: 1973 (119), 1984 (14)
References: Art Association, fig. 119; Dennis,
fig. 147
Gift of Happy Young and John B. Turner II
(72.12.62)
Note: Designed by Grant Wood. Forged by
George Keeler (1908-44).

146. *Set of Candelabra*, 1923
Wrought iron, 12³/₄ x 53¹/₂ x 13 in.
(32.4 x 135.9 x 33 cm.)
Unsigned
Provenance: Artist; to David Turner; to Mr.
and Mrs. John B. Turner II; acquired in 1972
Exhibited: 1973 (118)
Gift of Happy Young and John B. Turner II
(72.12.60)
Note: Designed by Grant Wood. Forged by
George Keeler (1908-44).

147. *Miscellaneous Hardware from Grant Wood's
Studio*, 1923-24
Wrought iron
Bell 13¹/₂ x 5¹/₄ x 7¹/₈ in.
(34.3 x 13.3 x 18.1 cm.), (82.1.4i)
Doorknob 3³/₄ x 1¹/₂ x 4¹/₂ in.
(9.5 x 3.8 x 11.4 cm.), (82.1.4a)
Hook 4⁷/₈ x 2³/₄ x 1¹/₂ in. (12.4 x 7 x 3.8 cm.),
(82.1.4b)
Hook 7 x 2⁷/₈ x 2 in. (17.8 x 7.3 x 5.1 cm.),
(82.1.4c)
Hook 9¹/₂ x 1¹/₂ x 1⁷/₈ in.
(24.1 x 3.8 x 4.8 cm.), (82.1.4f)
Handle 10³/₄ x 3¹/₈ x 4 in.
(27.3 x 7.9 x 10.2 cm.), (82.1.4d)
Handle 9 x 2¹/₄ x 1⁷/₈ in.
(22.9 x 5.7 x 4.8 cm.), (82.1.4e)
Key 8¹/₄ x 1¹/₂ x ¹/₂ in. (21 x 3.8 x 1.3 cm.),
(82.1.4g)
Hook 5¹/₈ x 3¹/₂ x 3 in. (13 x 8.9 x 7.6 cm.),
(82.1.4h)
Unsigned
Provenance: Artist; to David Turner; to Mr.
and Mrs. John B. Turner II; acquired in 1982
Gift of Happy Young and John B. Turner II
Note: Designed by Grant Wood. Forged by
George Keeler (1908-44).

148. *Imagination Isle Frieze*, 1924
Oil on canvas, 12 x 338 in. (30.5 x 858.5 cm.)
Unsigned
Provenance: Artist; to the Cedar Rapids
Community School District; to the Cedar
Rapids Museum of Art in 1970
References: *Gazette*, 22 November 1924, p. 12;
Gazette, 6 December 1924, p. 9; Corn, fig. 9
Community School District Collection
(70.3.174)
Note: By Grant Wood's students.

149. *Backdrop*, 1924
Oil on canvas, 156 x 395 in.
(396.2 x 1,003.3 cm.)
Unsigned
Provenance: Artist; to the Cedar Rapids
Community School District; to the Cedar
Rapids Museum of Art in 1970
Community School District Collection
(70.3.161)
Note: By Grant Wood's students.

150. *Corn Room Chandelier*, 1925-26
Iron and copper, 94 x 32 x 34 in.
(238.8 x 81.3 x 86.4 cm.)
Unsigned
Provenance: Artist; to Montrose Hotel, Cedar
Rapids; to Happy Young and John B. Turner
II; acquired in 1981
Gift of Happy Young and John B. Turner II
(81.17.3)
Note: Designed by Grant Wood. Forged by
George Keeler.

PRINTS

151. *No. 5 Turner Alley-Christmas Card*, 1927
Line cut from scratch-board drawing
Image: 10 x 7³/₁₆ in. (25.4 x 17.9 cm.)
Edition: Unknown, but small Printer: Grant
Wood
Reference: Czestochowski 1989*
Gift of Harriet Y. and John B. Turner II
(81.17.4)
Note: This work was printed by Wood and
considered by him to be his original work and
as such was signed by him.

152. *Bookplate: Isabel O. Stamats*, 1931
Linoleum cut
Image: 8¹/₂ x 5⁷/₈ in. (21.6 x 14.9 cm.)
Edition: Unknown
Reference: Czestochowski 1989
Note: Also used as a program design for the
Cedar Rapids Community Players production
of *A Kiss for Cinderella*.

153. *Tree-Planting Group*, 1937
Lithograph on stone
Image: 8³/₈ x 10⁷/₈ in. (21.3 x 27.3 cm.)
Edition: 260 Printer: George C. Miller
(1894-1965)
Reference: Czestochowski 1*
Museum Purchase, In Memory of Bea Ann
Huston (88.11)
Note: Published in 1937 by Associated
American Artists, New York. Impressions
dated.

154. *Seed Time And Harvest*, 1937
Lithograph on stone
Image: 7⁷/₁₆ x 12¹/₈ in. (18.9 x 30.7 cm.)
Edition: 260 Printer: George C. Miller
(1894-1965)
Reference: Czestochowski 2
Gift of Mr. Peter O. Stamats and Mr. Larry K.
Zirbel (85.6.2)
Note: Published in 1937 by Associated
American Artists, New York.

155. *January*, 1937
Lithograph on stone
Image: 8⁷/₈ x 11⁷/₈ in. (22.7 x 30.2 cm.)
Edition: 260 Printer: George C. Miller
(1894-1965)
Reference: Czestochowski 3
Gift of Harriet Y. and John B. Turner II
(72.12.33)
Note: Published in 1938 by Associated
American Artists, New York.

156. *Sultry Night*, 1937
Alternate Title: *Saturday Night Bath, Morning
Bath*
Lithograph on stone
Image: 9¹/₁₆ x 11³/₄ in. (22.9 x 29.8 cm.)
Edition: 100 Printer: George C. Miller
(1894-1965)
Reference: Czestochowski 4
Gift of Peter O. Stamats (85.3.7)
Note: Published in 1938-1939 by Associated
American Artists, New York.

157. *Honorary Degree*, 1937
Lithograph on stone
Image: 11¹³/₁₆ x 6¹⁵/₁₆ in. (30 x 17.6 cm.)
Edition: 260 Printer: George C. Miller
(1894-1965)
Reference: Czestochowski 5
Gift of Harriet Y. and John B. Turner II
(72.12.27)
Note: Published in 1938 by Associated
American Artists, New York.

*Refers to catalog raisonne by Joseph S.
Czestochowski, *The Lithographs and Related
Works by Grant Wood (1891-1942).* Foreward by
Robert P. Conway, Cedar Rapids, Iowa, Cedar
Rapids Museum of Art, 1989.

158. *July Fifteenth*, 1937-38
Lithograph on stone
Image: 9 x 11⁷/₈ in. (22.8 x 30.1 cm.)
Edition: 260 Printer: George C. Miller
(1894-1965)
Reference: Czestochowski 6
Gift of Harriet Y. and John B. Turner II
(72.12.34)
Note: Published in 1938 by Associated
American Artists, New York.

159. *Midnight Alarm*, 1938
Lithograph on stone
Image: 11⁷/₈ x 7 in. (30.2 x 17.7 cm.)
Edition: 260 Printer: George C. Miller
(1894-1965)
Reference: Czestochowski 7
Gift of Harriet Y. and John B. Turner II
(72.12.42)
Note: Published in 1939 by Associated
American Artists, New York.

160. *Shrine Quartet*, 1938
Lithograph on stone
Image: 7¹⁵/₁₆ x 11¹³/₁₆ in. (20.2 x 30 cm.)
Edition: 260 Printer: George C. Miller
(1894-1965)
Reference: Czestochowski 8
Gift of Harriet Y. and John B. Turner II
(72.12.61); also Gift of Peter O. Stamats and
Larry K. Zirbel (85.6.1)
Note: Published in 1939 by Associated
American Artists, New York.

161. *Fruits*, 1938-39
Lithograph on stone
Image: 7 x 9⁷/₈ in. (18.1 x 24.8 cm.)
Edition: 260 Printer: George C. Miller
(1894-1965)
Reference: Czestochowski 9
Gift of Harriet Y. and John B. Turner II
(72.12.24a)
Note: Published in 1939 by Associated
American Artists, New York.

162. *Tame Flowers*, 1938-39
Lithograph on stone
Image: 6¹¹/₁₆ x 10¹/₈ in. (17 x 25.2 cm.)
Edition: 260 Printer: George C. Miller
(1894-1965)
Reference: Czestochowski 10
Gift of Harriet Y. and John B. Turner II
(72.12.24b)
Note: Published in 1939 by Associated
American Artists, New York.

163. *Vegetables*, 1938-39
Lithograph on stone
Image: 7 x 9¹/₂ in. (17.7 x 24.1 cm.)
Edition: 260 Printer: George C. Miller
(1894-1965)
Reference: Czestochowski 11
Gift of Harriet Y. and John B. Turner II
(72.12.24c)
Note: Published in 1939 by Associated
American Artists, New York.
The Museum also owns another impression of
Vegetables with a collaged detail by Wood.
Museum Purchase, Leo Kuda Fund, In
Memory of His Parents Joseph and Mary
Kuda (86.15)

164. *Wild Flowers*, 1938-39
Lithograph on stone
Image: 6¹⁵/₁₆ x 9⁷/₈ in. (17.6 x 15.2 cm.)
Edition: 260 Printer: George C. Miller
(1894-1965)
Reference: Czestochowski 12
Gift of Harriet Y. and John B. Turner II
(72.12.24d)
Note: Published in 1939 by Associated
American Artists, New York.

165. *Fertility*, 1939
Lithograph on stone
Image: 8 $^{15}/_{16}$ x 11$^7/_8$ in. (22.7 x 30.2 cm.)
Edition: 260 Printer: George C. Miller
(1894-1965)
Reference: Czestochowski 13
Gift of Harriet Y. and John B. Turner II
(72.12.67)
Note: Published in 1939 by Associated
American Artists, New York.

166. *In The Spring*, 1939
Lithograph on stone
Image: 9 x 12 in. (22.7 x 30.4 cm.)
Edition: 260 Printer: George C. Miller
(1894-1965)
Reference: Czestochowski 14
Gift of Harriet Y. and John B. Turner II
(72.12.30)
Note: Published in 1939 by Associated
American Artists, New York.

167. *February*, 1940
Lithograph on stone
Image: 8 $^{15}/_{16}$ x 11$^7/_8$ in. (22.6 x 30 cm.)
Edition: 260 Printer: George C. Miller
(1894-1965)
Reference: Czestochowski 15
Gift of Harriet Y. and John B. Turner II
(72.12.19)
Note: Published in 1940 by Associated
American Artists, New York.

168. *Approaching Storm*, 1940
Lithograph on stone
Image: 11$^7/_8$ x 8 $^{15}/_{16}$ in. (30.1 x 22.6 cm.)
Edition: 260 Printer: George C. Miller
(1894-1965)
Reference: Czestochowski 16
Gift of Harriet Y. and John B. Turner II
(72.12.40)
Note: Published in 1940 by Associated
American Artists, New York.

169. *March*, 1940-1941.
Lithograph on stone
Image: 8 $^{15}/_{16}$ x 11$^7/_8$ in. (22.6 x 30.1 cm.)
Edition: 260 Printer: George C. Miller
(1894-1965)
Reference: Czestochowski 18
Gift of Harriet Y. and John B. Turner II
(72.12.41)
Note: Published in 1941 by Associated
American Artists, New York. Several
impressions of another state (1940) with the
image reversed have been located. This print
was not published and is catalogued as
Czestochowski 17.

170. *December Afternoon*, 1941
Lithograph on stone
Image: 9 x 11 $^{13}/_{16}$ in. (22.7 x 30.1 cm.)
Edition: 260 Printer: George C. Miller
(1894-1965)
Reference: Czestochowski 19
Gift of Harriet Y. and John B. Turner II
(72.12.14)
Note: Published in 1941 by Associated
American Artists, New York.

171. *Family Doctor*, 1941
Alternate Title: *Country Doctor*
Lithograph on stone
Image: 10 x 11 $^{15}/_{16}$ in. (25.3 x 30.2 cm.)
Edition: 300 Printer: George C. Miller
(1894-1965)
Reference: Czestochowski 20
Gift of Harriet Y. and John B. Turner II
(72.12.18)
Note: Commissioned by Abbott Laboratories,
Chicago.

GRANT WOOD

SELECTED EXHIBITION RECORDS

The exhibition records were compiled from catalogues, art museum annuals, documents in the Archives at the Cedar Rapids Museum of Art, articles in contemporary newspapers and periodicals, and inscriptions and tags found on paintings. Not all exhibition accounts are complete, especially those reconstructed from newspapers. As a result, some exhibition citations are incomplete, but are included to facilitate future research.

When available, a complete exhibition record consists of the year of exhibition followed by the exhibition or catalogue title, the sponsoring institution or group, the city and state location, the precise date, and original catalogue numbers. An abbreviated form of this information is found in the individual catalogue entries.

Note: When more than one artist was included in an exhibition, the works listed and their numbers are understood to refer to Grant Wood. Titles and dates (if any) are recorded as published.

1916¹
Exhibition of the Work of Northwestern Artists, Omaha Public Library and Museum, Omaha, Nebraska, 29 March-15 April 1916
 1. *The Shadow*

1916²
Twenty-third Annual Exhibition of the Art Students League of Chicago, Chicago, 25 April-7 May 1916
 116. *Viola Hanson*
 117. *S.W. Naville* (plaster)

1917
Annual Exhibition of Works by Northwestern Artists, St. Paul Art Institute Gallery, St. Paul, Minnesota, 1917
 190. *Ditch Digger*

1919
An Exhibition of Paintings by Grant Wood and Marvin D. Cone, The Killian Co., Picture Galleries, Cedar Rapids, 9-22 October 1919
 1. *A Sheltered Spot*
 2. *Looking for Wigglers*
 3. *In Retrospect*
 4. *Frugal Harvest*
 5. *Indian Creek*
 6. *A Modern Monolith*
 7. *Quiv'ring Aspen*
 8. *The Sexton's*
 9. *The Horse Traders*
 10. *Thirty One Seventy Eight*
 11. *Reflection*
 12. *The Old Stone Barn*
 13. *Reluctant Sun*
 14. *North Tenth Street East*
 15. *A Cubby in the Woods*
 16. *Feeding Time*
 17. *A Tree in June*
 18. *Fresh Plowed Field*
 19. *At Rest by the Road*
 20. *Sunbath*
 21. *Painted Rocks - McGregor*
 22. *Mixing Mortar*
 23. *Summer Breeze*

1920¹
An Exhibition of Paintings and Sculpture by Mrs. Charles Dieman, Marvin D. Cone, and Grant Wood, Public Library Art Gallery, Cedar Rapids Art Association, Cedar Rapids, 14-28 April 1920
 9. *Quiv'ring Aspen*
 10. *Thirty One Seventy Eight*
 11. *Old Stone Barn*
 12. *The Sexton's*
 13. *The Hermit's*
 14. *The Horse Traders*
 15. *Wigglers*
 16. *North Tenth Street East*
 17. *A Tree in June*
 18. *Fresh Plowed Field*
 19. *A Rest by the Road*
 20. *The Picture Painter*
 21. *Spring!*
 22. *Moonrise*
 23. *A Winter Eve*
 24. *The Yellow Birch*

 25. *Last Snow*
 26. *Dull Day*
 27. *January Thaw*
 28. *Cloud Shadows*
 29. *The Cut Bank*
 30. *The Kewpie Doll*
 31. *The Scarlet Tanager*
 32. *An Overmantel Decoration*
 33. *Retaliation*

1920²
An Exhibition of Paintings by Marvin D. Cone and Grant Wood, Roshek Brothers Company, Dubuque, Iowa, 3-17 May 1920
 1. *Quiv'ring Aspen*
 2. *Thirty One Seventy Eight*
 3. *Old Stone Barn*
 4. *The Sexton's*
 5. *The Hermits*
 6. *The Horse Traders*
 7. *Feeding Time*
 8. *Wigglers*
 9. *North Tenth Street East*
 10. *A Tree in June*
 11. *Fresh Plowed Field*
 12. *A Rest by the Road*
 13. *A Winter Eve*
 14. *The Yellow Birch*
 15. *Reflection*
 16. *Dull Day*
 17. *January Thaw*
 18. *A Cubby in the Woods*
 19. *Cloud Shadows*
 20. *The Cut Bank*
 21. *The Scarlet Tanager*

1920³
Paintings of Paris by Grant Wood and Marvin D. Cone, Public Library Art Gallery, Cedar Rapids, 10-20 November 1920
 1. *The Fountain of the Observatory*
 2. *Place de La Concorde*
 3. *The House of Mimi Pinson*
 4. *Avenue of Chestnuts*
 5. *Fountain of Voltaire*
 6. *The Steps, Luxembourg Gardens*
 7. *At Ville d'Avray*
 8. *The Crucifix*
 9. *Lion in the Luxembourg*
 10. *The Lost Estate*
 11. *Under the Bridge*
 12. *Reflections, Ville d'Avray*
 13. *Cafe of the Nimble Rabbit*
 14. *The Pool, Luxembourg Gardens*
 15. *St. Etienne du Mont*
 16. *Old and New*
 17. *From the Roman Amphitheatre*
 18. *The Square, Chatenay*
 19. *Pantheon at Sunset*
 20. *Corot's Pond, Ville d'Avray*
 21. *Church of Val du Grace*

 22. *The Gate in the Wall*
 23. *Docks, Montreal*
 24. *By the Fountain of the Medici's*
 25. *Pool at Versailles*
 26. *Fountain of Carpeaux*
 27. *The Thinker*
 28. *Basket Willows*
 29. *Street in Chatenay*
 30. *Harvest Fields*
 31. *Bridge at Moret*
 32. *Bronze Portrait Relief of Marvin D. Cone*

1921
Exhibition of Works by Grant Wood, Marvin Cone and Mrs. Charles Dieman, Public Library Art Gallery, Cedar Rapids Art Association, Cedar Rapids, September 1921
Exhibition list unavailable

1922
Group Exhibition of Works of *Marvin D. Cone, Grant Wood, Mrs. Charles Dieman, Miss Margaret Douglas,* Public Library Art Gallery, Cedar Rapids, 22-29 April 1922
 41. *White Oaks*
 42. *Evening Shadows*
 43. *George Greene Square*
 44. *A Phantasy Spring*
 45. *Winter Sunset*
 46. *The Cow Path*
 47. *Rustic Vista*
 48. *Fragment from Chanson Indoue* - Violin Solo by Fritz Kreisler
 49. *Adoration of the Home* - Outdoor Mural for Henry S. Ely & Co.
 50. *Lone Pine Inn* - Plans for decoration
 51. *Wall Panel in Applique* - Designed for John B. Turner & Son Executed by Nan Wood.
 52. *Photograph of Mural* - Made for National Masonic Research Building, Anamosa, Iowa.

1923
Group Exhibition of Paintings by Grant Wood and Marvin Cone, and Wrought Iron Pieces by George Keeler, Public Library Art Gallery, Cedar Rapids Art Association, Cedar Rapids, May 1923

 Van Antwerp Place
 The Thinker
 Tree Tapestry
 Pale Spring
 Lunettes: *Winter, Spring, Summer, Fall*
 Unidentified Small Canvases
 Unidentified Landscape with Creek
Complete exhibition list unavailable

1925

Exhibition of Paintings Done by Grant Wood in Europe, Public Library Art Gallery, Cedar Rapids Art Association, Cedar Rapids, May 1925
Exhibition list unavailable

1926[1]

Exhibition of Paintings by Grant Wood, Public Library Art Gallery, Cedar Rapids, 3-17 January 1926

 Iowa Autumn
 Blue Vase, Sorrento
 Egyptian Fountain, Sorrento
 Oil Jar, Sorrento
 Italian Farmyard
 Storm, Bay of Naples
 Sorrento Stairs
 Giotto's Towers
 Terraced Mountain
 Villa Gate, Versailles
 Ville d'Avray
 Fountain of the Observatory
 Breton Corner (watercolor)
 New Plaster, Paris
 La Place des Lices Brittany (watercolor)
 The Blue Door
 Cottage, Brittany
 J.G. Cherry Series
 Street in Palermo
 Road to Florence
 Fountain of the Medici
 Breton Market Place
 House with Blue Pole
 Street of the Dragon, Paris
 The Runners, Luxembourg Gardens, Paris
 Bridge at Moret
 Brittany Watercolors
 Evening, Bois de Boulogne
 Iowa Afternoon
 Fall Landscape

Complete exhibition list of approximately 65 works unavailable

1926[2]

Exhibition of Paintings by Grant Wood, Galerie Carmine, 51, Rue de Seine, Paris 1-12 July 1926

 1. *La Porte Barree—Chancelade*
 2. *Vieux Portail de l'Eglise Monacale*
 3. *Petite Chapelle de Chancelade*
 4. *Vieille Porte au Chateau Barriere*
 5. *Porte au pied de l'escalier—Perigueux*
 6. *Porte de l'Aigle Imperial—Perigueux*
 7. *Porte de l'Ancien Eveche'—Perigueux*
 8. *Porte au Blazons—Perigueux*
 9. *Porte Romaine—Perigueux*
 10. *Porte avec clous—Perigueux*
 11. *Porte Gothique—Perigueux*
 12. *Vieille porte au Coin—Perigueux*
 13. *Vieille porte du Marche—St. Emilion*
 14. *La "Petite Porte"—Musee de Cluny*
 15. *Porte Gothique (en partie) Musee de Cluny*
 16. *Porte de l'Eglise a Moret*
 17. *Porte interieure—St. Jean-le-Pauvre - Paris*
 18. *Porte du Jardin—St. Jean-le-Pauvre - Paris*
 19. *Porte de l'Eglise Collegiale—St. Emilion*
 20. *Porte de l'Eglise Monolythe—St. Emilion*
 21. *Porte du Clocher—St. Emilion*
 22. *Porte Interieure de l'Eglise Collegiale—St. Emilion*
 23. *Porte des Cloitres de l'Eglise Collegiale—St. Emilion*
 24. *Porte de l'Eglise a Marevil*
 25. *Porte du Cafe du Palais Cardinal St. Emilion*
 26. *Porte pres Vieux Puits—St. Emilion*
 27. *Vue d'une vieille porte—St. Emilion*
 28. *Porte d'une maison—Perigueux*
 29. *La Porte Marron—Paris*
 30. *Porte du Triomphe aux Tuileries—Paris*
 31. *Portes Commerciales—Paris*
 32. *Porte avec vases—St. Emilion*
 33. *La Porte Brunet—St. Emilion*
 34. *Porte avec palmes—St. Emilion*
 35. *La Porte Cadene—St. Emilion*
 36. *Porte aux Cordeliers—St. Emilion*
 37. *Chateau Barriere—Perigueux*

1926[3]

An Exhibition of Paintings by Grant Wood, Ben Knotts and Raoul Dastrac, Public Library Art Gallery, Cedar Rapids Art Association, Cedar Rapids, December 1926

St. Emilion

 1. *Porte du Cafe du Palais Cardinal**
 2. *Porte des Cloitres de l'Eglise Collegiale**
 3. *La Porte Cadene**
 4. *Vue d'une Vieille Porte**
 5. *Porte pres Vieux Puits**
 6. *Porte de l'Eglise Monolythe**
 7. *Porte avec Vases**
 8. *Painting from "Porte de l'Eglise Collegiale"**
 9. *Porte du Clocher**
 10. *Porte Interieure d'Eglise Collegiale**
 11. *Vieille Porte du Marche**
 12. *Porte aux Cordeliers**
 13. *Porte avec Palmes**
 14. *La Porte Brunet**

Paris

 15. *La Porte Marron**
 16. *La Petite Place*
 17. *Porte du Jardin*—St. Julien-le-Pauvre*
 18. *La "Petite Porte"*—Musee de Cluny*
 19. *Porte Gothique (en partie)*—Musee de Cluny*
 20. *Porte Interieure*—St. Julien-le-Pauvre*
 21. *Porte Commerciales**
 22. *Porte de l'Eglise a Moret**
 23. *Notre Dame*
 24. *Studio Window*
 25. *White Oats*
 26. *Zinnias and Delphinium*
 27. *McCloud's Run*
 28. *House in the Pines*
 29. *Elm and Hazel*
 30. *Painting from "La Porte Cadene"**
 31. *Old Thompson Place—Des Moines*
 32. *Painting from "Porte de l'Eglise Monolythe"**
 33. *The Baust House—Amana*
 34. *Glitter—Indian Creek*
 35. *Indian Creek—Midsummer*
 36. *Bowl of Flowers*
 37. *Soldiers' Monument—Des Moines*
 38. *Old Shoes*
 39. *Painting from "Porte Romaine."**
 40. *An Amana House*
 41. *The Valley*
 42. *Porte d'une Maison—St. Emilion*
 43. *House on the Mt. Vernon Road*

Perigueux

 44. *Chateau Barriere**
 45. *Porte de l'Eglise—St. Emilion**
 46. *Porte au Pied de l'Escalier**
 47. *Porte au Blazons*
 48. *Vieille Porte au Coin**
 49. *Petite Chapelle de Chancelade**
 50. *Porte Romaine**
 51. *The Brass Urn**
 52. *Porte d'une Maison**
 53. *Vieille Porte au Chateau Barriere**
 54. *Porte de l'Eglise a Marevil**
 55. *Porte avec Clous**
 56. *Porte de l'Ancien Eveche**
 57. *Porte Gothique**
 58. *La Porte Barree**

*From Paris Exhibit, July, 1926

1927[1]

Exhibition of Paintings by Grant Wood and Edgar Britton, Omaha Society of Fine Arts, Fontenelle Hotel, Omaha, Nebraska, 27 February-13 March 1927

 Glowing Moment
 The Blue Vase
 17th Century Doorway (Perigueux)
 Door at the Foot of the Stairs (Perigueux)
 The Grand Cascade, Bois de Bologne
 Little Door (Clueny)
 Inner Door (St. Emilion)
 Mr. Marshall's Amana
 The Windmill
 Sundrenched
 Patchwork Quilts
 Leaf Pattern
 Indian Village
 Sun-Tipped
 Corn Shocks (several)

Several paintings done with palette knife
Complete exhibition list unavailable

1927[2]

Exhibition of Paintings by Grant Wood, Chieftain Hotel, Council Bluffs, Iowa, 19-27 March 1927 (sponsored by the Council Bluffs Chapter of the DAR)

 Glowing Moment
 The Blue Vase
 17th Century Doorway (Perigueux)
 Door at the Foot of the Stairs (Perigueux)
 The Grand Cascade, Bois de Bologne
 Little Door (Clueny)
 Inner Door (St. Emilion)
 Mr. Marshall's Amana
 The Windmill
 Sundrenched
 Patchwork Quilts
 Leaf Pattern
 Indian Village
 Sun-Tipped
 Corn Shocks (several)

Several paintings done with palette knife
Complete exhibition list unavailable

1927[3]

Exhibition of Paintings by Grant Wood and Marvin D. Cone, Duluth Public Library, Duluth, Minnesota, 1-15 May 1927
Exhibition list unavailable

1927[4]

Exhibition of Paintings by Grant Wood and Marvin D. Cone, Walker Art Gallery, Minneapolis, 15 May 1927
Exhibition list unavailable

1927[5]

Exhibition of Paintings by Grant Wood and Marvin Cone, Cone Studio and Williston Hall, Coe College, Cedar Rapids, November 1927
Exhibition list unavailable

1928

Exhibition of Paintings by Grant Wood and Marvin D. Cone, Duluth Public Library, Duluth, Minnesota, September-October 1928
Exhibition list unavailable

1929[1]

Paintings by Grant Wood, Cedar Rapids Art Association, Cedar Rapids, February 1929

 1. *The Shadow*
 2. *Blue House—Munich*
 3. *Red and Yellow House*
 4. *Green and Orange House*
 5. *Pea Green House*
 6. *Red Bedding*
 7. *A Study in Angles*
 8. *36 Damm St.—Munich*
 9. *48 Damm St.—Munich*
 10. *Crucifix*
 11. *House by the Church—Nuremberg*
 12. *Market Place—Nuremberg*
 13. *Latin Quarter—Paris*
 14. *Church Door—St. Emilion*
 15. *Windmill*
 16. *Yellow Roses*
 17. *Coxcomb*
 18. *The Painted Screen*
 19. *Calendulas*
 20. *Wild Strawberries*
 21. *Loch Vale—Estes Park*
 22. *Portrait of John B. Turner*
 23. *Portrait of Master Gordon Fennell*
 24. *Sally Jane*

1929[2]

Exhibition of Paintings from the Permanent Collection of the Cedar Rapids Art Association, Public Library Art Gallery, Cedar Rapids, October 1929

 1. *Doorway*

1929[3]

Forty-second American Exhibition of Paintings and Sculpture, Art Institute of Chicago, Chicago, 24 October-8 December 1929

 1. *Woman with Plant[s]*

1930

Eighteenth Annual Exhibition of Selected Paintings by Contemporary American Artists, Toledo Museum of Art, Toledo, Ohio, 1 June-31 August 1930

 69. *Woman with Plant[s]*

1931[1]

126th Annual Exhibition, Pennsylvania Academy of the Fine Arts, Philadelphia, 25 January-15 March 1931

 261. *Woman with Plant[s]*
 340. *Appraisal*

1931[2]

Dubuque Artists' 1931 Exhibition and Loan Exhibition of the Iowa Artists' Club, Dubuque Art Association, Gallery Public Library, Dubuque, Iowa, 21 March-29 March 1931

 50. *House and Cornstalks*
 51. *Cornstalks*
 52. *Brook*

1933

Exhibition of Paintings by Grant Wood, Increase Robinson Gallery, 40 North Michigan Avenue, Chicago, June 1933

 1. *Stone City*
 2. *Victorian Survival*
 3. *Woman with Plant[s]*
 4. *Young Corn*
 5. *Arnold Comes of Age*
 6. *Labor Day*
 7. *Daughters of Revolution*
 8. *Fall Plowing*
 9. *Overmantel Decoration*
 10. *The Midnight Ride of Paul Revere*
 11. *The Birthplace of Herbert Hoover*
 12. *Portrait of Nan*
 13. *Portrait of Susan Shaffer*
 14. *Portrait of Mary Shaffer*
 15. *John B. Turner, Pioneer*

1935[1]

Catalogue of a Loan Exhibition of Drawings and Paintings by Grant Wood, The Lakeside Press Galleries, Chicago, February-March, 1935

1. *Currants*, 1907
2. *The Dutchman's*, 1916
3. *Feeding the Chickens*, 1917
4. *The Horse Trader's*, 1918
5. *The Old Sexton's Place*, 1919
6. *Misty Day, Paris*, 1920
7. *Square at Chatenay*, 1920
8. *Round House, Paris*, 1920
9. *Gardens, Versailles*, 1920
10. *The Cow Path*, 1920
11. *Breton Market*, 1924
12. *Italian Farmyard*, 1924
13. *The Blue Door*, 1924
14. *Fountain of the Medici*, 1924
15. *Blue Vase, Sorrento*, 1924
16. *Oil Jar, Sorrento*, 1924
17. *Cottage, Brittany*, 1925
18. *Street in Palermo*, 1925
19. *Old Shoes*, 1926
20. *Autumn*, 1926
21. *Yellow Doorway, St. Emilion*, 1927
22. *Roman Arch*, 1927
23. *Door at the Foot of the Stairs - Perigueux*, 1927
24. *Quilts*, 1928
25. *Midsummer*, 1928
26. *Red Bedding*, 1929
27. *Yellow House, Munich*, 1929
28. *Black Barn*, 1929
29. *Sunflower*, 1929
30. *Woman with Plants[s]*, 1929
31. *John B. Turner, Pioneer*, 1930
32. *Stone City*, 1930
33. *American Gothic*, 1930
34. *Overmantel Decoration*, 1930
35. *Portrait of Mary Van Vechten Shaffer*, 1930
36. *Portrait of Susan Angevine Shaffer*, 1930
37. *Sketch*, 1931
38. *Arnold Comes of Age*, 1931
39. *Midnight Ride of Paul Revere*, 1931
40. *Portrait of Melvin Blumberg*, 1931
41. *Birth-Place of Herbert Hoover*, 1931
42. *Birth-Place of Herbert Hoover (drawing)*, 1931
43. *Victorian Survival*, 1931
44. *Young Corn*, 1931
45. *Fall Plowing*, 1931
46. *Daughters of Revolution*, 1932
47. *Portrait of Mrs. Donald MacMurray*, 1932
48-49-50-51. Four Drawings for Mural, *Fruits of Iowa*, 1932
52. *Arbor Day*, 1932
53. *Spring Landscape*, 1932
54. *Race Horse (drawing)*, 1933
55. *Draft Horse (drawing)*, 1933
56. *Adolescence (drawing)*, 1933
57-58-59-60-61. Five Drawings, *History of Penmanship*, 1933
62. *Portrait of Nan*, 1933
63. *Dinner for Threshers*, 1934
64. *Dinner for Threshers (drawing)*, 1934
65-66. *Dinner for Threshers (drawing)*, 1934
67. *Death on Ridge Road (drawing)*, 1934

1935[2]

An Exhibition of Paintings and Drawings by Grant Wood, Ferargil Galleries, New York City, March-April 1935

1. *Currants*
2. *Feeding the Chickens*
3. *The Horse Traders*
4. *Misty Day, Paris*
5. *Breton Market*
6. *Italian Farmyard*
7. *The Blue Door*
8. *Fountain of the Medici*

9. *Oil Jar, Sorrento*
10. *Street in Palermo*
11. *Old Shoes*
12. *Yellow Doorway, St. Emilion*
13. *Woman with Plants[s]*
14. *Stone City*
15. *American Gothic*
16. *Portrait of Mary Van Vechten Shaffer*
17. *Portrait of Susan Angevine Shaffer*
18. *Arnold Comes of Age*
19. *Midnight Ride of Paul Revere*
20. *Birth-Place of Herbert Hoover*
21. *Birth-Place of Herbert Hoover (drawing)*
22. *Young Corn*
23. *Fall Plowing*
24-25-26-27. Four Drawings for Mural, *Fruits of Iowa*
28. *Arbor Day*
29. *Spring Landscape*
30. *Race Horse (drawing)*
31. *Draft Horse (drawing)*
32. *Adolescence (drawing)*
33. *Portrait of Nan*
34. *Dinner for Threshers*
35. *Dinner for Threshers (drawing)*
36. *Death on Ridge Road (drawing)*
37. *Plowing on Sunday (drawing)*
38. *O, Chautauqua (drawing)*
39. *Death on Ridge Road*
40. *The Assumption (drawing)*
41. *Spotted Man*
42. *French Doorway*

1936

Decorative Drawings by Grant Wood, Walker Galleries, 108 East 57th Street, New York City, 14 April-4 May 1936
From *Farm on the Hill*, by Madeline Darrough Horn

1. *Saturday Night*
2. *The Hired Girl*
3. *The Hired Man*
4. *Spilt Milk*
5. *Mending*
6. *Popcorn for Grandpa*
7. *Churning*
8. *Pets on the Farm*

Twelve Humorous Drawings

The Early Bird
Hero Worship
Envy
Joy Ride
Young Calf
The Escape
Surprise
Insect Suicide
Profane Setting Hen
Bold Bug
Lucky Bunny
Competition

1939

Exhibition of Paintings by Grant Wood and Marvin D. Cone, Fine Arts Festival, Iowa Union Lounge, University of Iowa, Iowa City, 16-23 July 1939

19. *Woman with Plant[s]*
20. *John B. Turner, Pioneer*
21. *Old Shoes*
22. *Stone City*
23. *American Gothic*
24. *Arnold Comes of Age*
25. *Midnight Ride of Paul Revere*
26. *Birthplace of Herbert Hoover*
27. *Victorian Survival*
28. *Young Corn*
29. *Fall Plowing*
30. *Portrait of Nan*

1942

Memorial Exhibition of Paintings and Drawings by Grant Wood, included in the *Fifty-third Annual Exhibition of American Paintings and Sculpture*, Art Institute of Chicago, 29 October-10 December 1942
Oils

1. *Adolescence*, 1940
2. *American Gothic*, 1930
3. *Arbor Day*, 1932
4. *Arnold Comes of Age*, 1930
5. *Birthplace of Herbert Hoover*, 1931
6. *Calendulas*, 1929
7. *Church Door, St. Emilion*, 1927
8. *Daughters of Revolution*, 1932
9. *Death on Ridge Road*, 1935
10. *Dinner for Threshers*, 1934
11. *Fall Plowing*, 1931
12. *Fountain of the Observatory*, 1920
13. *Hayfield*, 1939
14. *January*, 1940
15. *John B. Turner, Pioneer*, 1930
16. *Midnight Ride of Paul Revere*, 1931
17. *Near Sundown*, 1933
18. *The New Road*, 1939
19. *Old Shoes*, 1926
20. *Parson Weems' Fable*, 1939
21. *Portrait of Nan*, 1938
22. *Self Portrait (unfinished)*, 1932
23. *Spotted Man*, 1924
24. *Spring in Town*, 1941
25. *Spring Landscape*, 1932
26. *Stone City*, 1930
27. *Victorian Survival*, 1931
28. *Woman with Plant[s]*, 1929
29. *Young Corn*, 1931

Watercolors

30. *Currants*, 1907
31. *Fruit*, 1940
32. *Vegetables*, 1940
33. *Tame Flowers*, 1940
34. *Wild Flowers*, 1940

Drawings

35. *Adolescence (study)*, 1933
36. *Birthplace of Herbert Hoover (study)*, 1931
37. *December Afternoon*, 1941
38. *Draft Horse*, 1933
39. *Early March*, 1940
40. *February*, 1940
41. *Fertility*, 1939
42. *Good Influence*, 1936
43. *Honorary Degree*, 1935
44. *American Gothic*, 1930
45. *Race Horse*, 1933
46. *Return from Bohemia*, 1935
47. *Seed Time and Harvest*, 1937
48. *Spring in the Country*, 1941

1954

Reality and Fantasy 1900-1954, Walker Art Center, Minneapolis, 23 May-2 July 1954
175. *Young Corn*
176. *Dinner for Threshers*, Sections 1 and 3 (drawings)

1955

Thirty Years of Grant Wood Paintings, Metal Work, Bas Reliefs, Dubuque Public Library, Dubuque, Iowa, 15-23 February 1955 (presented by the Dubuque Art Association)

1. *After the Swim*
2. *Bust of de Musset—Luxembourg Gardens*
3. *Port de Bourgogne*
4. *Blue Vase*
5. *Along Cinder Path*

6. *Bird House*
7. *Door at the Foot of the Stairs—Perigueux*
8. *Stone City*
9. *American Gothic*
10. *The Appraisal*
11. *Victorian Survival*
12. *Young Corn*
13. *Wheat Shocks and Corn*
14. *Tree Planting*
15. *Adolescence*

1957

Grant Wood and the American Scene, Davenport Municipal Art Gallery, Davenport, Iowa, 3-24 February 1957
Paintings

1. *Bust of De Mussett, Luxembourg Garden*, 1920
2. *The Bridge*, 1920
3. *Blue Vase*, 1924
4. *Door at the Foot of the Stairs, Perigueux*, 1927
5. *American Gothic*, 1930
6. *Stone City*, 1930
7. *The Appraisal*, 1931
8. *Young Corn*, 1931
9. *A Self-Portrait*, 1932
10. *Wheat Shocks and Corn*, 1932
11. *The Creek*, 1934
12. *Adolescence*, 1940
13. *Spring in Town*, 1941
14. *Iowa Corn Field*, 1941

Drawings

15. *Tree Planting*, 1933
16. *Portrait of Former Vice President Henry Wallace*, 1940
17. *Daughters of Revolution*, 1932
18. *Dinner for Threshers*, 1934
19. *December Afternoon*, 1941

Idea sketches for the book, *Farm on the Hill*, by Madeline Darrough Horn

20. *Animals*
21. *Hired Girl*
22. *Grandma*
23. *Grandpa*

Lithographs

24. *July 15*
25. *In the Spring*
26. *Sultry Night*
27. *Shrine Quartet*
28. *Honorary Degree*
29. *Midnight Alarm*
30. *March*
31. *Basket of Fruit*
32. *Wild Flowers*
33. *Tame Flowers*

1959

Grant Wood, 1891-1942—A Retrospective Exhibition, University of Kansas Museum of Art, Lawrence, Kansas, 12 April-30 May 1959

1. *Currants*, 1907
2. *Quiv'ring Aspen*, 1917
3. *The Old Sexton's Place*, 1919
4. *Malnutrition: Portrait of Marvin Cone*, 1920
5. *Corner in Montmartre*, 1920
6. *Fountain in the Luxembourg Gardens*, 1920
7. *Fountain of the Medici*, 1924
8. *Italian Farmyard*, 1924
9. *Spotted Man*, 1924
10. *Ten Tons of Accuracy*, 1925
11. *Turret Lathe Operator*, 1925
12. *The Coppersmith*, 1925
13. *The Old J.G. Cherry Company Plant*, 1925
14. *Old Shoes*, 1926

15. *Church Door, St. Emilion*, 1927
16. *Church Doorway* (sketch for #15)
17. *Charles Manson, President of the Chamber of Commerce, as Bacchus*, 1928
18. *Black Barn*, 1929
19. *Truck Garden, Moret*, 1929
20. *Original Sketch for American Gothic*, 1929-30
21. *Portrait of Susan Angevine Shaffer*, 1930
22. *Portrait of Mary Van Vechten Shaffer*, 1930
23. *John B. Turner, Pioneer*, 1930
24. *Stone City*, 1930
25. *Stone City* (sketch for #24), 1930
26. *Iowa Gothic House*, 1930
27. *Fall Plowing*, 1931
28. *Young Corn*, 1931
29. *Self-Portrait* (unfinished), 1932
30. *Daughters of Revolution* (preliminary drawing), 1932
31. *Near Sundown*, 1933
32. *Tree Planting* (drawing), 1933
33. *Race Horse* (drawing), 1933
34. *Draft Horse* (drawing), 1933
35. *Dinner for Threshers* (drawing), 1934
36. *Study for Dinner for Threshers: Section No. 1* (oil sketch), 1934
37. *Study for Dinner for Threshers: Section No. 2* (oil sketch), 1934
38. *Return from Bohemia* (pastel), 1935
39. *Portrait of Nan*, 1936
40. *Spring Turning*, 1936
41. *Spring Turning* (preliminary drawing for #40), 1936
42. *Honorary Degree* (drawing), 1936
43. *Animals* (Illustration for *Farm on the Hill*)
44. *Sentimental Yearner*, 1936 (Illustration for Limited Editions, *Main Street*)
45. *Practical Idealist*, 1936 (Illustration for Limited Editions, Main Street)
46. *Plowing on Sunday* (drawing), 1938
47. *Parson Weems' Fable*, 1939
48. *In the Spring* (drawing), 1939
49. *Adolescence*, 1940
50. *Portrait of Henry Wallace*, 1940
51. *Spring in Town*, 1941
52. *Iowa Cornfield*, 1941
53. *February* (drawing), 1941
54. *March* (drawing), 1941

1972

Grant Wood—The Graphic Art, Cedar Rapids Art Center, Cedar Rapids, 19 March-16 April 1972
Drawings
1. *The Gardeners House*
2. *Sketch of a Bearded Man*
3. *Societies*
4. *Men of the Class*
5. *The Killian Co. Graphaphone is much appreciated*
6. *Captain George C. Proud*
7. *Higley's Block*
8. *The Old Fire Engine*
9. *Old Steam Motor*
10. *The Turner Mortuary*
11. *The Entrance Hall Turner's Mortuary*
Drawings for the Cedar Rapids Veteran's Memorial Coliseum Stained Glass Window, 1927-28
12. *Civil War Soldier*
13. *Mexican War Soldier*
14. *Soldier, War of 1812*
15. *Charles Manson, President of the Chamber of Commerce, as Bacchus*
16. *Saturday Night Bath*
17. *Sketch for a proposed painting of a preacher*

18. *Sketch for a proposed painting of a preacher*
19. *Birthplace of Herbert Hoover*
20. *Daughters of Revolution*
Drawings for the Mural *Fruits of Iowa*, 1932
21. *Boy with Watermelon*
22. *Girl with Stringbeans*
23. *Hired Hand Milking Cow*
24. *Woman Feeding Poultry*
25. *Race Horse*
26. *Draft Horse*
From *The Art of Writing*, for the A.N. Palmer Co., 1933
27. *Stylus and Wax Tablet of the Greeks*
28. *Picture Writing of the Stone Age*
29. *Brush of the Medieval Monk*
30. *Modern Method of Writing*
31. *Colonial Penman*
32. *John B. Northcott*
33. *Tree Planting*
34. *Dinner for Threshers*
35. *O, Chautauqua*
36. *Return from Bohemia*
Drawings for *Farm on the Hill*, by Madeline Darrough Horn.
37. *Animals*
38. *Hired Girl with Apples*
39. *Grandma Mending*
40. *Grandpa with Popcorn*
41. *Cat and Mouse*
42. *Bird and Worm*
43. *Duck and Duckling*
44. *Rooster and Chick*
45. *Calf and Thistle*
46. *Horse and Beetle*
47. *Bird and Bug*
48. *The Good Influence*
49. *Plowing on Sunday*
50. *January*
51. *In the Spring*
52. *Approaching Storm*
53. *Family Saying Grace*
54. *World War II Allied Aid Poster*
55. *Spring in the Country*
56. *December Afternoon*
Sketches from Wood's sketchpad (c. 1941) outlining ideas for a political painting about Chamberlain and Hitler. The painting was never made.
57. *The Wolf and the Lamb*
58. *Mr. Chamberlain*
59. *The Wolf and the Lamb*
60. *The Wolf and the Lamb*
61. *The Wolf and the Lamb, Hitler and Chamberlain*
62. *The Lion and the Mouse*

Prints
63. *Cross Eyed Man*
64. *Sultry Night*
65. *January*
66. *Tree Planting Group*
67. *Seedtime and Harvest*
68. *Honorary Degree*
69. *Fruits*
70. *Vegetables*
71. *Tame Flowers*
72. *Wild Flowers*
73. *Midnight Alarm*
74. *Shrine Quartet*
75. *In the Spring*
76. *March*
77. *July Fifteenth*
78. *Fertility*
79. *Approaching Storm*
80. *February*
81. *December Afternoon*
82. *Family Doctor*

1973

The Grant Wood Collection, Cedar Rapids Art Center, Cedar Rapids Art Association, Cedar Rapids, February 1973
Note: Dates are those assigned in 1973 catalogue only.
Paintings
1. *Cat with Fox Rug*, 1905
2. *Old House with Tree Shadows*, 1916
3. *Feeding the Chickens*, 1917
4. *Old Sexton's Place*, 1919
5. *The Horsetraders*, 1918
6. *Yellow House and Learning Tree*, 1919
7. *Old Stone Barn*, 1919
8. *Fall Landscape*, 1919
9. *Twilight - Triptych*, 1919
10. *Pine Tree*, 1920
11. *Leaning Trees, Paris*, 1920
12. *Paris Street Scene with Cafe*, 1920
13. *Tuileries Gate and Obelisk*, 1920
14. *Square at Chatenay*, 1920
15. *Fountain of Voltaire, Chatenay*, 1920
16. *Gate of the Old Chateau, Paris*, 1920
17. *A Corner of Montmartre, Paris*, 1920
18. *Rear of the Pantheon, Paris*, 1920
19. *The Pantheon*, 1920
20. *Church of Saint Genevieve*, 1920
21. *Corner Cafe, Paris*, 1920
22. *Misty Day, Fountain of the Observatory, Paris*, 1920
23. *Fountain in the Luxembourg Gardens, Paris*, 1920
24. *The Gate in Wall*, 1920
25. *Ville d'Avray, Paris*, 1920
26. *The Runners, Luxembourg Gardens, Paris*, 1920
27. *Landscape with Tree*, 1920
28. *Landscape near Indian Creeks*, 1920-21
29. *The Cow Path*, 1922
30. *Winter*, 1922-1925
31. *Spring*, 1922-1925
32. *Summer*, 1922-1925
33. *Autumn*, 1922-1925
34. *Bridge at Moret*, 1924
35. *Fountain at Versailles*, 1924
36. *Italian Farmyard*, 1924
37. *Portal with Blue Door, Italy*, 1924
38. *Balcony with Banners*, 1924
39. *Fountain of the Medici, Paris*, 1924
40. *House with Blue Pole*, 1924
41. *Street of the Dragon, Paris*, 1925
42. *The Old J.G. Cherry Plant*, 1925
43. *Ten Tons of Accuracy*, 1925
44. *The Shop Inspector*, 1925
45. *Turret Lathe Operator*, 1925
46. *The Coppersmith*, 1925
47. *The Coil Welder*, 1925
48. *The Painter*, 1925
49. *Old Shoes*, 1926
50. *Yellow Doorway, St. Emilion*, 1927
51. *Door at the Foot of the Stair*, 1927
52. *Indian Creek*, 1929
53. *John B. Turner—Pioneer*, 1928-1930
54. *Woman with Plants*, 1929
55. *Young Corn*, 1931
56. *Trees Hill*, 1933

Drawings
57. *Iris*, 1903-1904
58. *Daffodils*, 1903-1904
59. *Beets*, 1903-1904
60. *Leghorn*, 1903-1904
61. *Blue Bird*, 1903-1904
62. *Return of Columbus from America—March 15, 1493*, 1903-1904
63. *Boy in Raincoat*, 1903-1904

64. *Nan Wood's Book Plate*, 1903-1904
65. *Breton Market*, 1924
66. *Turner Mortuary, Front View, Wall and Gate*, 1924
67. *Turner Mortuary, Gate and Columns*, 1924
68. *Turner Mortuary, Gate and Columns*, 1924
69. *Turner Mortuary, Front Portico Columns*, 1924
70. *Turner Mortuary, Table Lamp and Two Chairs*, 1924
71. *Turner Mortuary, Fireplace, Round Room*, 1924
72. *Turner Mortuary, Fireplace, Reception Room*, 1924
73. *Turner Mortuary, Gatehouse*, 1924
74. *Turner Mortuary, Birdhouse*
75. *Turner Mortuary, Facade from the East*, 1924
76. *Turner Mortuary, View from the Southwest*, 1924
77. *Turner Mortuary, Open Gate and Tree*, 1924
78. *Turner Mortuary, Stairs and Balustrade*, 1924
79. *Higley Block, 1863*, 1924
80. *Old Steam Motor, 1880-1892*, 1924
81. *Old Fire Engine, 1886*, 1924
82. *Race Horse*, 1933
83. *Draft Horse*, 1933
84. *The Early Bird*, 1936
85. *Young Calf*, 1936
86. *The Escape*, 1936
87. *Insect Suicide*, 1936
88. *Bold Bug*, 1936
89. *Joy Ride*, 1936
90. *Hero Worship*, 1936
91. *Tree Planting*, 1933

Prints
92. *Sultry Night*, 1937
93. *January*, 1937
94. *Seedtime and Harvest*, 1937
95. *Honorary Degree*, 1937
96. *Fruits*, 1938
97. *Vegetables*, 1938
98. *Tame Flowers*, 1938
99. *Wild Flowers*, 1938
100. *Midnight Alarm*, 1939
101. *Shrine Quartet*, 1939
102. *In the Spring*, 1939
103. *March*, 1939
104. *July Fifteenth*, 1939
105. *Fertility*, 1939
106. *Approaching Storm*, 1940
107. *February*, 1941
108. *December Afternoon*, 1941
109. *Family Doctor*, 1941
110. *Blitzkrieg!*, 1940

Three Dimensional Objects
111. *Bas-relief Plaque of Marvin Cone*, 1920
112. *Lilies of the Alley (with clothespin)*, 1922-1925
113. *Lilies of the Alley (with shoehorn)*,
114. *Percy Heavy Thinker (mask)*, 1922-1925
115. *The Mourner's Bench*, 1923
116. *Star Screen*, 1924
117. *Pair of Overall-covered Doors*, 1924
118. *Pair of Candleholders*, 1924
119. *Single Candleholder*, 1924
120. *Door to Grant Wood's Studio*, 1924
121. *Firescreen Ornaments*, undated
122. *Self-portrait (caricature)*, undated
123. *Plaque of Charles B. Keeler*, undated
124. *Life Membership Plaque—Cedar Rapids Art Association*, 1917
125. *Bas-relief of Draped Classical Figure*, undated

1981

John Steuart Curry and Grant Wood: A Portrait of Rural America, Cedar Rapids Art Center, Cedar Rapids, 10 January-28 February 1981; Wichita State University, Wichita, Kansas, 11-20 March 1981; Museum of Art and Archaeology, University of Missouri, Columbia, 4-30 April 1981.

97. *Old Sexton's Place*, 1919
98. *"Malnutrition": Portrait of Marvin Cone*, 1919
99. *The Runners: Luxembourg Gardens, Paris*, 1920
100. *Adoration of the Home*, 1921
101. *Fanciful Depiction of Roundhouse and Power Plant*, 1920-1923
102. *Autumn*, 1922-1925
103. *Winter*, 1922-1925
104. *Spring*, 1922-1925
105. *Summer*, 1922-1925
106. *Turner Mortuary, View from the Southwest*, 1924
107. *The Old J.G. Cherry Plant*, 1925
108. *Ten Tons of Accuracy*, 1925
109. *Door at the Foot of the Stair*, 1927
110. *Indian Creek, Autumn*, 1928
111. *Vase of Zinnias*, 1928-1929
112. *Black Barn*, 1929
113. *Woman with Plant[s]*, 1929
114. *John B. Turner: Iowa Pioneer*, 1928-1930
115. *Arnold Comes of Age*, 1930*
116. *Appraisal*, 1931
117. *Fall Plowing* (sketch), 1931*
118. *Fall Plowing*, 1931
119. *The Birthplace of Herbert Hoover* (sketch), 1931
120. *The First Three Degrees of Free Masonry*, 1931*
121. *Self-Portrait* (sketch), 1932*
122. *Spring Plowing*, 1932*
123. *Draft Horse*, 1933
124. *Hired Hand Milking Cow*, 1931-1932
125. *Fruits of Iowa: Farmer's Daughter*, 1932
126. *Farmer's Daughter*, 1931-1932
127. *Fruits of Iowa: Farmer's Wife with Chickens*, 1932
128. *Farmer's Wife with Chickens*, 1932
129. *Fruits of Iowa: Farmer's Son*, 1932
130. *Trees and Hill*, 1933
131. *Near Sundown*, 1933
132. *Dinner for Threshers* (left section), 1933*
133. *Dinner for Threshers* (right section), 1933*
134. *Adolescence* (sketch), 1933-1934
135. *Return from Bohemia*, 1935
136. *Death on the Ridge Road*, 1935
137. *Grandma Mending*, 1935
138. *Grandpa Eating Popcorn*, 1935
139. *The Early Bird*, 1936
140. *Young Calf*, 1936
141. *The Escape*, 1936
142. *Insect Suicide*, 1936
143. *Bold Bug*, 1936
144. *Spring Turning* (sketch), 1936
145. *Study for Breaking the Prairie*, 1935-1939*
146. *Good Influence*, 1937
147. *Plowing on Sunday*, 1938
148. *New Road*, 1939
149. *Haying*, 1939
150. *Spring in Town* (sketch), 1936
151. *Spring in the Country*, 1941
152. *Iowa Cornfield*, 1941*
153. *Last Sketch*, 1941*
154. *Cross-Eyed Man*, 1920
155. *A Kiss for Cinderella*, 1931
156. *Tree-Planting Group*, 1932
157. *Tree-Planting Group* (drawing), 1933
158. *Seed Time and Harvest*, 1937
159. *January* (lithograph), 1937
160. *January* (drawing), 1938
161. *Sultry Night*, 1937
162. *Honorary Degree*, 1937
163. *Fruits*, 1938
164. *Tame Flowers*, 1938
165. *Vegetables*, 1938
166. *Wild Flowers*, 1938
167. *Fertility*, 1939
168. *Fertility* (charcoal), 1939
169. *In the Spring*, 1939
170. *In the Spring* (pencil), 1939
171. *July Fifteenth*, 1939
172. *Midnight Alarm*, 1939
173. *Shriners' Quartet*, 1939
174. *Approaching Storm*, 1940
175. *March*, 1941
176. *February*, 1941
177. *December Afternoon*, 1941
178. *December Afternoon* (charcoal), 1941
179. *Family Doctor*, 1941

*Not in exhibition

1983

Grant Wood: The Regionalist Vision, Whitney Museum of American Art, New York City, 16 June-4 September 1983; Minneapolis Institute of Arts, Minneapolis, 25 September-1 January 1984; Art Institute of Chicago, 21 January-15 April 1984; M.H. DeYoung Memorial Museum, San Francisco, 12 May-12 August 1984

1. *Quiv'ring Aspen*, 1917
2. *Old Sexton's Place*, 1919
3. *Fountain of Voltaire, Chatenay*, 1920
4. *Cedar Rapids, or Adoration of the Home*, 1921-22
5. *Lunette of Summer*, 1922-25
6. *Lunette of Autumn*, 1922-25
7. *The Runners, Luxembourg Gardens, Paris*, 1924
8. *Truck Garden, Moret*, 1924
9. *Yellow Doorway, St. Emilion*, 1924
10. *Lilies of the Alley*, 1925
11. *The Old J.G. Cherry Plant*, 1925
12. *Grandma Wood's House*, 1926
13. *Old Shoes*, 1926
14. *Study for Memorial Window*, 1927
15. *House in the Woods*, 1928
16. *Cornshocks*, 1928
17. *Calendulas*, 1928-29
18. *Portrait of John B. Turner, Pioneer*, 1928-30
19. *Woman with Plants[s]*, 1929
20. *Portrait of Mary Van Vechten Shaffer*, 1930
21. *Portrait of Susan Angevine Shaffer*, 1930
22. *Stone City*, 1930
23. *Sketch for American Gothic*, 1930
24. *Study for American Gothic*, 1930
25. *American Gothic*, 1930
26. *Overmantel Decoration*, 1930
27. *Appraisal*, 1931
28. *Victorian Survival*, 1931
29. *Midnight Ride of Paul Revere*, 1931
30. *Drawing for The Birthplace of Herbert Hoover*, 1931
31. *The Birthplace of Herbert Hoover*, 1931
32. *Plaid Sweater*, 1931
33. *Fall Plowing*, 1931
34. *Young Corn*, 1931
35. *Arbor Day*, 1932
36. *Daughters of Revolution*, 1932

Fruits of Iowa Series
37. *Farmer with Pigs*, 1932
38. *Boy Milking Cow*, 1932
39. *Farmer's Wife with Chickens*, 1932
40. *Farm Landscape*, 1932
41. *Portrait of Nan*, 1933
42. *Drawing for Dinner for Threshers*, 1934

43. *Dinner for Threshers*, 1934
44. *Drawing for Death on the Ridge Road*, 1935
45. *Death on the Ridge Road*, 1935
46. *Return from Bohemia*, 1935

Drawings for *Farm on the Hill*
47. *Grandpa Eating Popcorn*, 1935
48. *Grandma Mending*, 1935
49. *Study for Breaking the Prairie*, 1935-39
50. *Spring Turning*, 1936

Illustrations for *Main Street*
51. *The Good Influence*, 1936-1937
52. *Booster*, 1936-37
53. *Sentimental Yearner*, 1936-37
54. *The Radical*, 1936-37
55. *Village Slums*, 1936-37
56. *The Perfectionist*, 1936-37
57. *Main Street Mansion*, 1936-37
58. *Spring Plowing* (Drawing for Textile Design), 1939
59. *Cartoon for Parson Weems' Fable*, 1939
60. *Parson Weems' Fable*, 1939
61. *Adolescence*, 1940
62. *January*, 1940
63. *Sentimental Ballad*, 1940
64. *Self-Portrait*, 1932-41
65. *Spring in Town*, 1941

Prints
66. *Tree Planting Group*, 1937 (W-3)
67. *Seed Time And Harvest*, 1937 (W-4)
68. *January*, 1937 (W-5)
69. *Sultry Night*, 1937 (W-6)
70. *Honorary Degree*, 1937 (W-7)
71. *Fruits*, 1938 (W-8)
72. *Tame Flowers*, 1938 (W-9)
73. *Vegetables*, 1938 (W-10)
74. *Wild Flowers*, 1938 (W-11)
75. *Fertility*, 1939 (W-12)
76. *In The Spring*, 1939 (W-13)
77. *July Fifteenth*, 1939 (W-14)
78. *Midnight Alarm*, 1939 (W-15)
79. *Shrine Quartet*, 1939 (W-16)
80. *Approaching Storm*, 1940 (W-17)
81. *March*, 1941 (W-18)
82. *February*, 1941 (W-19)
83. *December Afternoon*, 1941 (W-20)
84. *Family Doctor*, 1941 (W-21)

Note: Numbers in parentheses refer to the catalogue raisonne of graphics of Grant Wood listed by Joseph S. Czestochowski in *John Steuart Curry & Grant Wood: A Portrait of Rural America*. (Columbia and London: University of Missouri Press, 1981).

1984

Grant Wood and Marvin Cone: An American Tradition, Lakeview Museum of Arts and Sciences, Peoria, Illinois, 2 December-30 December 1984; Dayton Art Institute, Dayton, Ohio, 19 January-17 March 1985; Tampa Museum, Tampa, Florida, 1 May-1 July 1985; Colorado Springs Fine Arts Center, Colorado Springs, Colorado, 14 July-31 August 1985; Grand Rapids Museum of Art, Grand Rapids, Michigan, 15 September-29 October 1985; Tucson Museum of Art, Tucson, Arizona, 15 November-2 January 1986; Philbrook Art Center, Tulsa, Oklahoma, 22 January-12 March 1986; Bowdoin College Museum of Art, Brunswick, Maine, 30 March-25 May 1986; Museum of Fine Arts, St. Petersburg, Florida, 8 June-20 July 1986; Hunter Museum of Art, Chattanooga, Tennessee, 3 August-14 September 1986; Beaumont Art

Museum, Beaumont, Texas, 26 September-9 November 1986; Norton Gallery and School of Art, West Palm Beach, Florida, 23 November-4 January 1987; Cummer Gallery of Art, Jacksonville, Florida, 18 January-1 March 1987; Springfield Art Museum, Springfield, Missouri, 15 March-26 April 1987; Arkansas Art Center, Little Rock, Arkansas, 10 May - 21 June, 1987; Bergstrom Mahler Museum, Neenah, Wisconsin, 1 July-15 August 1987; Amarillo Art Center, Amarillo, Texas, 1 September - 1 November 1987; University of New Mexico, Fine Arts Center, Albuquerque, New Mexico, 15 November - 31 December 1987.

1. *Iris*, 1903-04
2. *Return of Columbus from America*, 1903-04
3. *Necklace*, 1914-15
4. *Old Sexton's Place*, 1919
5. *Yellow House and Leaning Tree*, 1919
6. *Pine Trees*, 1920
7. *Ville d'Avray, Paris*, 1920
8. *Fountain of Voltaire, Chatenay*, 1920
9. *Adoration of the Home*, 1921-22
10. *Lunette of Summer*, 1922-25
11. *Lunette of Autumn*, 1922-25
12. *Yellow Doorway, St. Emilion*, 1924
13. *The Turner Mortuary, Front View, Wall and Gate*, 1924
14. *Single Candle Holder*, 1924
15. *Lilies of the Alley*, 1925
16. *The Shop Inspector*, 1925
17. *The Old J.G. Cherry Plant*, 1925
18. *Old Shoes*, 1926
19. *Higley's Block 1863-1914 and The Old Fire Engine 1886*, 1926
20. *Corn Room Mural* (detail), 1926
21. *Study for Memorial Window* (detail), 1927
22. *Portrait of John B. Turner - Pioneer*, 1928-30
23. *Young Corn*, 1928-30
24. *Draft Horse*, 1933
25. *Farm on the Hill Illustration, Hero Worship*, 1936
26. *Drawing for Tree Planting Group*, 1937
27. *Wild Flowers*, 1938
28. *March*, 1941
29. *Drawing for Adolescence*, 1938
30. *Cedar Rapids Art Association Plaque*, 1917
31. *Plaque of Charles B. Keeler*, 1920
32. *Mould of Marvin D. Cone Plaque*, 1920

1989

Grant Wood and Marvin Cone: An American Tradition, Federal Reserve System Gallery, Washington, D.C., 11 April-9 June 1989.

1. *Return of Columbus from America*, March 15, 1493
2. *The Horsetrader*
3. *Old Sexton's Place*
4. *Adoration of the Home*
5. *New Plaster, Paris*
6. *Fountain of the Medici*
7. *Iowa Afternoon*
8. *The Old J. G. Cherry Plant*
9. *Old Shoes*
10. *The Doorway, Perigueux*
11. *Indian Creek—Fall*
12. *Calendulas*
13. *Portrait of John B. Turner, Pioneer*
14. *Overmantel Decoration*
15. *Young Corn*
16. *Draft Horse—Sketch*
17. *Autumn Oaks*
18. *Hero Worship*
19. *Tree Planting Group*

GRANT WOOD

SELECTED BIBLIOGRAPHY

ARCHIVAL COLLECTIONS

Grant Wood Scrapbooks. Cedar Rapids Museum of Art.
These scrapbooks were assembled by the artist's patrons, David and John B. Turner II.

Grant Wood Scrapbooks. Davenport Art Museum, Iowa, and Archives of American Art, Smithsonian Institution, Washington, D.C.
These scrapbooks were assembled by the artist's sister, Nan Wood Graham.

Marian S. Mayer Papers. Archives of American Art, Smithsonian Institution, Washington, D.C.
These papers contain extensive Grant Wood materials. Also of interest is Park Rinard, "Return from Bohemia: A Painter's Story" (Typescript, 128 pp.). Originally prepared by Rinard in 1939 for his master's thesis to the Department of English, University of Iowa. Differences in the text do exist between this version and the uncompleted revisions by Rinard planned for publication by Doubleday.

WRITINGS BY GRANT WOOD

Aim of the Colony. Stone City Colony & Art School Brochure, 1932.

An Exhibition of Paintings by Marvin Cone. Cedar Rapids Art Association, Iowa, 1939.

Art in the Daily Life of the Child. Child Welfare Pamphlets, no. 73. Iowa City: University of Iowa Publications, 1939.

"At the Sign of 'Seven Seers.'" Regular column, *Cedar Rapids Republican*, 14 January 1926, p. 1; 21 January 1926, p. 1; 28 January 1926, p. 1; 4 February 1926, pp. 1, 15; 11 February 1926, p. 1; 12 February 1926, p. 10; 18 February 1926, pp. 1, 8; 25 February 1926, p. 1; 11 October 1926, p. 1; 18 October 1926, p. 1; 25 October 1926, p. 1; 15 November 1926, p. 1.

"Babble of Tongues, Picturesque Fellows in Famous Academie Julian Described by Grant Wood in Letter to Evening Gazette." *Cedar Rapids Evening Gazette*, 8 January 1924, p. 13.

"Contrasts Different Schools of Artists in a Gallery Talk." *Cedar Rapids Evening Gazette*, 15 April 1921, p. 14.

"A Definition of Regionalism." 16 November 1937. Grant Wood Scrapbooks, Cedar Rapids Museum of Art, Iowa. Reprinted in *Books at Iowa* 3 (November 1965): 3.

"Grant Wood Finds Restaurant Good Place..." *Cedar Rapids Evening Gazette*, 16 October 1923, p. 5.

"Grant Wood Has Hard Time Getting Nickname 'Woodenhead' at Julian's." *Cedar Rapids Evening Gazette*, 16 April 1924, p. 5.

"Grant Wood Writes of London Town." *Cedar Rapids Evening Gazette*, 17 September 1923, p. 2.

"'Innocents Abroad,' Or How the Yankees Misbehave in London." *Cedar Rapids Evening Gazette*, 21 September 1923, p. 29.

"John Steuart Curry and the Midwest." *Demcourier* XI, 2 (1941): 2-4.

"Letter." *New York Times*, city edition, 22 September 1935, sec. 6, p. 29.

"Letter." *Saturday Review of Literature*, 28 February 1942, p. 11.

"A New Spirit in American Art." *Popular Educator* 19 (6 December 1939): 1676-78.

"No Trespassing." *New Country Life* XXXI (April 1917): 118-22.

The Question of Exhibiting. Grant Wood Scrapbooks, Cedar Rapids Museum of Art, Iowa.

Review of *Paintings of the Modern Mind*, by Mary Cecil Allan. New York Publishing Co., 1930. Grant Wood Scrapbooks, Cedar Rapids Museum of Art, Iowa.

Revolt Against the City. With Frank Luther Mott. Whirling World Series, no. 1. Iowa City, Iowa: Clio, 1935. Also in James M. Dennis, *Grant Wood: A Study in American Art and Culture.* 2d ed. Columbia: University of Missouri Press, 1986, pp. 229-35; and Joseph S. Czestochowski, *John Steuart Curry and Grant Wood: A Portrait of Rural America.* Columbia: University of Missouri Press, 1981.

DISSERTATIONS AND THESES

Cruz, Martha O. "The Regionalist Triumvirate." Ann Arbor, Mich.: University Microfilms, 1975.

Goldberg, Kenneth. "The Paintings of Grant Wood." Master's thesis, State University of New York, Binghamton, 1972.

Keesee, Vincent Alvin. "Regionalism: The Book Illustrations of Benton, Curry and Wood." Ann Arbor, Mich.: University Microfilms, 1972.

BOOKS

Batchelder, Ernest A. *Design in Theory and Practice.* New York: The Inland Printing Company, 1910.

————. *The Principles of Design.* Chicago: The Inland Printing Company, 1904.

Brown, Hazel E. *Grant Wood and Marvin Cone: Artists of an Era.* Ames: Iowa State University Press, 1972.

Clements, Ralph. *Tales of the Town, Little-Known Anecdotes of Life in Cedar Rapids.* Cedar Rapids, Iowa: Stamats Publishing, 1967.

Corn, Wanda. *Grant Wood: The Regionalist Vision.* New Haven and London: Yale University Press, 1983. Published for the Minneapolis Institute of Art.

————. "The Birth of a National Icon: Grant Wood's *American Gothic*." In *Art: The Ape of Nature*. Edited by Moshe Barasch and Lucy Freeman Sandler. New York: Harry N. Abrams, 1981.

Cross, Mary. "The Quilts of Grant Wood's Family and Paintings." In *Uncoverings*. Edited by Sally Garoutte. Mill Valley, Calif.: American Quilt Society, 1982.

Czestochowski, Joseph S. *John Steuart Curry and Grant Wood: A Portrait of Rural America.* Columbia: University of Missouri Press, 1981.

DeLong, Lea Rosson, and Gregg R. Narber. *A Catalogue of New Deal Mural Art Projects in Iowa.* Des Moines, Iowa: 1982.

Dennis, James M. *Grant Wood: A Study in American Art and Culture.* 2d ed. Columbia: University of Missouri Press, 1986.

Duncan, Thomas. *O'Chautauqua: A Novel.* New York: Coward, McCann, 1935.

Garwood, Darrell. *Artist in Iowa: A Life of Grant Wood.* New York: W.W. Norton & Co., 1944.

Guedon, Mary Schulz. *Regionalist Art, Thomas Hart Benton, John Steuart Curry, and Grant Wood: A Guide to the Literature.* Metuchen, N..J.: Scarecrow Press, 1982.

Horn, Madeline Darrough. *Farm on the Hill.* New York: Charles Scribner's Sons, 1936.

Lewis, Sinclair. *Main Street.* Chicago and New York: The Lakeside Press for the Limited Edition Club, 1937.

Liffring-Zug, Joan, ed. *This Is Grant Wood Country.* Davenport, Iowa: Davenport Municipal Art Gallery, 1977.

Murray, Janette Stevenson, and Frederick Gray. *The Story of Cedar Rapids.* New York, 1950.

North, Sterling. *Plowing on Sunday.* New York: Macmillan, 1938.

Roberts, Kenneth. *Oliver Wiswell.* New York: Doubleday, Durant & Co., 1940.

Soby, James Thrall. "Grant Wood." In *New Art in America: Fifty Painters of the 20th Century.* Edited by John I. H. Baur. Greenwich, Conn.: New York Graphic Society/Praeger, 1957.

EXHIBITION CATALOGUES

Art Institute of Chicago. *Fifty-third Annual Exhibition of American Paintings and Sculpture.* Chicago, 1942.

Associated American Artists. *Grant Wood: The Lithographs.* New York City, 1984.

Cedar Rapids Art Association. *The Grant Wood Collection.* Cedar Rapids, Iowa, 1973.

————. *Grant Wood - Prints and Drawings.* Cedar Rapids, Iowa, 1989.

Cedar Rapids Art Center. *Grant Wood, The Graphic Work.* Cedar Rapids, Iowa, 1972.

Davenport Municipal Art Gallery. *Grant Wood and the American Scene.* Davenport, Iowa, 1957.

Elvehjem Museum of Art. *Grant Wood Still Lifes as Decorative Abstractions* (Introduction by James M. Dennis). Madison, Wisc., 1985.

Federal Reserve System Gallery. *Grant Wood and Marvin Cone.* Washington, D.C., 1989.

Ferargil Galleries. *Grant Wood.* New York City, 1935.

Hathorn Gallery, Skidmore College. *Grant Wood.* Saratoga Springs, N.Y., 1974.

John B. Turner & Son. *The Turner Mortuary.* Cedar Rapids, Iowa, 1924.

John B. Turner & Son. *Paintings by Grant Wood.* Cedar Rapids, Iowa, 1926.

Lakeside Press Galleries. *Catalogue of a Loan Exhibition of Drawings and Paintings by Grant Wood.* Chicago, 1935.

Minneapolis Institute of Art. *Grant Wood: The Regionalist Vision.* Minneapolis, 1983.

University of Kansas Museum of Art. *Grant Wood, 1891-1942.* Lawrence, Kans., 1959.

PERIODICALS

"Academy of Design Admits 15 Artists." *New York Times*, city edition, 13 March 1935, sec. 1, p. 17.

Alexander, Stephen. "White Haired Boy of the Crisis." *New Masses* XV, no. 6 (1935): 28.

"All Presentations of 'A Night in Old Seville' Admirable." *Cedar Rapids Republican*, 21 November 1926, p. 4.

"American Gothic: The Middle West as Depicted by Grant Wood, An American Painter." *Atelier* IV (1932): 34-37.

"American Scene." *New York Times Magazine*, 22 February 1942, sec. 7, pp. 14-15.

Anderson, Phil. "Wood that It Were So." *Mpls. St. Paul*, September 1983, pp. 57-59.

Arne, Gladys. "Artists' Exhibition Shows Rare Talent." *Cedar Rapids Evening Gazette*, 15 April 1920, p. 13.

———. "Interest Keen in Exhibit of Paintings." *Cedar Rapids Evening Gazette*, 19 April 1920, p. 6.

———. "Local Artists Encountered All Kinds of Difficulties Painting in France; Work Is Complimented." Cedar Rapids Evening Gazette, 20 November 1920, p. 3.

———. "New Art Exhibit Opens This Evening." *Cedar Rapids Evening Gazette*, 14 April 1920, p. 14.

———. "Views of Paris by Local Artist on Display Here Now." *Cedar Rapids Evening Gazette*, 15 November 1920, p. 11.

———. "Work of Two Local Artists Exhibited." *Cedar Rapids Evening Gazette*, 9 November 1920, p. 10.

"Art Association Sponsors Exhibit." *Cedar Rapids Evening Gazette*, 2 December 1926, p. 16.

"Art Association to Hold Open House at Public Library." *Cedar Rapids Evening Gazette*, 9 April 1921, p. 8.

"Art Center Shows 'Grant Wood in Europe' Exhibit." *Cedar Rapids Gazette*, 12 April 1970, sec. A, p. 4.

"Art Department Views Splendid Collection." *Cedar Rapids Evening Gazette*, 27 April 1921, p. 8.

"Art Exhibit." *Cedar Rapids Evening Gazette*, 21 September 1921, p. 10.

"Art Exhibit." *Cedar Rapids Evening Gazette*, 1 October 1921, p. 14.

"Art Exhibit." *Cedar Rapids Evening Gazette*, 1 December 1926, p. 12.

"Art Exhibit." *Omaha Sunday Bee-Omaha Sunday News*, 20 March 1927, sec. C, p. 5.

"Art Exhibit at Coe Is Event of Week." *Sunday Gazette and Republican* (Cedar Rapids), 13 November 1927, sec. 4, p. 1.

"Art Exhibit Is Being Shown at Public Library." *Cedar Rapids Evening Gazette*, 20 September 1921, p. 12.

"Art Exhibit Is Ready at Library." *Cedar Rapids Evening Gazette*, 22 September 1921, p. 12.

"Art in the Public Schools of Cedar Rapids." *Cedar Rapids Republican*, 16 August 1925, pp. 1, 2.

"Art Society Plans Local Art School." *Cedar Rapids Republican*, 14 February 1926, p. 2.

"Artist at Tea." *Omaha Sunday Bee-Omaha Sunday News*, 13 March 1927, sec. C, p. 2.

"Artist Denies Intent to 'Debunk' Legend." *New York Times*, late city edition, 3 January 1940, sec. 1, p. 18.

"Artist Grant Wood Dead." *Daily Iowan*, morning edition, 13 February 1942, pp. 1, 3.

"Artistic Thief Returns Grant Wood's Painting with Note." *Cedar Rapids Evening Gazette*, 27 January 1926, p. 10.

"Artists' Exhibition Shows Rare Talent." *Cedar Rapids Evening Gazette*, 15 April 1920, p. 13.

"Artists' Group Studios to Form Colony in City." *Cedar Rapids Republican*, 26 September 1926, sec. 1, p. 2.

"Artist Looks Us Over." *Kansas City Star*, 20 March 1931. n.p.

"Artist's Odyssey: Iowa via Europe." *Literary Digest* CXXI, 16 (1936): 30.

Ashbery, John. "Beyond American Gothic." *Newsweek*, 4 July 1983, pp. 80-81.

"Attractive Exhibit Opens at Library Gallery December 2; Art Association Tea, Sunday." *Cedar Rapids Republican*, 30 November 1926, p. 2.

"Attractive Exhibition of Paintings by Marvin Cone and Grant Wood." *Cedar Rapids Sunday Republican*, 12 October 1919, p. 7.

Baigell, Matthew. "Grant Wood Revisited." *Art Journal* XXVI, no. 2 (1966-67): 116-22.

Baldwin, Nick. "A Definitive Grant Wood Show." *Des Moines Sunday Register*, 29 May 1983, sec. C, p. 5.

———. "Critics Knock Wood—Hard." *Des Moines Sunday Register*, 24 July 1983, sec. C, p. 5.

Batchelder, Ernest A. "How Medieval Craftsmen Created Beauty by Meeting the Constructive Problems of Gothic Architecture." *The Craftsman* XVI (April-September 1909): 44-49.

———. "Carving as an Expression of Individuality: Its Purpose in Architecture." *The Craftsman* XVI (April-September 1909): 60-69.

Beattie, Ann. "Life Visits Grant Wood Country." *Life*, September 1983, pp. 56-67.

Belt, Byron. "Retrospective Courts New Respect for Grant Wood." *Chicago Sun-Times*, 22 August 1983, p. 42.

Benge, Joe. "The Art Exhibit in the Library." *Cedar Rapids Republican*, 9 May 1923, p. 3.

"Benton and Wood, from the Middle-West, Hold New York Show." *Art Digest* IX, no. 14 (1935): 12.

Benton, Thomas Hart. "Death of Grant Wood." *University Review* VIII, no. 3 (1942): 47-48.

———. "In Defense of Grant Wood's Art." *Cedar Rapids Gazette*, 23 December 1951, sec. 1, p. 7.

———. "Letter." *Life*, 8 February 1943, p. 7.

———, and John Steuart Curry. "The Death of Grant Wood." *University Review* VIII, no. 3 (1942): 147-49.

———, John Steuart Curry, William Kittredge, Reginald Marsh, and Margaret Thoma. "Grant Wood Memorial Issue." *Demcourier* XII, no. 3 (May 1942).

Berryman, Florence. "Grant Wood Commemorated in Chicago." *Magazine of Art* XXXV (1942): 268.

Bohrod, Aaron. "Letter." *Art Digest* XVII, no. 6 (1942): 4.

"Booklet Issued by Turner's Is Triumph in Art." *Cedar Rapids Evening Gazette*, 16 December 1924, p. 2.

Boston, Grace. "Stone City Is Ideal for Colony and Art School Planned by Cedar Rapids Artist." *Cedar Rapids Sunday Gazette and Republican*, 15 May 1932, sec. 1, p. 7.

Boswell, Peyton. "Grant Wood." *Art Digest* XVI, no. 10 (1942): 3.

———. "The Grant Wood Controversy." *Art Digest* XVII, no. 5 (1942): 3.

———. "Wood in the Frank Role of Illustrator." *Art Digest* X, no. 13 (1936): 8.

Bulliet, C. J. "American Normalcy Displayed in Annual Show; Iowa Farm Folks Hit Highest Spot." *Chicago Evening Post, Magazine of the Art World*, 28 October 1930, sec. 3, p. l.

"Cedar Rapids Art Association to Produce 'A Night in Old Seville'; Gallery to Represent Court Yard." *Cedar Rapids Republican*, 9 November 1926, p. 2.

"Cedar Rapids Has Real Asset in Art Gallery at the Public Library." *Cedar Rapids Evening Gazette*, 10 May 1923, p. 8.

"The Cedar Rapids Republican This Week Pays Tribute to . . . " *Cedar Rapids Republican*, 3 April 1927, sec. 2, p. 5.

"Cedar Rapids' River Front Scenes—-Including Signs, These Are Eye-Sores 'Young Titmarsh' Would Remove." *Cedar Rapids Republican*, 12 February 1926, pp. 10-11.

"Chicago Art Hit." *Newsweek*, 9 November 1942, p. 66.

"Chicago Critic Attacks Wood's Art." *Art Digest* XVII, no. 5 (1942): 23.

"Chicago Honors Memory of Grant Wood." *Art Digest* XVII, no. 3 (1942): 6.

Childs, Marquis. "The Artist in Iowa." *Creative Art* X (1932): 461-69.

"Classic Art Is Chaste, Says Grant Wood." *Cedar Rapids Republican*, 18 October 1925, sec. 2, p. 5.

"Coe to Exhibit Works of Marvin Cone, Grant Wood." *Cedar Rapids Sunday Gazette and Republican*, 6 November 1927, sec. 4, p. 2.

"College Club Hears Talk on Layman Artist." *Cedar Rapids Sunday Gazette and Republican*, 22 November 1931, sec. 4, p. 2.

"Colony and Art School—Stone City, Iowa." *American Magazine of Art* XXV (1932): 126-27.

Cone, Marvin. "Free Exhibit of Paintings by Grant Wood, Local Artist, in Art Gallery, Public Library." *Cedar Rapids Republican*, 10 January 1926, p. 4.

———. "Grant Wood's New Paintings, Shown at Little Gallery, Are Receiving Much Admiration." *Cedar Rapids Evening Gazette and Republican*, 14 February 1929, p. 2.

———. "More Praise for Wood's Paintings." *Cedar Rapids Evening Gazette*, 16 January 1926, p. 14.

———. "Painting Exhibit Reveals a Story." *Cedar Rapids Evening Gazette*, 4 December 1926, p. 14.

———. "Public Urged to See Art Exhibit Tomorrow." *Cedar Rapids Evening Gazette*, 11 December 1926, p. 15.

Corn, Wanda. "The Painting that Became a Symbol of a Nation's Spirit." *Smithsonian* XI, no. 8 (1980): 84-97.

Cox, Meg. "You'd Be Sour, Too..." *Wall Street Journal*, 18 May 1983, sec. 1, pp. 1, 29.

Craven, Thomas. "Grant Wood." *Scribner's Magazine* CI, no. 6 (1937): 16-22.

———. "Home-Grown Art." *Country Gentleman*, November 1935, pp. 18-19.

Cron, Robert. "The Glory that was Stone City's." *Des Moines Register*, 26 June 1932.

———. "Iowa Artists Club Forms Art Colony in Deserted Stone City Mansion." *Des Moines Sunday Register*, 8 May 1932.

Curry, John Steuart. "Grant." *University Review* VIII (1942): 148-49.

"D.A.R. to Sponsor Artists' Exhibit." *Council Bluffs Nonpareil*, 10 March 1927, p. 9.

"Daughters of Revolution." *Art Digest* IX, no. 1 (1934): 15.

"David Turner—Announcing a New Booklet." *Cedar Rapids Evening Gazette*, 21 July 1926, p. 5.

"David Turner—Announcing An Exhibit of Paintings by Grant Wood." *Cedar Rapids Evening Gazette*, 1 December 1926, p. 12.

"David Turner—Grant Wood." *Cedar Rapids Evening Gazette*, 12 January 1926, p. 12.

"David Turner—Visit the Exhibition of Paintings of Grant Wood, Ben Knotts, Raoul Drastac." *Cedar Rapids Republican*, 9 December 1926, p. 10.

Davis, Earle. "Grant Wood: He Painted America." *Kansas Quarterly* IV, no. 4 (1972): 5-11.

"Death of Grant Wood Regionalist." *Art News* XLI, no. 2 (1942): 7, 32.

"Diners Experience 'Thrill of Old Paris' during First Evening in Montmartre." *Cedar Rapids Republican*, 20 November 1925, p. 9.

"Dinner Parties Add to Gaiety of Montmartre Entertainment Last Night—Art Gallery, at Library." *Cedar Rapids Republican*, 20 November 1925, p. 9.

Doebel, Naomi. "Memorial Window for Island Building Will Be Symbol of Peace and Tribute to Heroic Dead." *Cedar Rapids Sunday Gazette and Republican*, 13 January 1929, sec. 1, p. 4.

Elsasser, Glen. "New Grant Wood Retrospective." *Chicago Tribune*, 26 June 1983, pp. 18-19.

"Eppley Hotel Magazine Praises Grant Wood and Edgar Brittan for Work." *Cedar Rapids Republican*, 17 October 1926, sec. 2, p. 14.

"Eppley to Open Council Bluffs Hotel Feb. 24." *Cedar Rapids Republican*, 20 February 1927, p. 2.

"Exhibit and Tea This Afternoon." *Cedar Rapids Republican*, 5 December 1926, p. 4.

"Exhibit of Paintings." *Cedar Rapids Republican*, 25 September 1921, p. 12.

"Exhibit of Paintings by Grant Wood, Ben Knotts and Raoul Dastrac in Gallery of Public Library Enjoyed by All Who Admire Expression in Art." *Cedar Rapids Republican*, 5 December 1926, sec. 3, p. 3.

"The Fine Arts Studios, Recent Achievement for Cedar Rapids; Faculty Has Fifteen Members." *Cedar Rapids Republican*, 29 September 1926, p. 9.

"Finds Best Art Subject in Midwest." *Omaha Bee-News*, 23 November 1932.

"Fine Display of French Pictures at Art Gallery." *Cedar Rapids Sunday Republican*, 14 November 1920, p. 2.

"First Presentation, 'A Night in Old Seville,' Big Success; Again Tonight, Tomorrow Night." *Cedar Rapids Republican*, 19 November 1926, sec. 2, p. 1.

"Folk Jam Little Gallery to Honor Grant Wood . . ." *Cedar Rapids Evening Gazette and Republican*, 12 February 1931, p. 12.

"Fruits of Iowa, Cedar Rapids." *American Magazine of Art* XXVI (1933): 151-52.

"Gallery Tea at Library Sunday, Two Hundred and Fifty Attend; Exhibit to Continue Ten Days." *Cedar Rapids Republican*, 6 December 1926, p. 2.

"Gertrude Stein Praises Grant Wood." *Montrose Mirror* (Iowa), 17 July 1934.

Glueck, Grace. "Whitney Museum Offers a 2nd Look at Grant Wood." *New York Times*, late edition, 17 June 1983, sec. C, pp. 1, 21.

Gooch, Boyce. "Letter." *Art Digest* XVII, no. 7 (1943): 4.

Graeme, Alice. "Grant Wood Illustrates a Book." *American Magazine of Art* XXIX (1936): 411-13.

Graham, Margaret. "Art Department Enjoyed Picnic at Ellis Park." *Cedar Rapids Republican*, 4 June 1925, p. 5.

_____. "Grant Wood Shows Pictures Painted in Europe to McKinley Students." *Cedar Rapids Republican*, 27 February 1925, p. 3.

_____. "'Imagination Isles' Transform McKinley Junior High Cafeteria." *Cedar Rapids Republican*, 13 March 1925, p. 8.

_____. "Teachers Elected for Next Year at Meeting of Board Monday Night." *Cedar Rapids Republican*, 6 May 1925, p. 5.

"Grant Wood." Editorial. *New York Times*, late city edition, 14 February 1942, sec. 1, p. 14.

"Grant Wood (Walker Galleries, New York)." *London Studio* XII, no. 1 (1936): 50-51.

"Grant Wood—A Genius of Iowa Prairies." *Cedar Rapids Republican*, 7 June 1925, sec. 2, p. 2.

"Grant Wood and Edgar Britton's Paintings on Exhibition, Omaha; Tea Sunday, at Hotel Fontenelle." *Cedar Rapids Republican*, 17 March 1927, p. 9.

"Grant Wood and Sara Sherman Maxon to Be Married Tonight in Minneapolis." *Cedar Rapids Gazette*, 2 March 1935, pp. 1-2.

"Grant Wood Art Display Opens Today." *Cedar Rapids Sunday Gazette and Republican*, 10 February 1929, sec. 3, p. 3.

"Grant Wood: Brilliant Painter of the Mid-Western Scene." *London Studio* XV, no. 83 (1938): 88-93.

"Grant Wood, Cedar Rapids Artist, to Give Talk Before Dubuque Art Association on Tuesday Evening." *Telegraph-Herald and Times-Journal*, 8 March 1932.

"Grant Wood Dies." *Art Digest* XVI, no. 10 (1942): 18.

"Grant Wood Dies; Famed Artist 50." *New York Times*, late city edition, 13 February 1942, sec. 1, p. 21.

"Grant Wood Explains Why He Prefers to Remain in Middle West in Talk at Kansas City." *Cedar Rapids Sunday Gazette and Republican*, 22 March 1931, sec. 1, p. 4.

"Grant Wood Gives Gallery Talk." *Cedar Rapids Republican*, 29 May 1925, p. 2.

"Grant Wood Goes East Today to Design Window." *Cedar Rapids Republican*, 31 March 1927, p. 9.

"Grant Wood Graphics Exhibit Opens Today." *Cedar Rapids Gazette*, 19 March 1972, sec. A, p. 13.

"Grant Wood Helps Young Artist Develop Technique." *Daily Iowan*, 3 November 1935.

"Grant Wood Host at Studio Party." *Cedar Rapids Republican*, 22 November 1926, p. 5.

"Grant Wood, Iowa's No. 1 Artist Who Died Last Winter, Gets Big Retrospective Show in Chicago." *Life*, 18 January 1943, pp. 52-58.

"Grant Wood Is One Artist of Reknown Appreciated in His Own City; Local Tributes." *Cedar Rapids Evening Gazette and Republican*, 11 February 1931, p. 13.

"Grant Wood in the East." *Art Digest* IX, no. 15 (1935): 18.

"Grant Wood, Iowa Artist, Visits Omaha This Week." *Omaha Evening Bee-Omaha Daily News*, 21 February 1927, p. 6.

"Grant Wood Leaving for New York City." *Cedar Rapids Republican*, 23 March 1927, p. 12.

"Grant Wood, Local Artist, Finds German People Are Friendly; Does 20 Paintings." *Cedar Rapids Evening Gazette and Republican*, 28 December 1928, p. 16.

"Grant Wood, Local Artist, to Give Talk on 'Experiences of an Artist in Europe' before Woman's Club." *Cedar Rapids Republican*, 1 March 1925, p. 4.

"Grant Wood Memorial Issue." *Demcourier* XII, no. 3 (May 1942): pp. 14-17.

"Grant Wood Organizes Hoover's Birthplace." *Art Digest* VI, no. 4 (1931): 7.

"Grant Wood Painting Given Place in Art Insitute Exhibition." *Cedar Rapids Evening Gazette and Republican*, 18 October 1929, p. 21.

"Grant Wood Paintings Show Familiar Scenes." *Cedar Rapids Evening Gazette*, 15 May 1923, p. 14.

"Grant Wood Presents Parson Weems." *Art Digest* XIV, no. 8 (1940): 7.

"Grant Wood Returns from Study in Old World Art Centers." *Cedar Rapids Republican*, 4 September 1924, p. 2.

"Grant Wood Sees Music Proves Theory by Sketch." *Cedar Rapids Evening Gazette*, 25 April 1922, p. 13.

"Grant Wood Speaks of Sicilian Beauty." *Cedar Rapids Republican*, 7 January 1926, p. 12.

"Grant Wood Talks to C.R. Ad Club." *Cedar Rapids Republican*, 1 October 1926, p. 14.

"Grant Wood Tells in Prologue about McKinley Tableaux." *Cedar Rapids Evening Gazette and Republican*, 15 December 1928, p. 12.

"Grant Wood Tells Story of Latest Work." *Iowa City Press-Citizen*, evening edition, 6 January 1940, p. 12.

"Grant Wood to Be Buried Saturday at Anamosa; Scene of Boyhood." *Iowa City Press-Citizen*, evening edition, 13 February 1942, p. 8.

"Grant Wood to Design $9,000 Stained Glass Window to Go in Memorial; to Depict Wars." *Cedar Rapids Republican*, 25 January 1927, p. 10.

"Grant Wood to Give Talk on Year in Europe." *Cedar Rapids Republican*, 27 May 1925, p. 2.

"Grant Wood to Show How an Artist Paints at Gallery Tomorrow." *Cedar Rapids Evening Gazette*, 11 May 1923, p. 12.

"Grant Wood to Talk and Show Paintings." *Cedar Rapids Evening Gazette*, 27 May 1925, p. 14.

"Grant Wood Will Design Memorial Building Window." *Cedar Rapids Evening Gazette*, 25 January 1927, p. 1.

"Grant Wood, Young Artist of Cedar Rapids, Recalls Stories of Fun on Farm Near Anamosa." *Cedar Rapids Republican*, 10 February 1926, p. 9.

"Grant Wood's Art Work on Exhibit in Public Library." *Cedar Rapids Evening Gazette*, 4 January 1926, p. 14.

"Grant Wood's Four Personalities." *Cedar Rapids Republican*, 14 March 1926, sec. 2, p. 4.

"Grant Wood's Industrial Paintings of Cherry Plant." *Cedar Rapids Evening Gazette*, 17 November 1925, p. 24.

"Grant Wood's Merriment of Soul." *Art Digest* X, no. 15 (1936): p. 14.

Gray, Don. "Grant Wood Retrospective." *Art World*, VII, No. 10 (1983): p. 2.

Hanson, Eleanor. "Grant Wood." *Wellesley Review* XIV, no. 5 (1940): pp. 13-17.

"He Plans for a Native Art." *New York Sun*, 10 October 1934, n.p. Grant Wood Scrapbooks—New York Public Library.

"Home Pictures Full of Charm at Art Exhibition." *Cedar Rapids Republican*, 15 April 1920, p. 7.

"Honored at Home." *Art Digest* XII, no. 13 (1938): 9.

Hughes, Robert. "Scooting Back to Anamosa," *Time*, 27 June 1983, pp. 68-69.

Hullihan, Robert. "Grant Wood's America." *Des Moines Sunday Register-Picture*, 2 October 1983, pp. 8-10, 12-15.

"Humane Posters Exhibited Last Time Tonight." *Cedar Rapids Republican*, 28 May 1925, p. 12.

"Ice Wagon Artist's Colony." *Christian Science Monitor*, 24 August 1932.

Idema, James. "Rediscovering a Midwestern Master." *Inland* 4 (1983): 9-17.

"Illinois to Honor Iowa's Grant Wood." *Art Digest* XVI, no. 11 (1942): 9.

"Important Works of Grant Wood." *Demcourier* XII, no. 3 (1942): 14-17.

"Interest Keen in Exhibit of Paintings." *Cedar Rapids Evening Gazette*, 19 April 1920, p. 6.

"Interview with Nan Wood Graham." *SEE* I, no. 5 (1978): 2.

"An Iowa Artist Discovers Iowa." *Literary Digest* CXIV, no. 7 (1932): 13-14.

"Iowa Cows Give Grant Wood His Best Thoughts." *New York Herald Tribune*, late city edition, 23 January 1936, p. 17.

"Iowa Detail." *Time*, 5 September 1932, p. 33.

"Iowa Secret." *Art Digest* VIII, no. 1 (1933): 6.

"Iowa State University Library Murals." *Fort Dodge Messenger-Chronicle* (Iowa), 17 June 1937, n.p.

"Iowans Get Mad." *Art Digest* V, no. 7 (1931): 9.

"Iowa's Painter." *Time*, 23 February 1942, p. 65.

"Issue Booklet on Paintings by Wood in Turner Mortuary." *Cedar Rapids Evening Gazette*, 13 July 1926, p. 14.

Jackson, Edna Barrett. "Cedar Rapids' Art Colony." *Cedar Rapids Republican*, 12 September 1926, sec. 2, p. 3.

Janson, H. W. "Benton and Wood: Champions of Regionalism." *Magazine of Art* XXXIX (1946): 184-86, 198-99.

_____. "The Case of the Naked Chicken." *College Art Journal* XV (Winter 1955): 124-27.

_____. "The International Aspects of Regionalism." *College Art Journal* II (May 1943): 110-15.

_____. "Review of Artist in Iowa—A Life of Grant Wood, by Darrell Garwood." *Magazine of Art* XXXVIII (November 1945): 280-82.

Jewell, Edward Alden. "Grant Wood Show Opens." *New York Times*, late city edition, 16 April 1935, sec. 1, p. 19.

_____. "The Nation Paints Its Walls." *New York Times*, late city edition, 27 May 1934, sec. 10, p. 7.

"John C. Reid Is Elected to Presidency of Cedar Rapids Art Association; Review Year." *Cedar Rapids Republican*, 1 February 1927, p. 11.

Keeler, George. "Exhibit of Works by City Artists in Public Library Is Extended by Big Demand." *Cedar Rapids Evening Gazette*, 29 April 1922, p. 16.

Keerdoja, Eileen, and Ronald Henkoff. "The 'Gothic' Model Keeps a Vigil." *Newsweek*, 8 December 1980. pp. 17, 20.

Kienitz, John Fabian. "Grant Wood." *Art in America* XXXI (1943): 49-50.

Kinney, Jean. "Grant Wood: He Got His Best Ideas while Milking a Cow." *New York Times*, late city edition, 2 June 1974, sec. 2, pp. 1, 14.

Kirstein, Lincoln. "An Iowa Memling." *Art Front* I, no. 6 (1935): 6, 8.

"Knocking Wood." *Art Digest* XVII, no. 5 (1942): 12.

Koen, Irma Rene. "The Art of Grant Wood." *Christian Science Monitor*, Atlantic edition, 26 March 1932, p. 6.

Lankes, J. J. "Letter." *Art Digest* XVII, no. 6 (1942): 4.

"Local Art Association Opens a Fine Exhibition." *Cedar Rapids Republican*, 15 April 1921, p. 5.

"Local Artists at Iowa City Today." *Cedar Rapids Republican*, 14 November 1926, sec. 2, p. 1.

"Local Artists Exhibit Their Work in Omaha." *Cedar Rapids Republican*, 27 February 1927, p. 2.

"Local Artists Painting Corn Room in Bluffs." *Cedar Rapids Republican*, 6 February 1927, sec. 2, p. 2.

"Local Artists Well Represented at Public Library Art Exhibit." *Cedar Rapids Republican and Times*, 24 April 1922, p. 5.

"Local Artists' Works Are Enjoyed by Many Visitors at Library." *Cedar Rapids Evening Gazette*, 8 May 1923, p. 15.

"Local Boys Exhibit Their Works of Art." *Cedar Rapids Evening Gazette*, 8 October 1919, p. 11.

The Long Voyage Home as Seen and Painted by Nine American Artists." *American Artist* IV (September 1940): 4-14.

"Make Reservations Early for 'Night in Old Seville." *Cedar Rapids Republican*, 16 November 1926, p. 2.

The Man on Horseback. "Paris Newspaper Goads Grant Wood into Writing Biography of Infinitives." *Cedar Rapids Republican*, 26 September 1926, sec. 2, p. 2.

"Many Original Greetings Sent by Local Folk." *Cedar Rapids Evening Gazette*, 26 December 1925, p. 12.

"Many Paintings Being Shown in Local Art Gallery." *Cedar Rapids Evening Gazette and Republican*, 12 October 1929, p. 5.

"Many Turn Out for Lecture by Iowa Artist." *Dubuque Telegraph-Herald and Times-Journal*, 7 March 1932, n.p.

"Marvin Cone and the Late Grant Wood Were Lifelong Friends." *Coe College Cosmos*, 25 February 1942, p. 1.

"McKinley Art Students Paint Frieze." *Cedar Rapids Evening Gazette*, 6 December 1924, p. 9.

"McKinley Students Paint Huge Frieze." *Cedar Rapids Evening Gazette*, 22 November 1924, p. 12.

"Middle West and Art." *New York Times*, late city edition, 9 June 1935, sec. 9, p. 8.

"Mid-West Is Producing an Indigenous Art." *Art Digest* VIII, no. 7 (1933): 10.

Miller, Arthur. "Miller Evaluates Wood." *Art Digest* XVI, no. 11 (1942): 9.

Miller, Harlan. "Stone City Colony Likely to Become Conspicuous Episode in American Art." *Des Moines Sunday Register*, 31 July 1932, n.p.

"Miss Martin Reviews Local Exhibit of Art." *Cedar Rapids Evening Gazette*, 21 April 1920, p. 3.

Montz, Wanda. "Grant Wood Joins 'Daughters' for Tea Party on Canvas." *Cedar Rapids Gazette*, 7 March 1937, p. 9.

Morley, Christopher. "The Bowling Green." *Saturday Review of Literature*, 17 January 1931, p. 533.

————. "The Bowling Green." *Saturday Review of Literature*, 25 February 1933, p. 450.

Morsell, Mary. "Grant Wood." *Art News* XXXIII, no. 30 (1935): 13.

Mumford, Lewis. "The Art Galleries; A Group of Americans." *New Yorker*, 4 May 1935, pp. 28, 31-32.

"Mural Decoration Makes Library an Attractive Study." *Cedar Rapids Evening Gazette*, 5 February 1927, p. 12.

"Mural Painting Is Praised." *Cedar Rapids Republican*, 22 March 1925, sec. 2, p. 3.

"Murals, Landscapes, Decorative Art Are Part of Exhibition." *Cedar Rapids Evening Gazette*, 5 May 1923, p. 14.

"My Own, My Native Land." *Magazine of Art* XXXV (1942): 118.

"New Art Exhibit Opens This Evening." *Cedar Rapids Evening Gazette*, 14 April 1920, p. 14.

"New Murals in Iowa by Grant Wood and the PWAP." *Fortune*, January 1935, pp. 66-68.

"New Turner Mortuary to Be Opened Next Week; Is a Fine Establishment." *Cedar Rapids Evening Gazette*, 13 December 1924, p. 12.

"News from the States: Iowa." *Saturday Review of Literature*, 12 August 1933, p. 47.

Nichols, Dale. "Letter." *Art Digest* XVII, no. 5 (1942): 4.

"'A Night in Old Seville' Opening Presentation This Evening, Gallery, Library." *Cedar Rapids Republican*, 18 November 1926, p. 12.

"Omaha Gets an Iowa Idyl by Grant Wood." *Art Digest* V, no. 16 (1930-31): 11.

"Paintings by Two Local Artists Win Distinction." *Cedar Rapids Sunday Gazette and Republican*, 15 December 1929, sec. 2, p. 2.

"Paintings of Grant Wood and Marvin Cone Are Praised." *Cedar Rapids Evening Gazette and Republican*, 15 November 1927, p. 13.

"Paintings Late in Arriving." *Cedar Rapids Republican*, 21 September 1921, p. 6.

"Parson Weems' Fable." *Life*, 19 February 1940, pp. 32-33.

"Period Piece." *Time*, 8 January 1940, p. 41.

"Percy Heavythinker to Visit McKinley." *Cedar Rapids Evening Gazette*, 4 October 1924, p. 12.

Pickering, Ruth. "Grant Wood, Painter in Overalls." *North American Review* CCXL (1935): pp. 271-77.

"Portraits by Grant Wood of Local Subjects Arouse Favorable Comment." *Cedar Rapids Sunday Gazette and Republican*, 17 February 1929, sec. 4, p. 2.

"Put Art in Home Is Watson's Plea." *Cedar Rapids Republican*, 9 December 1926, p. 8.

Rinard, Park. "Grant Wood Restores a Heritage of Charm." *Our Home* 2 (1939): 16-19.

Robinson, Ralph. "Letter." *New York Times*, late city edition, 7 January 1940, sec. 4, p. 9.

"Room in Local Hotel Pictures Corn, Iowa's Pride and Joy, through Brush of Local Artist." *Cedar Rapids Republican*, 13 June 1926, sec. 1, p. 3.

"Rotary Club Views Local Art Display." *Cedar Rapids Republican*, 13 January 1926, p. 16.

Rowan, Edward B. "Art News of the Little Gallery." *Cedar Rapids Sunday Gazette and Republican*, 17 February 1929, sec. 4, p. 3.

————. "Art News of the Little Gallery." *Cedar Rapids Sunday Gazette and Republican*, 5 January 1930, sec. 4, p. 4.

————. "Stone City Project." *Cedar Rapids Gazette*, 19 June 1932.

Sanger, Hortense. "Grant Wood's America." *New Republic* CIII (1940): 683.

Sayre, Ann H. "Illustrational Work by Grant Wood." *Art News* 34 (25 April 1936): 9.

Schjeldhl, Peter. "American Gothic Again." *Vanity Fair*, June 1983, pp. 94-98.

Schulze, Franz. "How Worldly Is Grant Wood." *Chicago Sun-Times*, 15 January 1984, p. 22.

Seldes, Gilbert. "Notes and Queries." *Today* IV, no. 4 (1935): 16.

Seely, Garretson. "McKinley School." *Cedar Rapids Evening Gazette*, 12 May 1923, p. 13.

"Self-Portraits of Iowa Artists Exhibited by Iowa Federation of Women's Clubs." *Des Moines Sunday Register*, 3 April 1932.

"Service for Grant Wood." *New York Times*, late city edition, 15 February 1942, sec. 1, p. 45.

"Show Fine Works by Local Artists at Killian Store." *Cedar Rapids Republican*, 10 October 1919, p. 8.

"Son of the Soil Masters Painting before Showing N.Y." *Newsweek*, 20 April 1935, p. 20.

Steele, Mike. "Grant Wood, Purveyor of Social History and Images." *Minneapolis Tribune*, 25 September 1983, p. 16.

"Stone City." *Cedar Rapids Gazette*, 5 February 1961, p. 3.

"Stone City Colony Likely to Become Conspicuous Episode in American Art." *Des Moines Register*, 31 July 1932, p. 13

"Stone City's Second Season." *American Magazine of Art* XXVI (1933): 390-91.

"Study of Art in Public Schools Here Causes Hot Discussion by the Public." *Cedar Rapids Republican*, 12 August 1925, pp. 1, 12.

Suckow, Ruth. "The Folk Idea in American Life." *Scribner's Magazine* LXXXVII (September 1930): 453.

————. "Midwestern Primitive." *Harper's Monthly Magazine* 156 (March 1928): 59-68.

"Sunday Tea." *Omaha Daily Bee-Omaha Daily News*, 11 March 1927, p. 7.

Sweeney, James Johnson. "Grant Wood." *New Republic* LXXXIII (1935): 76-77.

Taylor, Adeline. "Easterners Look Wistfully at Midwest as Nation's Art Crown Brought to It; Grant Wood Lionized on New York Visit." *Cedar Rapids Gazette*, 21 October 1934, sec. 1, p. 4.

————. "Grant Wood Hailed from West to Berlin as Discovery." *Cedar Rapids Sunday Gazette and Republican*, 25 January 1931, p. 4.

————. "Grant Wood's Penetrating Eye and Skillful Brush to Deal Next with Scene of America's Pet Institutions." *Cedar Rapids Gazette*, 25 September 1932, sec. 1, p. 3.

————. "We Go Calling in Exclusive Ice Wagon Row at Stone City." *Cedar Rapids Gazette*, 17 July 1932.

"They Posed for Wood's 'American Gothic'." *Art Digest* XVII, no. 1 (1942): 13.

"Tonight Is Good Time to See School Art Work." *Cedar Rapids Evening Gazette*, 28 May 1925, p. 16.

"Tory Spirit." *Art Digest* IX, no. 2 (1934): 13.

Tully, Judd. "Portrait of Americana." *Horizon*, May 1983, pp. 37-43.

"Two Local Artists Work on Murals for Eppley Hotel." *Cedar Rapids Republican*, 13 February 1927, p. 3.

"Unique Art Colony Will Open Studio House." *Cedar Rapids Republican*, 17 October 1926, sec. 2, p. 12.

"U.S. Scene." *Time*, 24 December 1934, pp. 24-37.

"Views of Paris, by Local Artists, on Display Here Now." *Cedar Rapids Evening Gazette*, 15 November 1920, p. 11.

"Visitors Invited to Art Exhibition at Public Library." *Cedar Rapids Republican*, 20 September 1921, p. 6.

"Watches and Telephones Mean Nothing to Artists, Grant Wood Tells Club." *Cedar Rapids Republican*, 3 March 1925, p. 2.

Watson, Forbes. "The Phenomenal Professor Wood." *American Magazine of Art* XXVII (1935): 285, 288-89.

"Week of Open House to Enjoy Local Art Gallery." *Cedar Rapids Republican*, 10 April 1921, p. 8.

"When Tillage Begins Other Arts Follow." *Survey Graphic* XXII (1934): 322-23.

Whiting, Frederick A., Jr. "Stone, Steel and Fire: Stone City Comes to Life." *American Magazine of Art*, 25 December 1932, pp. 333-42.

Wolff, Theodore F. "A Latter Day Look at Grant Wood, American Hero." *Christian Science Monitor*, 5 July 1983, p. 13.

"Wood and Britton Return; Complete Hotel Decoration." *Cedar Rapids Republican*, 8 March 1927, p. 3.

"Wood, Hard-Bitten." *Art Digest* X, no. 9 (1936): 18.

"Wood Works." *Time*, 22 April 1935, p. 56.

"Work of Henry S. Eddy and Local Artists on Exhibition at Library." *Cedar Rapids Evening Gazette*, 24 September 1921, p. 14.

"Work of Two Local Artists Exhibited." *Cedar Rapids Evening Gazette*, 9 November 1920, p. 10.

Appendices

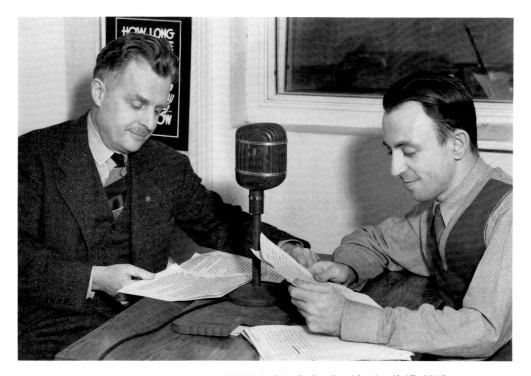

Marvin D. Cone — Radio broadcast at W.M.T. Radio, Cedar Rapids, April 17, 1942.

MARVIN Well, I didn't know about it then. What could I do? . . . You know, Dave, climbing these long stairs up to the top floor of Old Main nearly always makes me think of Grant Wood.

DAVE How's that?

MARVIN Well, Grant used to get out of breath quite easily, you know. He was a hearty fellow and rather chubby, and when we were in France together I was always wanting to climb the towers of cathedrals or any other high places. We went up to Antwerp to get the boat for home and stayed there three or four days. One afternoon when we were a bit tired of walking around in the art museum, I proposed climbing the tower of the Antwerp cathedral. Grant consented in a mild obliging sort of way, and we started up. Now that cathedral tower was a real skyscraper and about half-way up Grant balked and said: "You go on up—I've had enough—I'll be sitting right here when you come down."

DAVE You forget that he had more weight to carry than you had. Was he there when you came down?

MARVIN Oh sure—there he was—looking out a little window sketching the ships in the harbor.

DAVE Well, Grant was a great fellow. I happen to know something about his climbing ability. One year, out in Colorado, he—

MARVIN Here, let's sit down and rest a minute.

DAVE O.K. Well, as I was saying, one year, out in Estes Park, Grant had charge of the art activities in the Cheley camps and I had made up my mind that I wanted to climb Long's Peak. Grant said he didn't care about climbing up, but he would take a horse and go along as far as the boulder field and then do some sketching while I climbed on up. When we got to the boulder field we found a group of students there from the University of Colorado who were going to the top. There was a guide who offered to take 'em up, but they said no, they didn't need a guide. About that time Grant changed his mind and decided that he'd go all the way up so *we* hired the guide. I'm telling you it was mighty hard work. We'd take about three or four steps forward and then stop

to get our breath. After a while, there was no turning back — we simply had to keep on going — and finally we made the top after a long, hard pull. Grant's pink complexion turned a brilliant red and when we got back to camp late in the afternoon everybody called him "Redwood"

instead of Grant Wood, and he was known as "Redwood" the rest of the time he was there!

MARVIN That's a new one on me! It's hard for me to imagine Grant up on top of Long's Peak. His face was always pink, of course, even back in high school days. He was naturally shy, and people used to think he was blushing. Remember the pinkish looking beard he had when we came back from Paris the first time?

DAVE I sure do. I have a photograph of him with that beard — Say, how on earth did he happen to grow a beard anyway?

MARVIN Well, Grant never moved very fast — he wasn't exactly what you'd call speedy — and he used to take a lot of time every morning shaving. I was always ready before he was, and anxious to get out painting. One morning when he seemed extra slow I asked him why on earth he just didn't let 'em grow? He said quite mildly, "That's an idea," and from then on there was no more shaving. But the joke of it was that in a week or so he was putting in more time fussing with his beard than he used to take shaving! And oh man! What whiskers they turned out to be! He knew he looked funny but he took a dare and wore the thing back to Cedar Rapids. At first, you know, his friends here didn't recognize him! They'd stare at him in an amazed and bewildered sort of way. He got a wallop out of that.

DAVE Grant got a wallop out of everything he did — enjoyed living every minute and had lots of fun.

MARVIN You bet he did. Remember that old automobile he had and the wooden arm and hand that he cut out and painted and had it fixed so that he could slide it out when he was going to make a left turn? Oh boy, I can still see him laughing when he worked the thing. Everyone who saw it got a laugh out of it, too.

DAVE Yes, I remember that, and I wish to goodness I had that old wooden hand. I wonder whatever became of it?

MARVIN I don't know — suppose it went with the car when he sold it.

DAVE Grant had a lot of funny things happen to him. Somehow or other he got into all sorts of scrapes, but always got a bang out of it even when the joke was on himself. I can see him yet standing up and swaying from side to side while he was telling something that amused

him. He liked to tell about the time a very prominent Cedar Rapids woman stopped him on the street and asked: "Well, Grant, what are your fairy fingers doing now?" Now, you know that Grant's fingers were far from being delicate and slim — they were the hands of a worker, short and stubby.

MARVIN Yes, I remember him telling that story and it was really funny the way he told it. Of course, with those chubby fingers of his he could do the most delicate kind of work and carry out a lot of endless

ideas. Did you ever know anyone who had more schemes he wanted to try out?

DAVE He had more unusual ideas than anyone I've ever known.

MARVIN Even when he was sick he was cooking up plans for future work. A couple of weeks before he died he told me that he was itching to do a portrait of his father — a sort of companion piece to the one of his mother which hangs down at the Art Association gallery.

DAVE It's a shame he couldn't have done that. Once he got started on an idea he generally went through with it.

MARVIN His mother has told me that frequently he used to work until two or three o'clock in the morning if the painting were going well. She used to try to get him to stop and go to bed, but if things were happening on his canvas he wanted to keep going. Time didn't mean much to him. I can't imagine him punching a time-clock.

DAVE The work he did on those huge drawings for the memorial window down at the coliseum was a good example of his persistence. He started them up in his studio, and the thing finally got so big that he took it over to the Quaker Oats plant — up in their recreation hall — where he set the thing up the full size of the window. We all went over there once to see him work — remember, way up on top a big stepladder.

MARVIN Yes, I remember. You know, that was really a whale of a job for Grant to take on . . . but he knew he could do it — he met the difficulties as they came, and — well, there's the window down there today.

DAVE Say, Grant never signed that window, did he? There's no marker there for anyone to know that he did the work. Something really ought to be done about that.

MARVIN You're right — because that coliseum window is one of the finest things in Cedar Rapids.

DAVE Maybe the Art Association should do something about getting a bronze plate put up.

MARVIN Somebody should, that's certain, because someday all of Grant's old personal friends will be out of the picture, and people will begin to wonder who made that window. You know, Dave, I think that while a good many of Grant's old friends are still living we ought to

each one write down all the things he remembers — and then have all of 'em typed up and bound in a book. I'd certainly like to have such a thing.

DAVE That would be fun to do. There's Fan Prescott and Florence Johnston, Hazel Brown and Mary Lackersteen, who could all remember some mighty interesting things.

MARVIN Sure, there are lots of people who could add material which will be forgotten pretty soon if it isn't put down. There are so many funny stories once you begin to think back.

DAVE Remember the baby chicken Grant's sister Nan got one Easter? He used it in her portrait—you know the one—she holds it in her hand. Then, as the chicken grew up, he got the idea for that painting he called "Adolescence." That was a honey, wasn't it?

MARVIN One of the best! But the poor chicken—it choked to death trying to swallow one of the rubber cigarettes Grant had around to fool people with! Tragedy and comedy all at once! Grant used the stuff that was all around him as material for pictures. Once someone asked him why he didn't do paintings of the ocean, and his only answer was a big grin.

DAVE He did a picture once of some old patch-work quilts hanging on a clothesline. Jay Sigmund owned that one I think.

MARVIN Well, gee whiz, Dave, if we had a stenographer here right now taking down all this stuff we've been talking about, we'd have a chapter of our book already. We could call this one "Odds and Ends."

DAVE I was down at the Montrose hotel the other day, and took time to look at Grant's paintings up there on the mezzanine floor. Those are dandy things. He really went to town when he did those. I like 'em because they have some humor in them. It's too bad there isn't more of his work in public buildings where people could see it every day.

MARVIN I like that one—down at the motel—of the fellow milking the cow. You know, the one of the rear of the cow with her tail hanging straight down like a rope! As far as that goes, they're all very swell things and very much Grant Wood. They really express him and his slant on Iowa. He liked farm people—of course, he had experience on farms and knew the genuine qualities of the people there, and the satisfactions of farm life.

DAVE He liked farm animals, too. That's why he liked that young chicken with pin-feathers!

MARVIN You know, when I think about Grant it's nearly always the funny things that come to mind—you're smiling right now, Dave . . . Come on, you're thinking of a story. Let's have it.

DAVE Well, I remember once we were having a sort of a costume party at our house. Hazel Brown and Mary Lackersteen were there and so was MacKinlay Kantor—remember him?

MARVIN Sure, he worked on the old *Republican*.

DAVE Well, Grant came to our party all dressed up as an angel. He had on his sister's white nightgown, and up the back of it he'd rigged up some sort of a wire arrangement that held up a gilded halo over his head. He was the dog-gonedest looking angel you ever saw! With his round, pink cheeks—oh boy!

MARVIN Sounds to me more like an archangel! Well, Grant's voice was nice and quiet and a professional angel ought to speak softly—Say, Dave, didn't Grant start you off collecting Currier and Ives prints?

DAVE That's right. He gave me my first Currier and Ives and got me

interested in its real American flavor or whatever you want to call it. Now I have over a hundred good examples and I love 'em.

MARVIN I think most of Grant's paintings were really as essentially American as Currier and Ives. When you think back—-there was *Parson Weem's Fable*, *Dinner for Threshers*, *Daughters of Revolution*, *American Gothic*—and the Paul Revere picture—Those things are really American stuff.

DAVE Then the portrait of my father with the old map of Linn County as a background-junk-if that isn't American, what is? I saw most of those pictures being painted. I used to go over to his studio every so often to see how things were coming along, and I watched those pictures grow from start to finish. There was Grant always plugging away—-dressed in his old blue overalls. Remember them? He used to insist that he could predict changes in the weather by his overalls! If they drooped more than usual it was going to rain or storm or some such crazy idea!

MARVIN Yes, Grant got a lot of downright fun pretending that he believed such things. He had his tongue in his cheek lots of the time. His mother used to chuckle over his odd notions and make fun of him sometimes when he'd come out with some preposterous idea. But she enjoyed it too. She liked to laugh.

DAVE Grant's mother was a sweet person and she certainly had a lot of faith in her children. Grant used to call her "Mom" just as gently as if he were a little boy.

MARVIN Yep, those were happy years when they lived in the studio down there at 5 Turner Alley. Also, when they lived in Kenwood in that house that Grant built himself. Remember the stepping stones he made for the back lawn?

DAVE Sure, those big ones shaped like a giant's footprint—-without shoes—-you could see all the toes.

MARVIN He cast those in cement, didn't he? I wonder what ever became of them?

DAVE Well, the lot was later filled in after Grant and his mother and

sister left that home. As far as I know, the big cement footprints were covered over with several feet of earth. I tried my best to locate them with a big iron probe, and I even dug some holes but couldn't find one of them.

MARVIN I'd like to have one, all right. Grant was good at making things with his hands, and took pride in a workmanlike job. He could do almost anything with any kind of material. He worked slowly, . . . but, you know, when he finally got a thing finished, it was A Number One.

DAVE That makes me think of the metal flowers he used to make—he called them "junk-flowers."

MARVIN That was when he was teaching at McKinley High School, I think. Along about 1922.

DAVE Yeah, somewhere around in there. Anyway, he got his kids in school to collect odd little items like old mucilage brushes, clothespins, pop-bottle tops, bits of barbed-wire—any little bits of junk—then they made metal leaves and painted the whole thing, and there was a Grant Wood "Junk-flower"! The funny part of it was that when you put a real plant beside one of the metal plants, the junk-flowers looked better than the real ones!

MARVIN You still have some of those pots of flowers, haven't you?

DAVE I have three or four of 'em. I wouldn't part with 'em for anything. You know, Grant put just as much thought and care into making those things as he did later on into his paintings. He put his whole soul into whatever he did. He gave it the works!

MARVIN Oh sure! Everything he did, he did well. And he was ingenious, you know, in scheming out ways to do things. Think of the beautifully designed frames he made for his paintings. Did you know that he used part of an old linen table-cloth that was his mother's to cover the frame on her portrait? He stained it a soft gray color, and it gives a beautiful texture to the frame. Of course, there was some sentiment connected with it—although Grant wouldn't have admitted that.

DAVE No, he would have said he thought it made a good-looking frame, and that's about all.

MARVIN Thinking again about his designing ability—just remember the scenery he planned and built for the Community Players. Those were first class sets. Come to think of it, Dave, Grant made the first set of scenery that was ever used in the Coe College theater. Laura Pearl Stewart got him to do it. She could tell you about that.

DAVE Grant always had a real interest in the theater—Come to think of it, the Community Players really got started up in Grant's studio. He was one of the organizers of that group, and they gave their first show up there. Grant rigged up some sort of a little stage and the audience sat on the floor.

MARVIN I missed that first show somehow or other.

DAVE Well, you should have been there. Everyone had a wonderful time. It was what you'd call a bang-up success! Grant was a great guy for popcorn and apples, and we ate those between acts.

MARVIN Gee! I've had a lot of good times up in Grant's studio—and met a lot of distinguished people there too. What a great place it was!

DAVE Yeah, it was a honey! You saw it before he started in on it, didn't you? When it was the old hayloft of the barn. Grant tore out all the hay and grain chutes and built an outside stairway. Then he sank a bathtub down in the hole where the inside stairs used to be. He didn't like the old pine floor as it was, with the boards running east and west, so he took a saw and cut grooves running north and south, marking six-inch squares. Then he had his school kids come over and paint the squares different colors so that finally it looked like a beautiful tile floor. After that fire that partly destroyed the studio, we used the insurance money to put in a grand old English floor with the boards held together with wooden pegs instead of nails.

MARVIN I haven't been in the old studio for a long, long time. Does the floor still look good?

DAVE Yeah, it's in first-class shape. In fact, the whole studio is still in good condition.

MARVIN Look, you still have that little chest of drawers that he used for a palette, haven't you?

DAVE Sure! It's out at my home now. He mixed his paints on top of that for practically all his important paintings. The same piece of plate glass that he used is still on top.

MARVIN You want to hang on to that.

DAVE Marvin, tell me about that skinny portrait that Grant painted of you—the one I saw in your studio the other day.

MARVIN Well, that's kind of a joke! We painted each other at the same time, just for fun. He really made me skinnier than I was, and I made him look fatter than he was. He called his painting of me "Malnutrition," so I called the one I had done of him "Overstimulation." That one was burned up in the studio fire. I prize the one he did of me because it's the only oil painting of his that I have.

DAVE You two fellows ought to have exchanged paintings once in a while.

MARVIN We could have—but never thought about it. That one summer in Paris each of us did about 25 small pictures. By the way, we staged an exhibition on the ocean coming back. Hung them up in one of the big lounges of the boat, and the passengers enjoyed it because they had seen a lot of the places we had painted.

DAVE Didn't you meet your wife on that boat coming home?

MARVIN Yes, that's another reason I'll never forget the middle of the Atlantic Ocean! What are you looking at your watch for?

DAVE Well, I came up here to see the drawings and paintings done by your students, and we've been sitting here for over 20 minutes talking about Grant.

MARVIN We had to get our breath after that long climb up the stairs—anyway, it's been fun. Better to talk about an artist we both knew than some paint-pusher who lived a couple of centuries ago. Well, the student drawings are in the room right over there—let's go in and see them.

DAVE Wait a minute—I just thought of another Grant Wood story. This one shows how forgetful he was—What I mean is, he'd get so absorbed in whatever he happened to be doing, that he'd forget everything else he had to do. This time we were down in Des Moines and right in the middle of—

APPENDIX B

OIL SKETCHES BY GRANT WOOD

This appendix provides a reference for Grant Wood's 1930s oil sketches of the Iowa landscape. Although all of Wood's known works from the 1930s are included, it is likely that others will be located.

Between the mid-1920s and the early 1930s, Wood made frequent sketching trips to the countryside around Cedar Rapids and Stone City. His good friend Marvin Cone often accompanied him, as he had in the late 1910s. These excursions were more frequent in 1932 and 1933, when the Stone City Art Colony was emphasizing outdoor oil sketching. Wood placed a high value on these sketches, since they were preparatory to contemplated works. They also reflected the actual nuances of the countryside, a quality central to a regionalist philosophy. During the 1930s, as Wood became busier and better known, he no longer had the time for frequent outdoor sketching excursions. Instead, he concentrated on major exhibition pieces, his book illustrations, and his lithographs.

Often, these oil sketches of the Iowa countryside were not signed. This is not surprising, since Wood did not necessarily view them as complete or highly finished works of art. Instead, they remained in his studio to assist contemplated works or were given to acquaintances. It is known that a number of these works were signed in late 1949 or early 1950 with Wood's name and the inscription "sketch." This was done at about the same time—but by another hand—that his *Self-Portrait*, 1932 (Davenport Museum of Art) was partially repainted in the shirt and foreground area. In contrast, a number of spurious works with Wood's name have appeared in recent years. Despite a signature and sometimes a date, these examples show no relationship to the artist's work either in style or in subject matter.

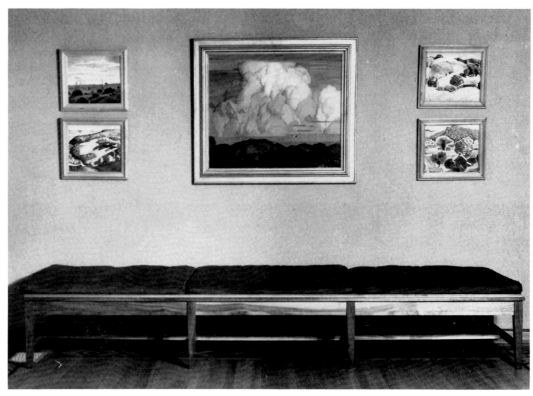

Exhibition of Grant Wood oil sketches and Marvin D. Cone's *Prelude* at the Cedar Rapids Art Association - c. 1931.

1. *Iowa Afternoon*, 1924*
Oil on composition board, 13 x 14⁷/₈ in. (33 x 37.8 cm.)
Inscribed lower left: *Grant Wood 1924*: lower left: *Grant Wood*
Cedar Rapids Museum of Art, Gift of Margaret and Frank Race (86.2)

2. *Fall Landscape*, 1924*
Oil on composition board, 13¹/₈ x 15 in. (33.3 x 38 cm.)
Inscribed lower center: *Grant Wood*
Cedar Rapids Museum of Art, Gift of Happy Young and John B. Turner II (72.12.17)

3. *Sun-Drenched*, 1926-27*
Oil on composition board, 13 x 15 in. (33 x 38 cm.)
Unsigned

4. *Chaff*, 1927*
Oil on panel, 10¹/₈ x 13 in. (25.7 x 33 cm.)
Unsigned
Cedar Rapids Museum of Art, Gift of John B. Turner II in memory of Happy Turner (81.17.6)

5. *Amber*, 1927*
Oil on composition board, 13 x 15 in. (33 x 38 cm.)
Inscribed lower right: *Grant Wood 1927*
Cedar Rapids Museum of Art, Gift of John Reid Cooper and Lee Cooper van de Velde in honor of their grandparents John C. and Sophie S. Reid, and their parents James L. and Catherine Reid Cooper (89.5.3)

6. *Cornshocks*, 1927*
Oil on composition board, 13 x 15 in. (33 x 38 cm.)
Inscribed lower left: *Grant Wood 1927*
Terrace Hill Society, Iowa, Gift of John B. Turner II

7. *Cornshocks*, 1928*
Oil on composition board, 15 x 13 in. (38 x 33 cm.)
Inscribed lower right: *Grant Wood 1928*

8. *Indian Creek, Midsummer*, 1928*
Oil on composition board, 13 x 15 in. (33 x 38 cm.)
Inscribed lower left: *Grant Wood 1928*

9. *Indian Creek*, c. 1928*
Oil on composition board, 13 x 15 in. (33 x 38 cm.)
Inscribed lower center: *Grant Wood*

*The pre-1930s works are included to provide an historical erspective for Grant Wood's 1930s sketches.

31.

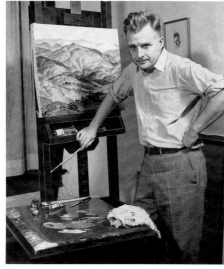
33.

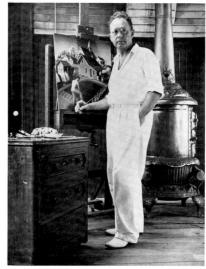
35.

32.

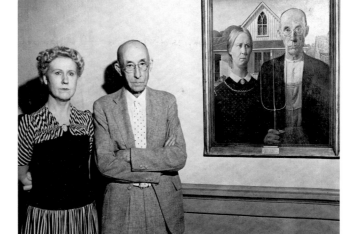
36.

25. Marvin D. Cone with sketching class in Viola, Iowa, 1932. Photograph by John W. Barry [1905-1988].
26. John Steuart Curry and Grant Wood at The Stone City Art Colony, July, 1933. Photograph by John W. Barry [1905-1988].
27. The Stone City Art Colony faculty, Summer 1932. Photograph by John W. Barry [1905-1988].
28. Grant Wood, 1930s. Photograph by John W. Barry [1905-1988].
29. Marvin D. Cone in Cedar Rapids, Summer 1933. Photograph by John W. Barry [1905-1988].
30. The Cone family (Marvin D., Doris and Winnifred) in Cedar Rapids, 1938.
31. Grant Wood, late 1930s.
32. Grant Wood completing the drawing for *Vegetables,* 1939. Photograph by George Yales.
33. Marvin D. Cone in his Granby Building Studio, Cedar Rapids, 1939.
34. Cedar Rapids Art Association Auction of Marvin D. Cone paintings, November, 1939.
35. Grant Wood with *Spring in Town,* 1940, in his Clear Lake, Iowa studio.
36. Nan Wood Graham and Dr. B.H. McKeeby next to *American Gothic,* 1942, at the Art Institute of Chicago.

34.

37.

38.

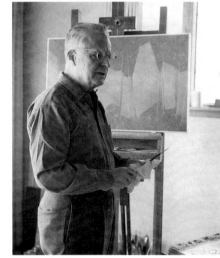

40.

42.

39.

41.

37. Marvin D. Cone with his grandchildren Stephen, Sheila, and Winnifred Weeks, 1959. Photograph by Joan Liffring-Zug.
38. Winnifred S. and Marvin D. Cone, 1962. Photograph by George T. Henry.
39. Marvin D. Cone in his studio, 1962. Photograph by George T. Henry.
40. Marvin D. Cone in his studio with *Golden Segments #2,* 1962. Photograph by George T. Henry.
41. Marvin D. Cone in his studio, 1962. Photograph by George T. Henry.
42. Marvin D. Cone in his Cedar Rapids Studio, 1960s. Photograph by George T. Henry.

MARVIN D. CONE

CONCORDANCE

ACQUISITION NUMBER	CATALOGUE NUMBER
32.1	53
39.1	80
51.1	97
69.4.2	51
69.4.3	59
70.1	68
70.3.1	81
70.3.2	14
70.3.3	87
70.3.4	43
70.3.5	57
70.3.6	70
70.3.7	20
70.3.8	82
70.4	41
71.2	231
73.4	227
80.3	93
80.11	75
81.1	76
82.4.1	21
82.10.1	64
82.10.2	109
82.10.3	79
83.1.1	229
83.1.2	77
83.1.3	56
83.1.4	89
83.1.5	94
83.1.6	202
83.1.7	84
83.1.8	73
83.1.9	30
83.1.10	91
83.1.11	86
83.2.1	111
83.2.2	110
83.2.3	24
83.2.4	102
83.3	107
83.4	100
83.5	42
83.7.1	3
83.7.2	243
83.7.3	83
83.7.4	83
83.7.5	92
83.7.6	10
83.7.7	95
83.7.8	96
83.7.9	9
83.7.10	69
83.10	50
83.15	38
83.16	39
83.17	113
84.1	211
84.11	48
85.2.1	85
85.2.2	66
85.2.3	115
85.2.4	126
85.2.5	124
85.2.6	125
85.2.7	127
85.2.8	156
85.2.9	2
85.2.10	99
85.2.11	88
85.2.12	103
85.2.13	98
85.8	61
86.1.1	1
86.1.2	4
86.1.3	22
86.1.4	5
86.1.5	8
86.1.6	6
86.1.7	7
86.1.8	13
86.1.9	15
86.1.10	23
86.1.11	31
86.1.12	27
86.1.13	25
86.1.13	33
86.1.14	28
86.1.15	16
86.1.16	32
86.1.17	45
86.1.18	40
86.1.19	36
86.1.20	47
86.1.20	55
86.1.21	44
86.1.22	46
86.1.23	49
86.1.24	52
86.1.25	58
86.1.26	65
86.1.27	67
86.1.28	104
86.1.29	108
86.1.30	114
86.1.31	19
86.1.32	62
86.1.32	63
86.1.33	112
86.1.34	78
86.1.35	72
86.1.36	208
86.1.37	230
86.1.38	155
86.1.39	272
86.1.40	273
86.1.41	180
86.1.42	201
86.1.43	261
86.1.44	277
86.1.45	265
86.1.46	263
86.1.47	266
86.1.48	262
86.1.49	260
86.1.50	234
86.1.51	191
86.1.52	254
86.1.53	268
86.1.54	129
86.1.55	199
86.1.56	173
86.1.57	132
86.1.58	153
86.1.59	165
86.1.60	138
86.1.61	164
86.1.62	170
86.1.63	133
86.1.64	171
86.1.65	264
86.1.66	242
86.1.67	267
86.1.68	128
86.1.69a	140
86.1.69b	135
86.1.69c	136
86.1.69d	182
86.1.69e	137
86.1.69f	139
86.1.69g	119
86.1.69h	134
86.1.69i	120
86.1.69j	159
86.1.70a	157
86.1.70b	160
86.1.70c	158
86.1.70d	118
86.1.70e	130
86.1.70f	117
86.1.70g	235
86.1.71a	207
86.1.71b	233
86.1.71c	121
86.1.71d	122
86.1.72	123
86.1.73a	193
86.1.73b	190
86.1.73c	195
86.1.73d	194
86.1.73e	196
86.1.73f	197
86.1.73g	203
86.1.73h	16
86.1.73i	131
86.1.73j	183
86.1.73k	184
86.1.74	185
86.1.75	259
86.1.76	209
86.1.77	228
86.1.78	210
86.1.79	275
86.1.80	250
86.1.81	257
86.1.82	255
86.1.83	256
86.1.84	258
86.1.85	274
86.1.86	279
86.1.87	186
86.1.88	244
86.1.89	253
86.1.90	223
86.1.91	271
86.1.92	270
86.1.93	269
86.1.94	276
86.1.95	224
86.1.96	218
86.1.97	220
86.1.98	221
86.1.99	222
86.1.100	168
86.1.101	167
86.1.102	166
86.1.103	198
86.1.104	252
86.1.105	241
86.1.106	232
86.1.107	169
86.1.108	172
86.1.109	141
86.1.110	176
86.1.111	188
86.1.112	206
86.1.113	226
86.1.114	245
86.1.115	187
86.1.116	246
86.1.117	251
86.1.118	177
86.1.119	204
86.1.120	142
86.1.121	175
86.1.122	181
86.1.123	174
86.1.124	161
86.1.125	162
86.1.126	247
86.1.127	225
86.1.128	248
86.1.129	200
86.1.130	216
86.1.131	192
86.1.132	278
86.1.133	212
86.1.134	249
86.1.135	217
86.1.136	213
86.1.137	215
86.1.138	214
86.1.139	143
86.1.140	178
86.1.141	189
86.1.142	116
86.1.143	144
86.1.144	145
86.1.145	163
86.1.146	146
86.1.147	147
86.1.148	152
86.1.149	148
86.1.150	149
86.1.151	154
86.1.152	150
86.1.153	151
86.1.154	238
86.1.155	239
86.1.156	240
86.1.157	236
86.1.158	205
86.1.159	237
86.1.160	11
86.1.161	179
86.1.162	280
86.4	18
87.3.1	35
88.5.1	29
88.5.2	37
88.6	90
88.7.1	101
88.7.2	105
89.1.1	12
89.1.2	17
89.1.3	26
89.1.4	34
89.1.5	54
89.1.6	60
89.1.7	71
89.1.7a	219
89.1.8	74
89.3.1	106

GRANT WOOD

CONCORDANCE

ACQUISITION NUMBER	CATALOGUE NUMBER
31.1	109
32.2	93
69.4.1	59
69.12	144
70.2.1	49
70.2.2	48
70.3.117	111
70.3.160a	43
70.3.160b	44
70.3.160c	45
70.3.160d	46
70.3.161	149
70.3.162a	122
70.3.162b	118
70.3.162c	120
70.3.162d	124
70.3.162e	121
70.3.162f	123
70.3.162g	119
70.3.165	20
70.3.169	143
70.3.170	35
70.3.171	60
70.3.172	133
70.3.173	23
70.3.174	148
70.3.175	125
70.3.176	115
72.12.1	1
72.12.2	74
72.12.3	2
72.12.4	52
72.12.5	4
72.12.6	55
72.12.7	11
72.12.8	91
72.12.9	31
72.12.10	32
72.12.11	39
72.12.12	42
72.12.13	5
72.12.14	170
72.12.15	135
72.12.16	113
72.12.17	61
72.12.18	171
72.12.19	167
72.12.20	17
72.12.21	37
72.12.22	56
72.12.23	28
72.12.24a	161
72.12.24b	162
72.12.24c	163
72.12.24d	164
72.12.25	30
72.12.26	86
72.12.27	157
72.12.28	18
72.12.29	57
72.12.30	166
72.12.31	7
72.12.32	53
72.12.33	155
72.12.34	158
72.12.35	38
72.12.36	3
72.12.37	129
72.12.38	139
72.12.39	140
72.12.40	168
72.12.41	169
72.12.42	159
72.12.43	25
72.12.45	87
72.12.46	54
72.12.47	16
72.12.48	22
72.12.49	85
72.12.50	21
72.12.51	138
72.12.52	27
72.12.53	131
72.12.54	130
72.12.55	114
72.12.56	33
72.12.57	132
72.12.58	6
72.12.59	128
72.12.60	146
72.12.61	160
72.12.62	145
72.12.63	34
72.12.64	134
72.12.65	58
72.12.66	36
72.12.67	165
72.12.68	71
72.12.69	26
72.12.70	65
72.12.71	68
72.12.72	64
72.12.73	69
72.12.74	63
72.12.75	66
72.12.76	67
72.12.77	40
72.12.78	47
72.12.79	142
72.12.80	70
72.12.81	73
72.12.82	75
72.12.83	72
72.12.84	165
72.13	126
73.3	110
73.6	97
73.7.1	76
73.7.2	76
74.4	129
74.5.2	79
74.5.3	78
74.5.4	81
74.5.5	77
74.5.6	82
74.5.7	80
74.5.8	83
75.3	12
75.10	24
76.2.2	104
76.2.3	95
76.2.4	29
78.1	107
79.1	89
80.1	41
80.2	19
80.5.1	116
80.5.2	117
81.11	108
81.17.1	76
81.17.2	76
81.17.3	150
81.17.4	151
81.17.5	84
81.17.6	98
81.17.7	50
82.1.1	147
82.1.2	136
82.1.3	137
82.1.4a	147
82.1.4b	147
82.1.4c	147
82.1.4d	147
82.1.4e	147
82.1.4f	147
82.1.4g	147
82.1.4h	147
82.1.5	127
82.22.1a	101
82.22.1b	105
82.22.2a	98
82.22.2b	103
83.12	141
84.12	94
85.3.7	156
85.5	112
85.6.1	160
85.6.2	154
86.2	62
86.6	99
86.7	92
86.15	163
87.3.2	90
87.4.1	8
87.4.2	9
87.4.3	10
87.4.4	14
87.4.5	15
87.4.6	13
88.11	153
89.5.1	51
89.5.2	106
89.5.3	96
89.5.4	102
89.5.5	100